# *The Artist's Guide to* DRAWING REALISTIC ANIMALS

## DOUG LINDSTRAND

**NORTH LIGHT BOOKS**

CINCINNATI, OHIO

www.artistsnetwork.com

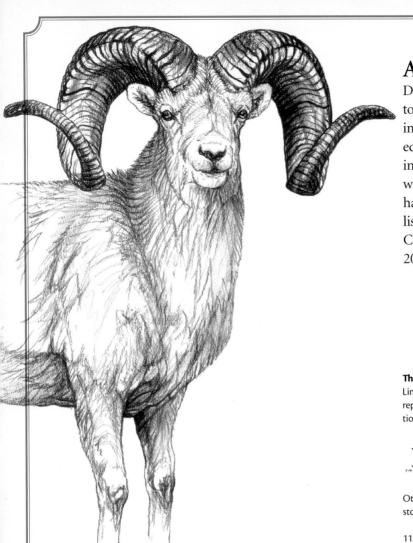

## ABOUT THE AUTHOR

Doug Lindstrand is a self-employed wildlife artist and photographer living in Anchorage, Alaska. He moved to Alaska in 1970 after finishing college in Minnesota, acquiring an education in art and biology to further his goal of working with animals. He spent a number of years living in the wilds of Alaska to study animals and practice his art. Doug has published numerous books, some of which he has published himself. His works include *Alaska Sketchbook* (Fox Chapel, 1995), *Drawing America's Wildlife* (Fox Chapel, 2003) and *Mountain Royalty* (self-published, 2004).

**The Artist's Guide to Drawing Realistic Animals**. Copyright © 2006 by Doug Lindstrand. Printed in Singapore. All rights reserved. No part of this book may be reproduced in any form or by any electronic or mechanical means including information storage and retrieval systems without permission in writing from the publisher,

**fw** F+W PUBLICATIONS, INC.

except by a reviewer who may quote brief passages in a review. Published by North Light Books, an imprint of F+W Publications, Inc., 4700 East Galbraith Road, Cincinnati, Ohio, 45236. (800) 289-0963. First Edition.

Other fine North Light Books are available from your local bookstore, art supply store or direct from the publisher.

11  10  09  08  07    6  5  4  3  2

DISTRIBUTED IN CANADA BY FRASER DIRECT
100 Armstrong Avenue
Georgetown, ON, Canada  L7G 5S4
Tel: (905) 877-4411

DISTRIBUTED IN THE U.K. AND EUROPE BY DAVID & CHARLES
Brunel House, Newton Abbot, Devon, TQ12 4PU, England
Tel: (+44) 1626 323200, Fax: (+44) 1626 323319
Email: postmaster@davidandcharles.co.uk

DISTRIBUTED IN AUSTRALIA BY CAPRICORN LINK
P.O. Box 704, S. Windsor NSW, 2756 Australia
Tel: (02) 4577-3555

**Library of Congress Cataloging-in-Publication Data**

Lindstrand, Doug.
  The artist's guide to drawing realistic animals / Doug Lindstrand.-- 1st ed.
      p. cm.
  Includes index.
ISBN-13: 978-1-58180-728-8 (pbk. : alk. paper)
ISBN-10: 1-58180-728-7 (pbk. : alk. paper)
1. Animals in art. 2. Drawing--Technique. I. Title.
NC780.L49 2006
743.6--dc22                                    2006000491

Edited by Mona Michael and Kelly Messerly
Designed by Wendy Dunning
Production art by Kathy Bergstrom and Sean Braemer
Production coordinated by Jennifer L. Wagner

## METRIC CONVERSION CHART

| To convert | to | multiply by |
| --- | --- | --- |
| Inches | Centimeters | 2.54 |
| Centimeters | Inches | 0.4 |
| Feet | Centimeters | 30.5 |
| Centimeters | Feet | 0.03 |
| Yards | Meters | 0.9 |
| Meters | Yards | 1.1 |

*PHOTOGRAPHING DALL SHEEP*

## ACKNOWLEDGMENTS

Artists are the product of their life experiences and so all develop differently. I was fortunate to grow up in a small town and in a loving family that always provided opportunity and encouragement. The friendly people and rural country around Winthrop, Minnesota, allowed me to roam, sketch and study nature and wildlife. It was here that I determined I would someday make a career involving animals and also, hopefully, art.

Naturally there are dozens of people that I owe thanks to for helping me along this road to becoming an artist. I have always tried to thank these kind and generous people and since I don't want to name some and forgetfully omit others, I therefore won't list everyone by name. A special thanks, though, to my parents, August and Blandina, and my sisters, JoAnn, Joyce and Karen for their special love and inspiration.

Thanks also to the wonderful staff at North Light Books and to Pam Wissman who proposed and pursued the idea of this drawing book. A special thanks to my editors, Mona Michael and Kelly Messerly, whom I enjoyed working with throughout the book-development process and who taught me so much about how to put my drawing techniques into understandable text and illustrations. The result of this "team project" is, I hope, an instructional book that artists may find helpful enough to inspire them to pick up their pencils and draw.

## DEDICATION

This book is dedicated to those individuals who have devoted their time, effort, resources and vision to the care and preservation of our planet's magnificent wildlife.

# Table of Contents

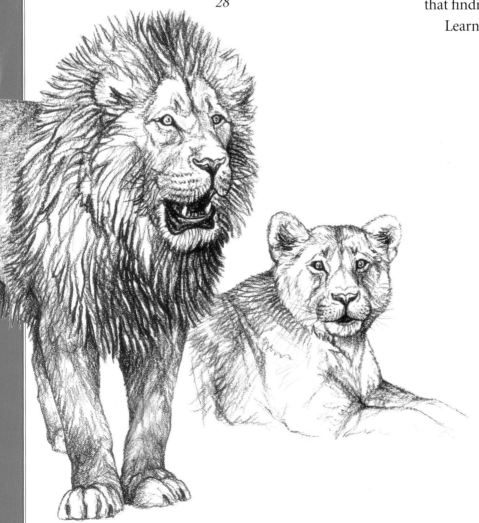

# 5 Other Animals, Large & Small

The wide variety of the animal kingdom makes drawing animals both challenging and fun. Learn how to draw everything from a tiny cottontail rabbit to a massive African elephant.
*106*

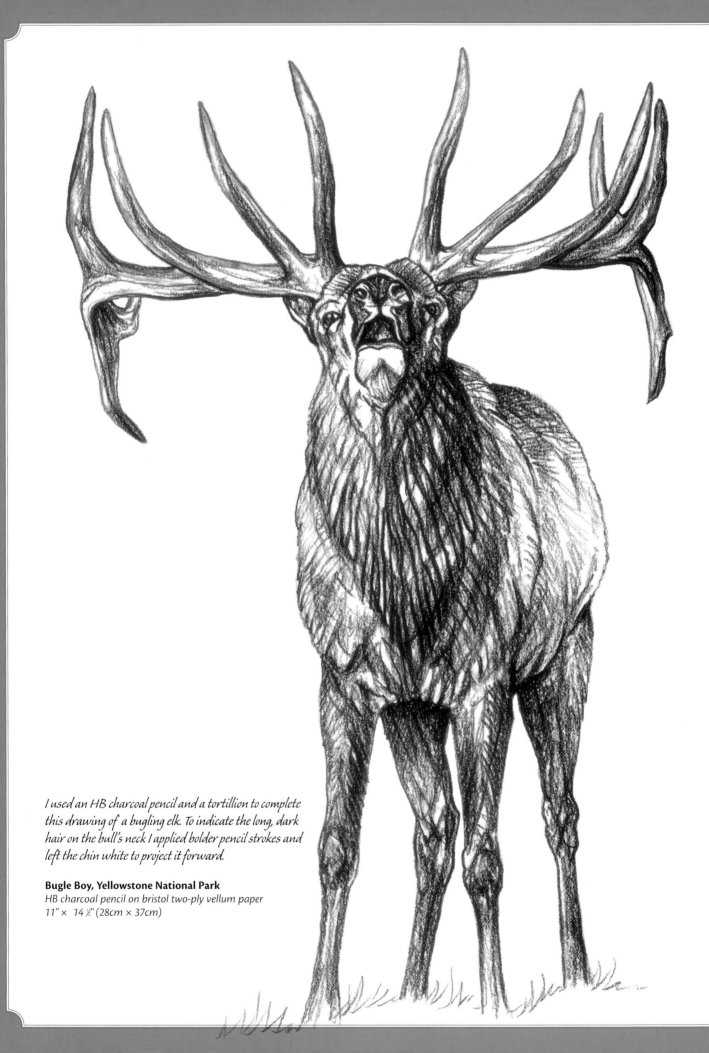

*I used an HB charcoal pencil and a tortillion to complete this drawing of a bugling elk. To indicate the long, dark hair on the bull's neck I applied bolder pencil strokes and left the chin white to project it forward.*

**Bugle Boy, Yellowstone National Park**
*HB charcoal pencil on bristol two-ply vellum paper*
*11" × 14½" (28cm × 37cm)*

# 1 Getting Started

Drawing animals is more than just making a realistic picture; it's about capturing an animal's essence in a way that makes it come alive on the paper. To do this, there are a few techniques you need to know and materials you should be comfortable with. You don't need much to draw your favorite animals realistically, and this chapter will show you how to use these few drawing tools and techniques effectively. Always remember that one of the most important secrets to drawing animals is to enjoy the adventure and challenge of becoming a better artist.

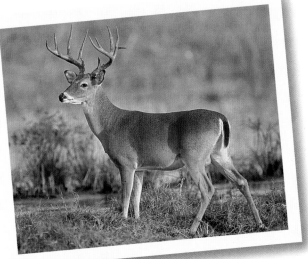

This white-tailed deer has a particularly nice pose and the photograph captures its colors well. Refer to the photographs throughout this book as you create your own animal drawings.

Obtaining reference material on animals often means going afield. You must, after all, go to where the animals are. This means going to zoos, parks, mountains and meadows. Every animal has a different home and you must seek them out to obtain the necessary information to accurately portray animals in your art. Although cats and dogs can often be studied and drawn in the comfort of your own home, most birds and mammals live in the wild or in other outdoor environments. Therefore, you should travel with a field pack stocked with the necessary art tools. A decent camera with which to take reference photos will simplify your job of illustrating animals, too. After all, without adequate and accurate reference material, it is more difficult to portray your subject realistically. I recommend a 35mm SLR (single-lens reflex) camera with different lenses.

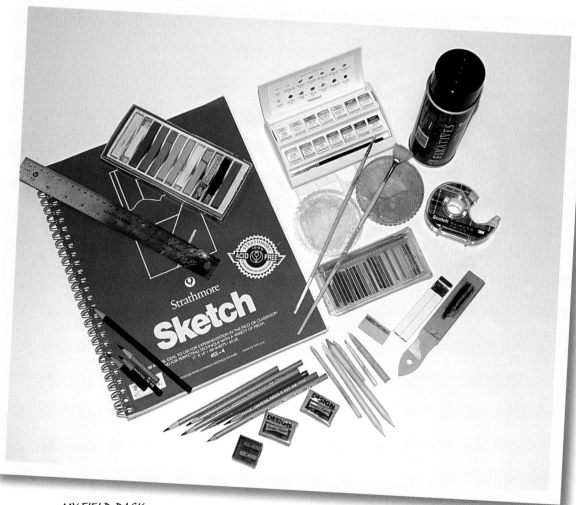

*MY FIELD PACK*
*My personal field pack is normally stocked with a sketch pad, pencils, erasers, pastels, watercolor box, brushes, sharpening tools, tortillions, transparent tape, rulers and a can of fixative. Depending on my quarry, I may also carry binoculars and camera gear. Certain animals such as small, fidgety birds are easier to illustrate with reference photos. More dangerous animals are best drawn from a safe distance.*

# Drawing Materials

Art is truly a process of searching, experimenting and changing. Your style will certainly evolve as you grow as an artist, and the drawing materials need will change as well.

I have singled out certain drawing tools that suit me. Test these items for yourself, but don't restrict yourself to only these. Try different tools and enjoy this process of growing as an artist. You are truly *unique* and you should allow the world to see and enjoy your special vision. Study the techniques of other artists, but always maintain the goal of being *you* and developing your individual skills.

Of course, you also may need sketch pads, tracing paper, grid paper, pastels, watercolors, etc. How extended this list becomes will depend on you. My choices for basic materials for drawing animals are:

**Pencils:** I use HB charcoal pencils, HB graphite pencils, and no. 4 extra-hard pencils. The darkness or lightness of your pencil marks is controlled by two things: the type of pencil you use and how much pressure you apply. Harder pencils are easy to keep sharp and are best for making precise lines.

**Papers:** I use textured illustration board and bristol two-ply cotton-fiber paper. Illustration board is great for feathers and fur because as you draw a line, the paper's firm surface and slightly rough texture (*tooth*) will create little skips. Bristol paper is not as firm as illustration board but it is strong enough to withstand many erasings, making it an excellent surface for ini-

tial sketches. A sheet is 23" × 29" (58cm × 74cm) and I normally cut it into four equal pieces because it's easier to find frames for smaller sizes.

**Kneaded Erasers:** Use a kneaded eraser for cleaning large areas or for shaping and erasing a hard-to-reach area. They also can be used to lift off some of the charcoal or graphite to soften areas that are too dark. Use harder rubber or art gum erasers to eliminate stubborn lines and marks.

**Tortillions:** These rolled, pointed paper sticks come in an assortment of sizes and are used for blending or softening pencil lines. They help you tone in shadow areas and make your drawings appear three-dimensional.

**Razor Blades:** Sometimes razor blades are good for picking out highlights or for details such as whiskers in a dark area of a drawing. Use the blades carefully.

**Fixative:** Fixative will "fix" your pencil marks in place. It helps to prevent smudges. But remember, you can't erase the lines once a fixative is applied. Use light mists when applying and not a heavy soak.

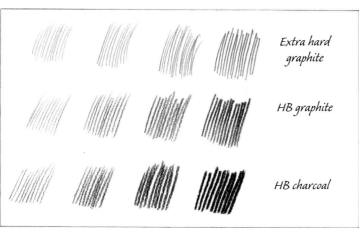

Extra hard graphite

HB graphite

HB charcoal

*PRACTICE WITH VARIOUS PENCILS AND PENCIL PRESSURES*
*This example illustrates the lines of three different pencils made with varying degrees of pressure. With practice you will find the pencils that best suit your needs.*

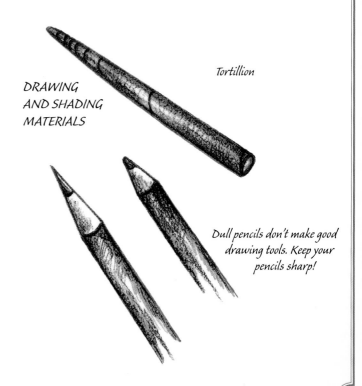

*Tortillion*

DRAWING AND SHADING MATERIALS

*Dull pencils don't make good drawing tools. Keep your pencils sharp!*

# Charcoal and Graphite

Charcoal pencils are my favorite medium for animals. I prefer charcoal pencils to charcoal sticks because the pencils are easier to use and are less messy than the sticks. They come in varying degrees of hardness. The H stands for hard and the B for soft. There is also an HB hardness that is between the H and B. I use an HB charcoal to add the finishing touches on most of my work. Charcoal pencils can create a wider range of tones than graphite pencils, including a blacker black; graphite can produce only a dark gray. Because of this, charcoal pencils can produce a wider range of tones.

Many artists prefer a more grayish tone, so if that's the case, graphite pencils are the perfect choice. Like charcoal, they come in many degrees of hardness (H through B). I like to use HB or harder graphite pencils for doodling and field sketching because graphite sticks to the paper better than charcoal so your sketch pads stay cleaner.

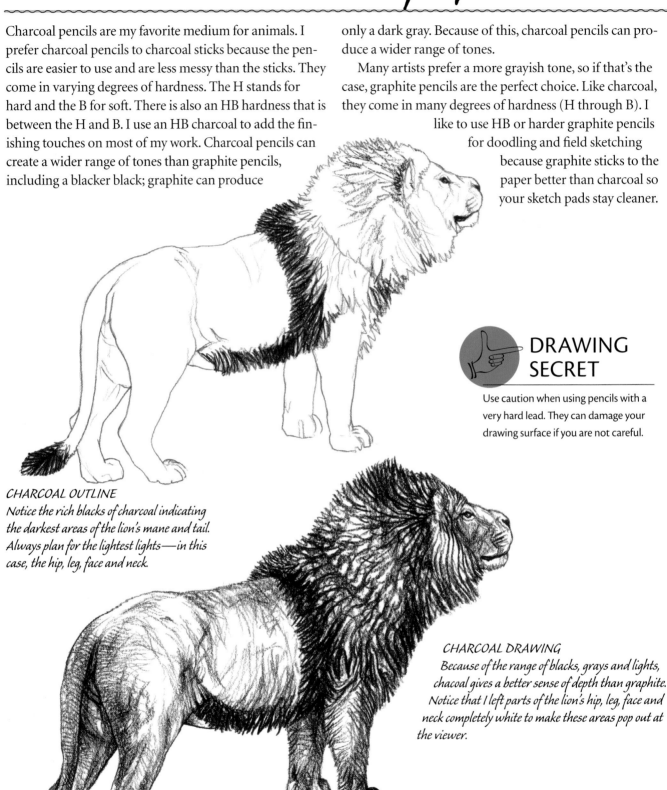

## DRAWING SECRET

Use caution when using pencils with a very hard lead. They can damage your drawing surface if you are not careful.

*CHARCOAL OUTLINE*
*Notice the rich blacks of charcoal indicating the darkest areas of the lion's mane and tail. Always plan for the lightest lights—in this case, the hip, leg, face and neck.*

*CHARCOAL DRAWING*
*Because of the range of blacks, grays and lights, chacoal gives a better sense of depth than graphite. Notice that I left parts of the lion's hip, leg, face and neck completely white to make these areas pop out at the viewer.*

## Charcoal Pencils

A drawing's sense of depth is achieved by using a wide range of values between white and black. Charcoal pencils will give you this range better than the gray-black of graphite pencils. Remember to make your darkest pencil marks last.

I prefer to use a hard graphite pencil to lay in my final animal outline. I use a HB charcoal pencil if the outline needs a very sharp line.

## Graphite Pencils

Graphite pencils are nice, all-around pencils because they stay sharp and are not as messy as charcoal pencils, which are good for adding the darkest darks to finish a drawing.

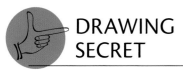 **DRAWING SECRET**

Save the blackest blacks for the areas in your drawing that you want to appear in shadow or to recede. These are usually the last tones you will add.

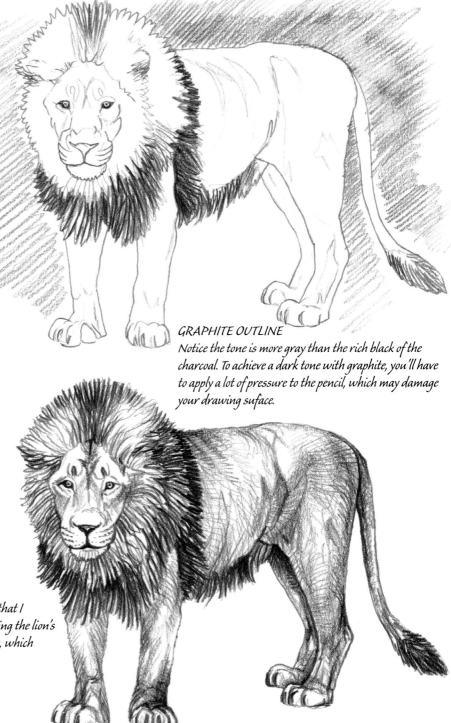

*GRAPHITE OUTLINE*
*Notice the tone is more gray than the rich black of the charcoal. To achieve a dark tone with graphite, you'll have to apply a lot of pressure to the pencil, which may damage your drawing suface.*

*GRAPHITE DRAWING*
*Here you can see there isn't quite the value range that I achieved with the charcoal drawing. In this drawing the lion's face is closest to the viewer, so I left a lot of it white, which makes the face seem to protrude from its ruff.*

# Begin With Gesture Sketches

*Gesture sketches* are rough drawings that capture the essence of a moment. They should be done quickly. If you spend too much time on it, it's no longer a gesture sketch. Gesture sketches are great for developing your eye-hand coordination. I normally use circles to lay out the basic torso and head. Then I quickly add other shapes such as triangles, ovals and cylinders to add the legs and tails.

You need gesture sketches in order to build reference material and your own store of knowledge about how animals behave. Pets and captive animals in zoos make excellent models for observing firsthand important details such as the animal's stripes or markings.

Record your observations with field sketches and reference photographs and save them in files for future use. Sit and watch the animals as they move about or rest, then create gesture sketches that capture those poses and movements. Remember that your purpose here is only to record the animal's pose or a particular physical characteristic. Later you can refine these quick doodles into more detailed drawings (and the sooner you do this, the better you'll be able to recall the details).

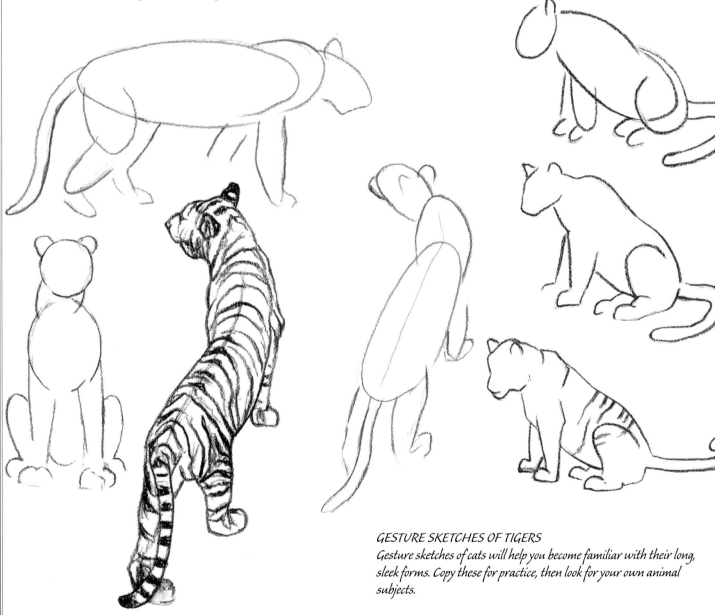

**GESTURE SKETCHES OF TIGERS**
*Gesture sketches of cats will help you become familiar with their long, sleek forms. Copy these for practice, then look for your own animal subjects.*

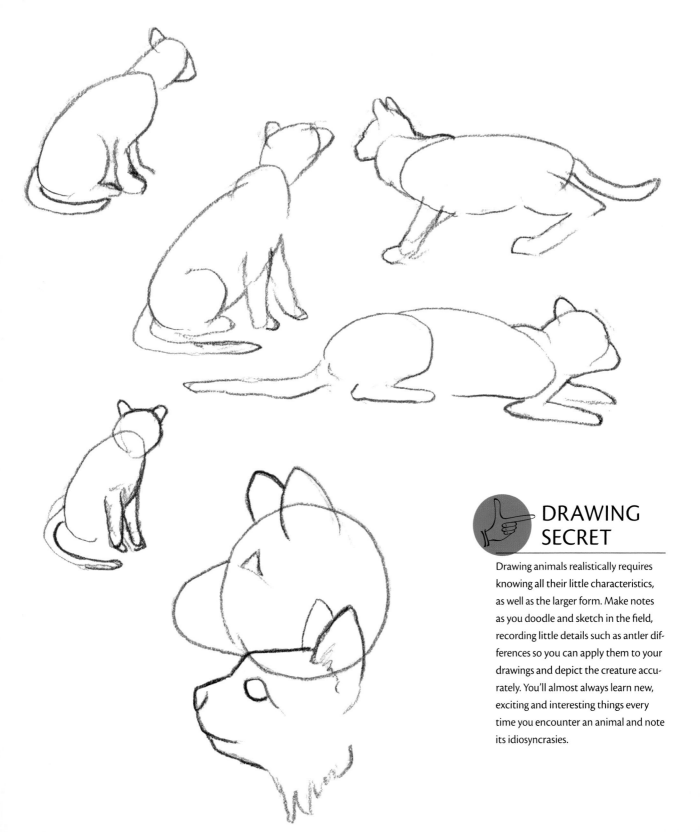

## DRAWING SECRET

Drawing animals realistically requires knowing all their little characteristics, as well as the larger form. Make notes as you doodle and sketch in the field, recording little details such as antler differences so you can apply them to your drawings and depict the creature accurately. You'll almost always learn new, exciting and interesting things every time you encounter an animal and note its idiosyncrasies.

# Build Form With Basic Shapes

Animals have very few sharp or square shapes. Always think soft and round as you draw the basic shapes of an animal. Of course, you may have to begin by "blocking" things in with rectangles or squares before reshaping them into a more realistic figure. Starting with the basic shapes will help you proportion and define your animal. Experiment with creating an animal's form using circles, squares, cylinders, pyramids and rectangles. In time you will be able to see your animal models in terms of their basic shapes.

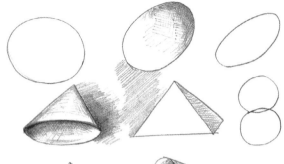
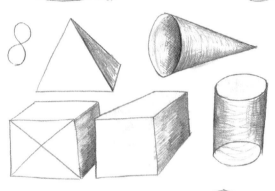

 **DRAWING SECRET**

I always finish the face of my animal subjects first. Then I prefer to start from the left side of my drawing and work toward the right. Since I am right-handed, I lay a piece of paper over the rest of my drawing to prevent any smudging my hand might cause.

*PRACTICE DRAWING BASIC SHAPES*
*Copy the shading techniques shown here to get the hang of making things look three-dimensional.*

*1 Initial doodle*

*2 Refined shape and proportions*

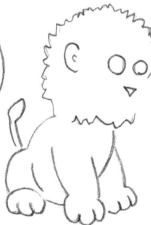

*3 Further refinement with details*

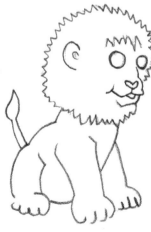

*4 Final outline with facial details placed correctly*

PUTTING BASIC SHAPES TO USE
*Although this cartoon lion demonstrates the ease with which you can turn basic shapes into an animal, you can see how you could also draw a more realistic animal. It just comes down to making sure your proportions and shapes are correct.*

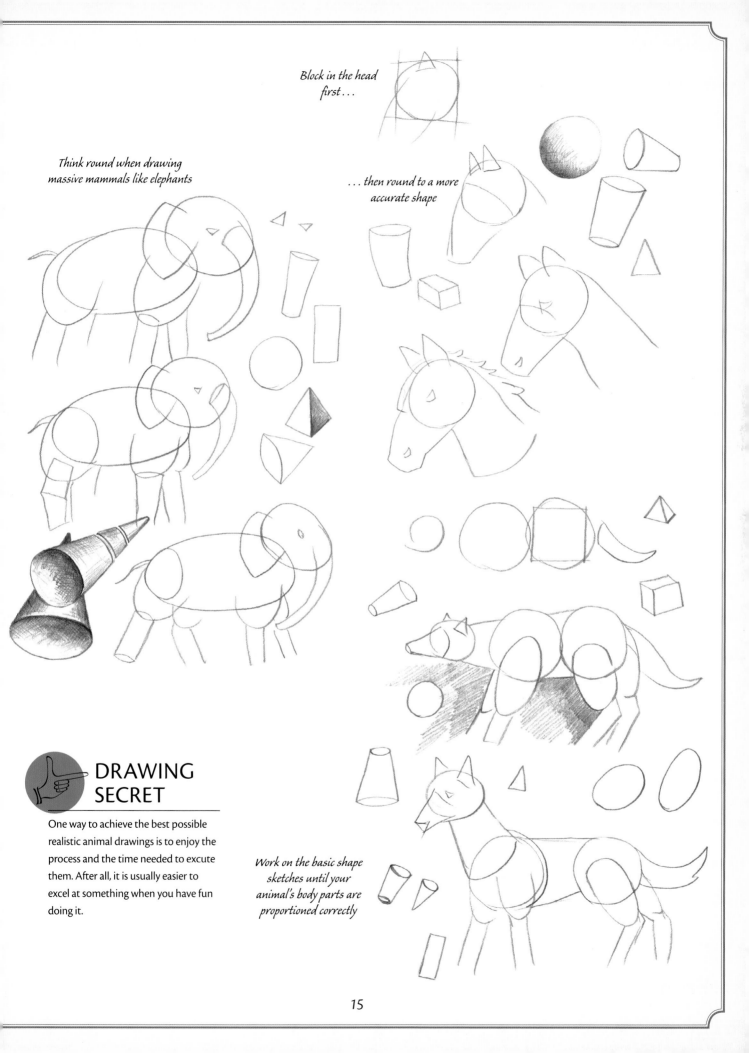

*Block in the head first . . .*

*Think round when drawing massive mammals like elephants*

*. . . then round to a more accurate shape*

## DRAWING SECRET

One way to achieve the best possible realistic animal drawings is to enjoy the process and the time needed to excute them. After all, it is usually easier to excel at something when you have fun doing it.

*Work on the basic shape sketches until your animal's body parts are proportioned correctly*

# Using Value

Drawing a realistic form depends largely on *value*, the relative lightness or darkness of a tone. You must have both light and dark areas in your drawings to give an animal shape. The fewer values you use, the "flatter," or more cartoonlike, your image will appear. You can create values with your pencils or charcoals using several different methods. The main techniques I use are:

- **Hatching:** Drawing parallel lines to indicate shading.

- **Pointillism:** Using dots of varying colors or darkness to create the effect of value change.

- **Crosshatching:** Line strokes that intersect each other. I use pointillism the least. Usually I'll use hatching or crosshatching to add the shadow areas, then I use a tortillion to smudge and blend my hatchmarks for smooth transitions from dark to light.

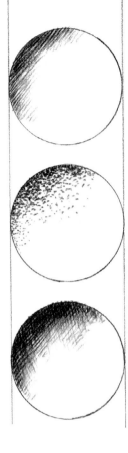

*VALUE HELPS CREATE FORM*
*If these circles were an animal I was drawing, I would blend these pencil marks with a tortillion to soften the edge where the pencil marks fade into white.*

| Hatching | Pointillism | Crosshatching |
|---|---|---|
| 1 | 1 | 1 |
| 2 | 2 | 2 |
| 3 | 3 | 3 |
| 4 | 4 | 4 |

*PRACTICE CREATING VALUES*
*With pencil and paper, make simple scales showing the range of values you can create with different pencil techniques. These scales are called value scales.*

You learned how basic shapes combine to make animals on page 14. And you've practiced creating different values on page 16. Now, let's put the techniques together and use value to give form to these shapes.

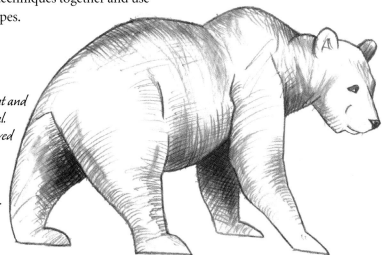

## VALUE AT WORK

*Here's an outline of a bear with light and dark pencil lines shaping the animal. The darkest pencil marks are reserved for the deepest shadow areas and the areas farthest away from the viewer. The white (unmarked) areas are those closest to the viewer and also those where light appears to hit the bear.*

## HIGHLIGHTS, MIDTONES AND DARK SHADOWS

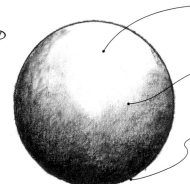

*The full light (highlight) area where light strikes the ball is your lightest value.*

*The medium values (midtone) area where white fades into the darker shadow areas*

*Your darkest shadows and darks will always be directly opposite the full light areas*

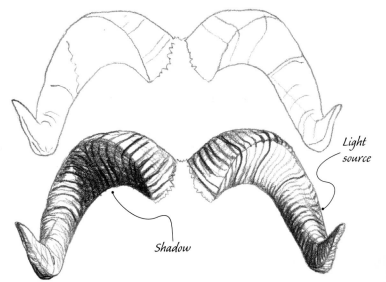

Light source

Shadow

## HORN VALUE STUDY

*In this example I drew an outline of horns and then used an HB graphite pencil and tortillion to shape them. Note the direction of the light and see where the shadows occur.*

# Blending and Softening Lines

When you soften hard lines by blending them, your shading will appear more natural. After all, no animal has any hard lines in reality.

*PRACTICE USING TORTILLIONS TO BLEND AND SOFTEN PENCIL LINES*
*Draw a series of lines with your pencil and then blend them by rubbing the lines with a tortillion until the lines disappear and you develop a soft gray blended area. Sometimes you may find it easier to merely use your fingertip to soften and blend lines.*

*BLENDING MAKES DRAWINGS LOOK REALISTIC*
*Most parts of an animal are rounded, with one color gradually fading into another. Even a black-and-white skunk doesn't change from black to white without any transition. Create transitions in your drawings by blending.*

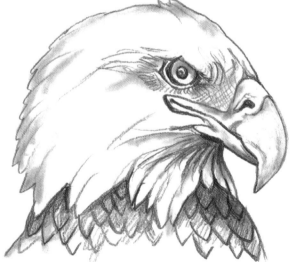

*Blending brings this illustration to life*

# Using Grids to Adjust a Drawing's Size

Often you'll have to enlarge or reduce your outline prior to transferring it to your final paper. Employing a grid of reference points should help guide you.

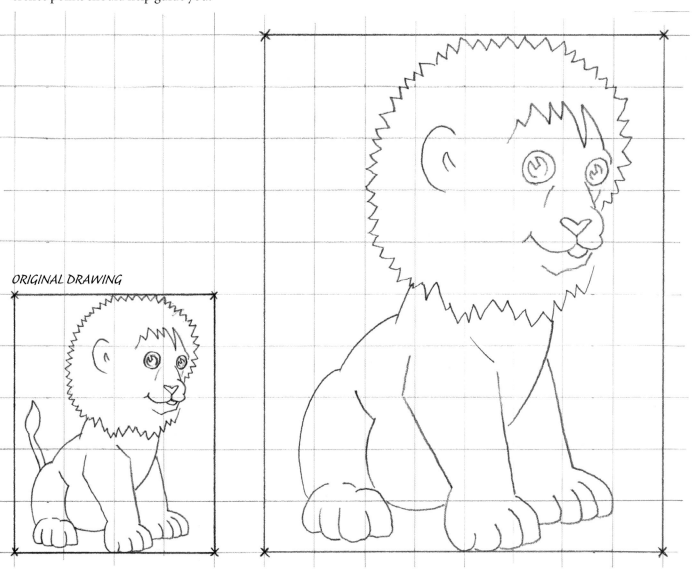

*ORIGINAL DRAWING*

 **DRAWING SECRET**

If you need to change your image size only slightly, try a copy machine. You can adjust to any percentage you wish on the machine, then use tracing paper to transfer the image back to your drawing paper.

*ENLARGED LION*

*In this example I wanted to enlarge the original image by 200%. Since I used the same size grid for both, I used four squares (two up and two across) in the enlarged drawing for every one square in the original. Although I drew the grid for this example by hand, you can purchase grid paper, which will save you time and effort.*

*I purposely left out the tail on the enlargement. Try drawing it in using the grid lines as guides.*

# The Drawing Process

This detailed step-by-step process works well for me and provides consistent results. Follow this process as you begin, altering it along the way as you discover what works best for you.

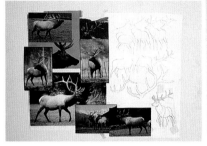

*1*

## 1 GATHER REFERENCE MATERIAL AND DRAW AN ACCURATE OUTLINE

*Use material such as field sketches, notes and photographs of the chosen bird or mammal to draw an outline of the animal. Using the reference material, choose a pose and lay out a sketch (or doodle) on tracing paper. After this initial sketch is made, place another piece of tracing paper atop the first sketch to further refine the drawing.*

## 2 PREPARE THE OUTLINE FOR TRANSFER TO THE FINAL SURFACE

*Once you've created an accurate outline of your subject, check the drawing's proportions and accuracy. Determine if you would like to make the outline larger. If so, follow the procedure on page 19 for adjusting a drawing's size. Once you have the size you want, turn the drawing over and trace over your outline on the reverse side of the tracing paper. Press fairly hard, but be careful not to tear the paper. I like to use charcoal pencils for this step.*

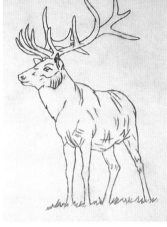

*2*

## 3 TRANSFER TO THE FINAL SURFACE

*Turn your tracing paper back to the correct side and trace over the drawing with your pencil. As you trace over the outline, you will transfer the charcoal on the back of your tracing paper to the final surface.*

## 4 ADD DETAILS

*Start with the head and add details to the face and antlers. Use a piece of tracing paper as a hand rest so you don't smudge the drawing. Gradually add details to the rest of the body.*

## 5 ADD THE FINISHING DETAILS

*Add the remaining details, tonal variations, markings and darkest darks, giving your drawing the extra touches that make it look finished. At this point, set your drawing aside for a little bit. When you come back to it, you'll be able to look at your drawing more objectively and see if you need to add anything else.*

*3*

## 6 CLEAN UP THE DRAWING AND PRESERVE IT

*Erase any unwanted lines, fingerprints and smudges and spray the finished drawing with a fixative to protect it. Use a couple of light mists rather than a heavy soaking.*

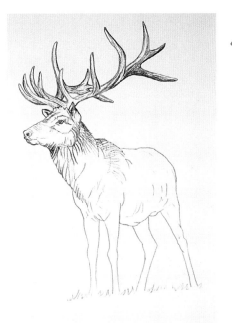

4

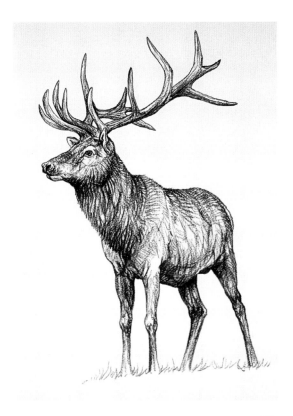

5

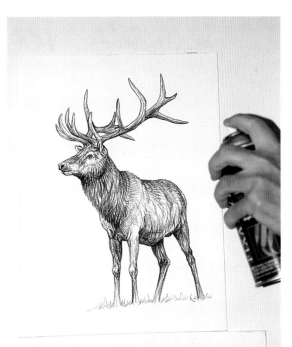

6

# Practice Your New Skills

Let's put some of the new techniques you've learned into practice. When learning to draw animals, what better place to begin than with the magnificent "King of Beasts," the African lion? Its heavy neck ruff and sleek hide make it a fun subject to draw as well.

**ANIMAL SECRET**

Cat bodies are longer than they are tall. Make sure these proportions are reflected in your drawing.

*1* DRAW THE BASIC SHAPES
*First you must decide on a pose. Time spent on achieving an accurate outline will save you a lot of time later. Doodle to find a pose you like.*

*2* DEFINE THE STRUCTURE
*Lay tracing paper on top of the first sketch. Use your initial sketch as a basis upon which you will define the lion's structure. This will further refine the animal's shape and essence.*

*3* REFINE THE SKETCH
*Using another tracing paper overlay, further refine the sketch (pages 20–21). Clean up your lines and add more details that define the shape of the face and body. Make all your changes and refinements prior to beginning the work on your final drawing paper. This will result in a cleaner piece of art.*

*4* CHECK OUTLINE DETAILS AND DRAWING PROPORTIONS
*Continue working on an accurate outline with another tracing paper overlay. Check your proportions, making adjustments as necessary.*

*5* FINISH THE OUTLINE AND ADD DETAILS
*Do another tracing paper overlay and finalize the positioning of facial details such as the eyes, ears, nose and mouth. Check the body again to make sure it is proportioned correctly. Once you feel that everything is as correct as possible, you can consider your outline finished. Make sure you are satisfied with the outline before you transfer it to the final surface.*

*6* TRANSFER THE IMAGE AND FINISH
*Once the outline is transferred to your drawing paper, fill in the details. Make your pencil lines both follow the direction of the fur and help round out the limbs and torso. Use hatching to create values then blend them slightly with a tortillion. Add fullness and depth to the mane with extra-dark charcoal lines. Spray with fixative and let it dry.*

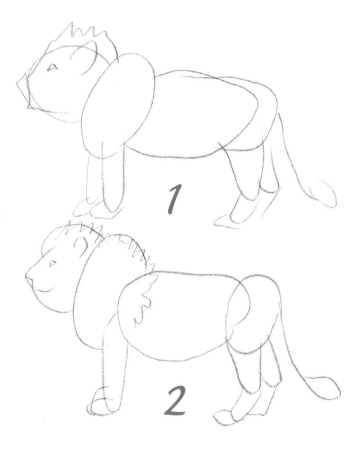

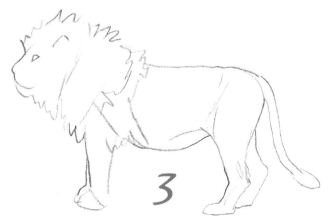

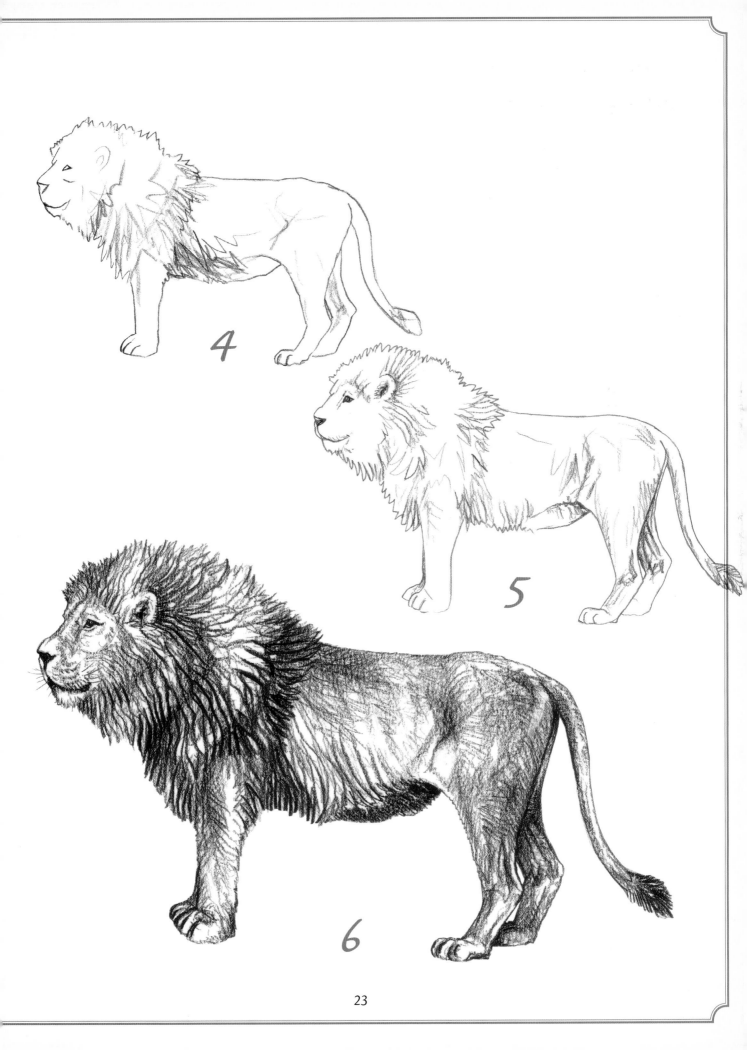

4

5

6

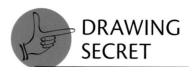
# White Creates Light

A drawing's white, unmarked areas are just as important as the actual pencil lines. In this drawing there will be a strong light coming from the left, which will make that side of the lion's face very bright. You will create lights and darks in two different ways: in one you will fill in all the areas with tone, and in the second you will add darks while leaving light areas blank. Try both methods to really get a feel for the difference white lights can make.

The color of the paper is the lightest tone you can get. Leaving blank areas is a great technique to use to designate the lightest lights.

## DRAWING SECRET

Once you've completed your final outline, try waiting a day or two before transferring the image to your drawing paper. Keep the drawing in a place where you can glance at it occasionally. A fresh look may make a previously unnoticed flaw obvious to you.

*1 ESTABLISH THE BASIC OUTLINE*
*Use tracing paper overlays to get an accurate outline of the lion's face. Make sure your outline is as accurate as possible—especially the position of the facial features.*

*2 FILL IN THE DARKS FIRST*
*Use charcoal and a tortillion to entirely fill in the dark area of the drawing. Then add pencil lines to define the fur details.*

*2 DRAW PENCIL LINES AND LEAVE THE LIGHTS*
*Draw the lion's mane with pencil lines. Use a tortillion to shade in parts of the mane and face, leaving white areas for highlights. Notice the increased depth you've created with the contrast of light and dark.*

# Pencil Practice

Practice drawing animals with different types of pencils and applying different degrees of pressure. Press hard for a dark color or press lightly for light areas. Only by understanding your drawing tools will you be able to use them effectively. A good exercise is to use different types of pencils on a single drawing. This will help you understand which pencil is best for which element.

*USE VARIOUS PENCILS ON A
SINGLE DRAWING
Line darkness depends on the type
of pencil you use and the amount of
pressure you apply. (See page 9 for
another pencil exercise.)*

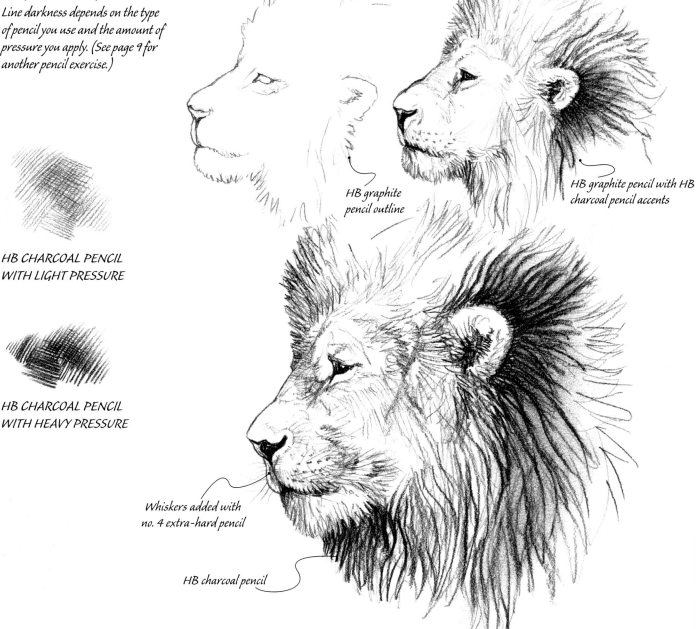

*HB CHARCOAL PENCIL
WITH LIGHT PRESSURE*

*HB CHARCOAL PENCIL
WITH HEAVY PRESSURE*

*HB graphite
pencil outline*

*HB graphite pencil with HB
charcoal pencil accents*

*Whiskers added with
no. 4 extra-hard pencil*

*HB charcoal pencil*

You don't always need to blend or smudge your pencil lines. To achieve some effects, such as a cub's rough fur or whiskers, there's no need for blending or smudging; the lines will do the work for you. Features contain lines and tones that indicate details. Even minimal shading will give you an initial indication of where darker tones will be necessary as you get closer to finishing the drawing.

## DRAWING SECRET

Reference photos are extremely important for artists who want to portray their subjects accurately. Having a store of varied reference photos will provide you with many different perspectives of your subject.

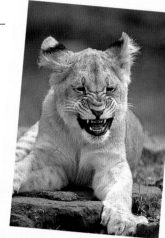

*LION CUB OUTLINE*
*The minimal shading in this outline shows areas where darker tones will be necessary. From this point you can begin to fill in the details.*

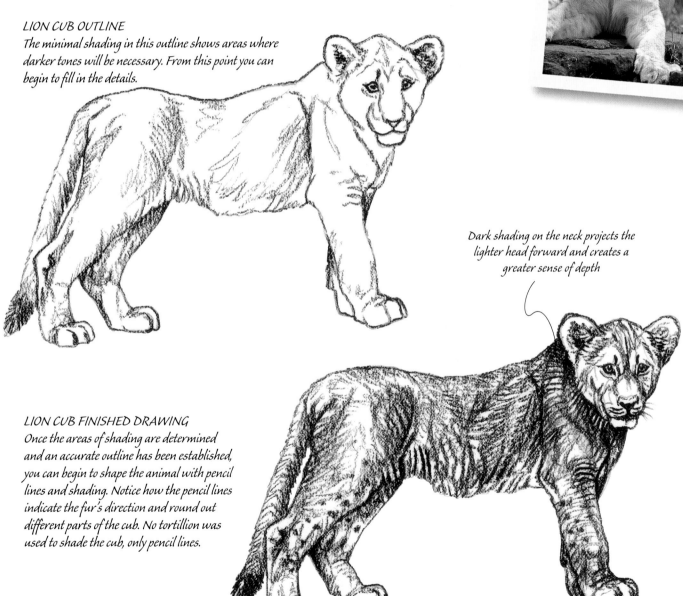

*Dark shading on the neck projects the lighter head forward and creates a greater sense of depth*

*LION CUB FINISHED DRAWING*
*Once the areas of shading are determined and an accurate outline has been established, you can begin to shape the animal with pencil lines and shading. Notice how the pencil lines indicate the fur's direction and round out different parts of the cub. No tortillion was used to shade the cub, only pencil lines.*

# Blending Effects

Shade and blend your dark shadow areas carefully. It is easy to over-darken an area and then be unable to erase the area to return it to white. It's best to leave a little "sparkle" of white paper showing through on your animals' fur. This helps illustrate how light sparkles off the tips of the fur. Tortillions come in a variety of sizes, so experiment to find ones that suit your needs.

## ANIMAL SECRET

Young lion cubs have "spot" markings during their first few months of life.

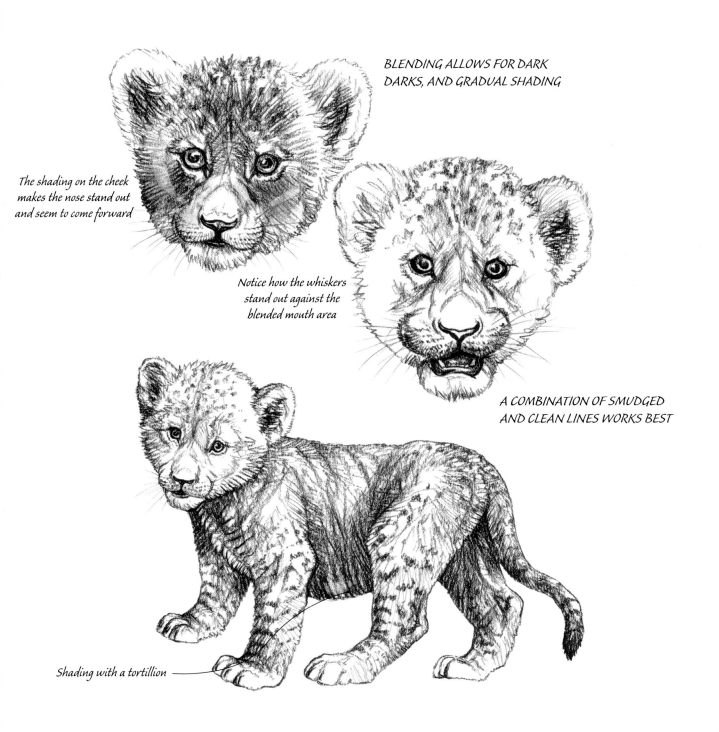

BLENDING ALLOWS FOR DARK DARKS, AND GRADUAL SHADING

*The shading on the cheek makes the nose stand out and seem to come forward*

*Notice how the whiskers stand out against the blended mouth area*

A COMBINATION OF SMUDGED AND CLEAN LINES WORKS BEST

*Shading with a tortillion*

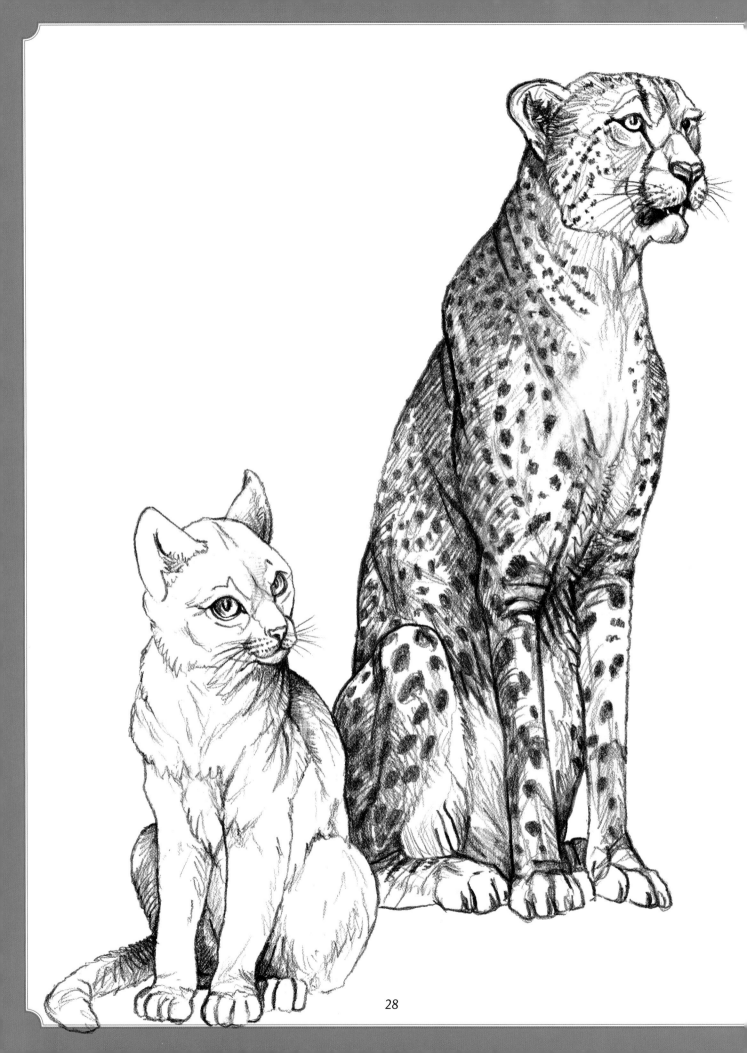

# 2 Cats & Their Relatives

From domestic house cats to wild cheetahs, all members of the feline family are very similar in their basic structure. House cats are readily found in various sitting, grooming and sleeping positions. This makes it easy for you to practice drawing them from many angles.

When drawing other members of the feline family, it's a good idea to draw from reference photos or from live examples as each cat species has unique characteristics. Try to capture all aspects of a cat's nature, too; practice portraying them both lazily relaxed and explosively alert.

**Domestic Cat and Cheetah**
*Gaphite pencil on bristol paper*
*14 ½" × 11" (37cm × 28cm)*

# Domestic Cats

Pet cats make ideal animal subjects. You can find them in all sorts of interesting positions and they are tame enough to let you get close to them. Plus, you can practice your sketches from the comfort of your living room couch. Once your gesture sketches have produced a pose that you like, you can move on to refining it step by step until you have developed an outline to transfer to the appropriate final surface. Then begin to add details to your subject and shape it with pencil lines and shading. Remember to start lightly and gradually build up the details. The areas closest to you should be left light, areas in the middle distance should be gray and the blacks will appear farthest away.

*DOMESTIC CAT*
*Domestic cats have more pointed ears and proportionally larger eyes than do their larger relatives.*

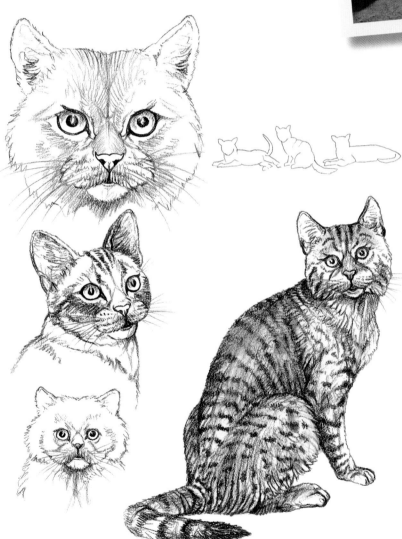

*PETS MAKE GREAT SUBJECTS*
*Sketch your cat from different sides and angles. Domestic cats, with their wide variety of breeds, are fun to draw because they are so full of expression.*

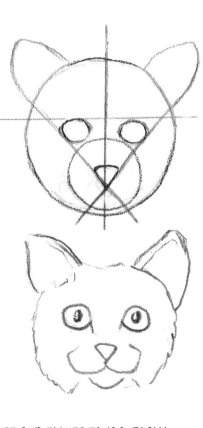

*USE GUIDELINES TO ADD FACIAL FEATURES*
*Map out the face with a horizontal and a vertical guideline to properly place facial features (see page 40).*

# Walking Cat

Doodles and gesture sketches are essential to giving you choices from which to choose the best pose. Drawing your subject accurately takes practice; doodle the basic shapes until you feel close to the correct proportions. Once you've achieved the correct proportions, use tracing paper overlays to get an accurate form, which you can then refine into an accurate outline.

I sketched this thumbnail at an animal shelter. Follow the steps to draw a walking cat.

*1 ESTABLISH THE BASIC FORM*
*Draw the foundation of the cat with basic shapes. You may have to do your initial sketch numerous times in order to capture the basic form.*

*2 ROUND OUT THE FORM*
*Use tracing paper overlays to smooth out the cat's shape. At this point, make spaces where the eyes will go and refine the tail a bit more. Only a few pencil lines should round the cat's form.*

*3 ADD SHADOWS AND FUR*
*Shade the areas that recede, or appear farther away. The contrast will make the light areas appear closer. You can see how only a few darkened areas are enough to make the cat appear three-dimensional.*

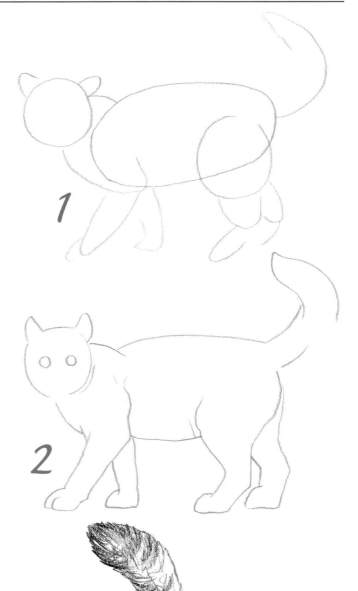

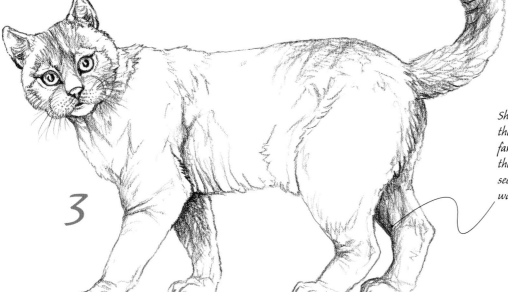

*Shadows make the back legs seem farther away, while the lighter front legs seem to come forward*

# Cat With Long Fur

When drawing fur, don't make it look too perfect. Make some pencil lines wiggly and slightly change the direction of some fur with your strokes. This will add to your drawing's realistic appearance.

Use the same technique for drawing both long and short fur, only change the length of your pencil lines. Whether you draw long or short fur, your pencil lines should always match the curves of your animal's body.

*1 DRAW BASIC SHAPES*
*Animals possess very few straight lines. Think curves!*

*2 ROUND OUT THE CAT'S FORM AND BEGIN TO ADD FUR*
*With tracing paper overlays, refine your drawing with a graphite pencil until it looks accurate. Indicate the placement of the facial features and the position of the toes. Since this cat has very long fur, map out the shape of the fur. This will guide you as you fill in the fur's details.*

*3 TRANSFER TO THE FINAL SURFACE AND ADD DETAILS*
*Make sure the cat is correctly sized, then transfer the drawing to the final surface and begin to add details. Start with the facial features, then begin to refine the direction of the fur, building on top of the rough outline you created in the previous step.*

*4 COMPLETE THE SHADOWS AND FUR*
*Use an HB charcoal pencil to add the rest of the fur and the details of the eyes, nose and mouth. Apply the fur on the chest and hips with long, uninterrupted, curving lines. The white areas accent the deep black lines to create the illusion of a thick, deep coat. With a hard graphite pencil, add the whiskers. Spray with fixative.*

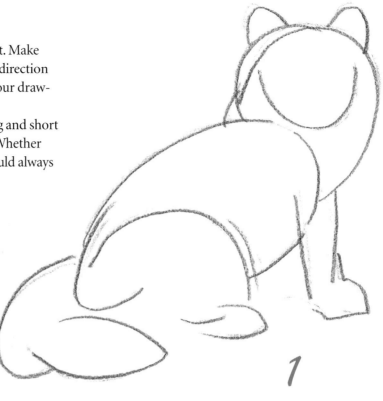

1

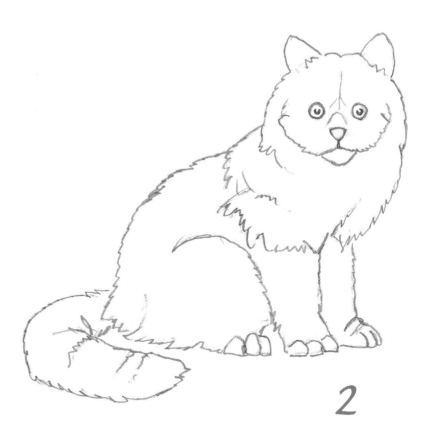

2

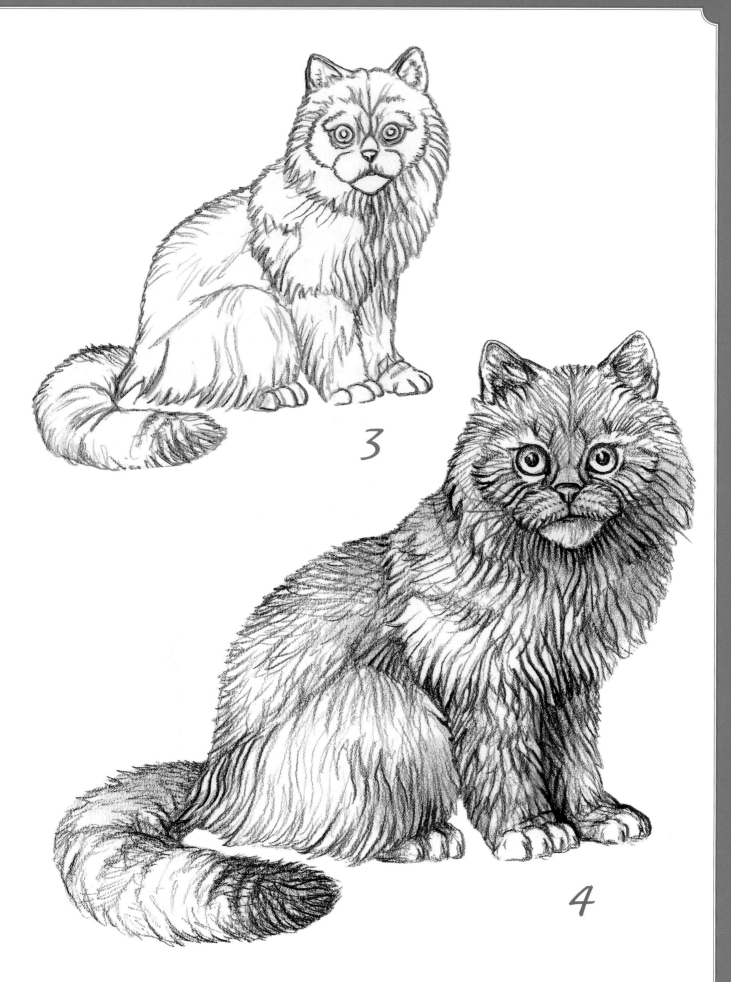

3

4

# Stripes and Spots

Stripes and spots are made up of individual hairs. Keep this in mind as you draw animals with these markings. Give your stripes and spots character by drawing individual hairs within the contrasting patches of fur.

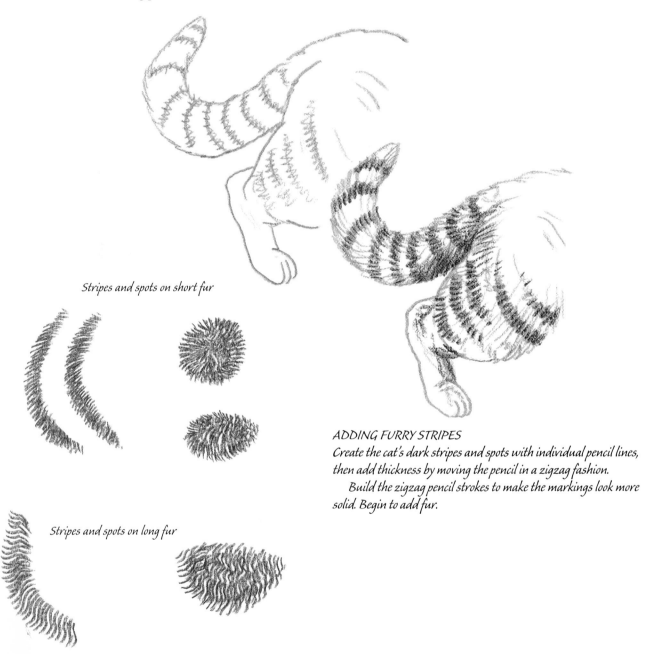

*Stripes and spots on short fur*

*Stripes and spots on long fur*

**ADDING FURRY STRIPES**
*Create the cat's dark stripes and spots with individual pencil lines, then add thickness by moving the pencil in a zigzag fashion.*
    *Build the zigzag pencil strokes to make the markings look more solid. Begin to add fur.*

**GIVE FUR MARKINGS CHARACTER**
*Vary your pencil strokes depending on the length of the fur. Don't make the spots and stripes too perfect—no animal has completely uniform markings.*

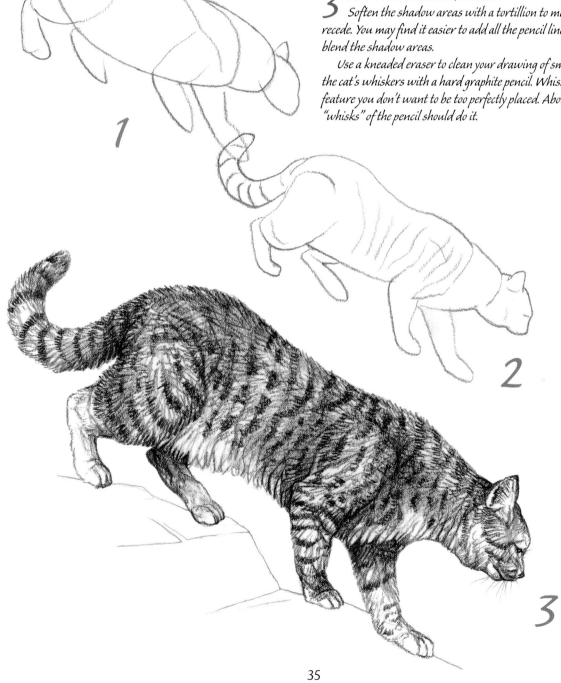

DEMONSTRATION

# Cat With Stripes and Spots

The stripes on a cat will change and become distorted as the animal moves, so make sure your drawings reflect this.

*1 DRAW THE BASIC SHAPES*
*Use tracing paper overlays to get the basic form and pose you desire.*

*2 ROUND OUT THE BODY AND BEGIN ADDING DETAILS*
*Once you've established the final outline, lightly indicate the markings on the cat's body. Make them light enough to be erased and changed if necessary.*

*3 ADD THE FINISHING DETAILS*
*Soften the shadow areas with a tortillion to make those areas recede. You may find it easier to add all the pencil lines before you blend the shadow areas.*

*Use a kneaded eraser to clean your drawing of smudges, then add the cat's whiskers with a hard graphite pencil. Whiskers are another feature you don't want to be too perfectly placed. About a dozen "whisks" of the pencil should do it.*

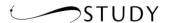
# Mouth and Teeth

When drawing big, predatory cats, you must become familiar with their tooth structure because teeth are an important feature of these magnificent species. Shapes and spacing will vary among species and will change as a cat grows. Cats are primarily carnivores, so each tooth is a miniature cutting instrument and as such should appear very sharp when drawn.

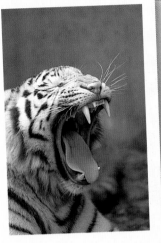
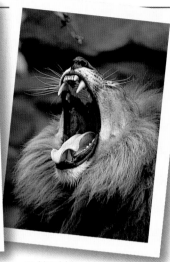

WHITE INDOCHINESE TIGER

MALE LION

*Two long canine teeth*

*Gap between teeth*

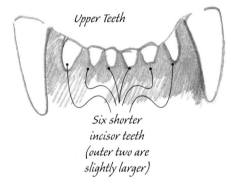

*Upper Teeth*

*Six shorter incisor teeth (outer two are slightly larger)*

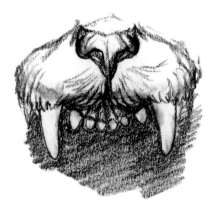

DETAILED DRAWING OF UPPER TEETH

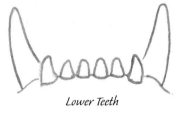

*Lower Teeth*

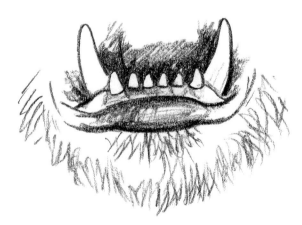

DETAILED DRAWING OF LOWER TEETH

*PAY ATTENTION TO SHAPE AND SPACING*
*Getting the correct shape and spacing of the teeth will improve as you practice. Try going to your bathroom mirror and observing your own teeth to get an idea of the textures and shapes of teeth and gums.*

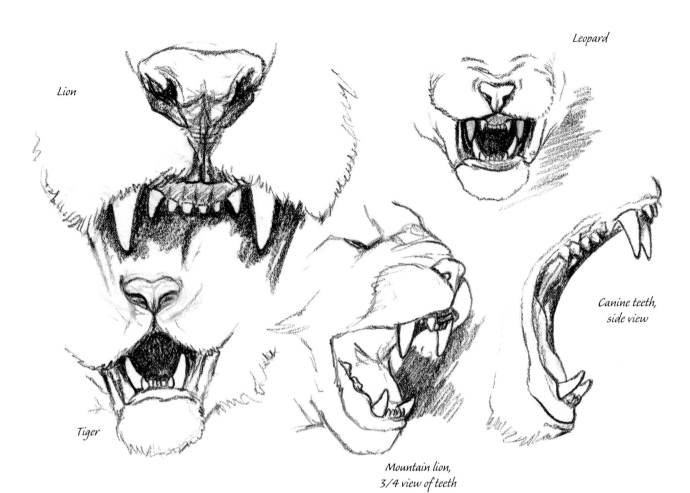

Lion

Leopard

Canine teeth,
side view

Tiger

Mountain lion,
3/4 view of teeth

## TEETH ARE AN IMPORTANT FEATURE OF BIG CATS
After studying the teeth of big cats it is easy to understand why they are deadly predators. The lower canine teeth are closer together than the upper canines and, when the mouth closes, are in front. There are two long canine teeth and six incisor teeth on both the top and the bottom.

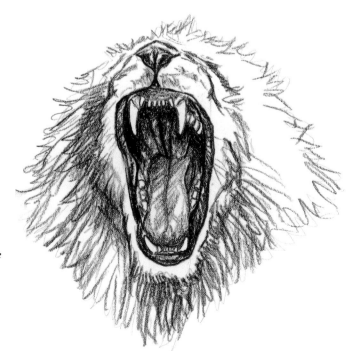

## FULL VIEW OF A LION'S MOUTH
Creating the illusion of depth is very important to properly illustrate a cat's mouth. The value changes between the whites, grays and dark blacks add depth to your drawing. The pure white canine teeth are the focal point here.

# TIGERS

No other animal can slink like a cat. Its sleek, athletic form emphasizes quickness and stealth. Tigers possess a certain sturdiness, power and muscle definition that small house cats lack. Even if your tiger isn't perfectly drawn, the addition of its stripes will make it obvious the cat is a tiger.

## ANIMAL SECRET

Tigers are the only big cats with stripes.

*DRAWING STRIPES*
*Stripes are normally the last detail you add. Lightly build up the hairs within the stripe and use a tortillion to gently blend these together. Make sure the stripes follow the tiger's body curves.*

*CAPTURE EACH TIGER'S INDIVIDUALITY*
*Cats, like people, are different from each other in various minor ways. Stripe patterns and coloring differ between tigers. In fact, tiger stripes vary from side to side on an individual tiger. These are sketches of Siberian tigers, but notice the differences in the striping patterns.*

*Draw the ears with a white spot behind the black tips*

*Stripes do not perfectly match from side to side*

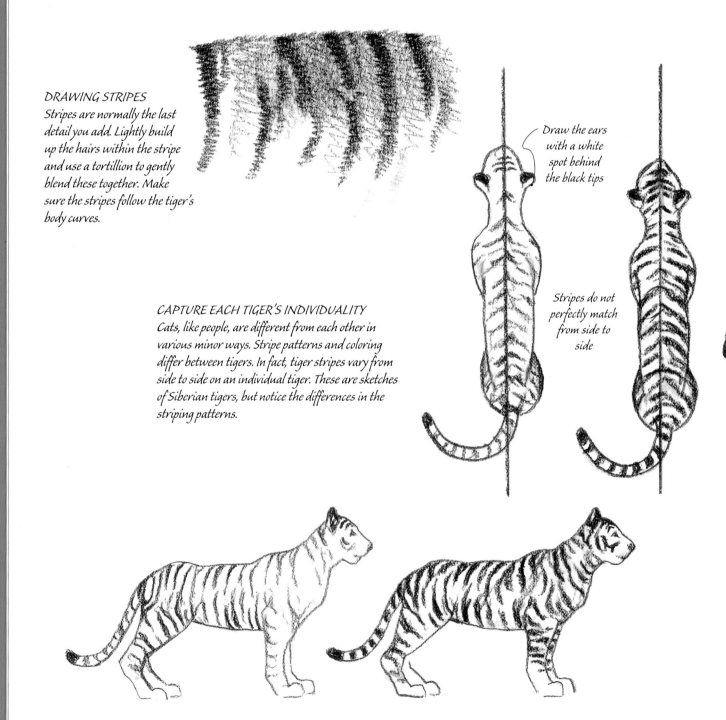

# White Tiger

Even animals with white fur require value variations to give them shape and to make them look realistic. Just use fewer pencil lines to indicate the middle tones and let the white of the paper show through for the lightest areas.

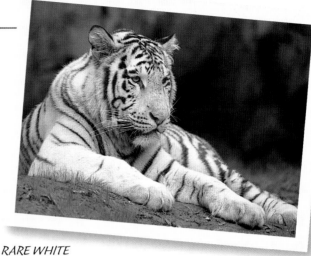

*RARE WHITE
BENGAL TIGER
White tigers differ from the more common orange and black tigers in more than just their fur. They also have bluish eyes and brownish stripes.*

*WHITE TIGER
When you draw a white tiger, keep your pencil lines to a minimum. Your drawing should be as white and clean as possible to further suggest to the viewer that the tiger is white. Notice the zigzag pattern on the stripes. This helps illustrate that the lighter-colored hair blends into the darker stripes.*

# Tiger Head and Face

The face is the most interesting part of an animal, so it's important to draw it as accurately as possible. Cat faces have a very circular shape. Using intersecting guidelines will help you place the facial features accurately. Once you've established the basic shapes and spacing, you can add the details.

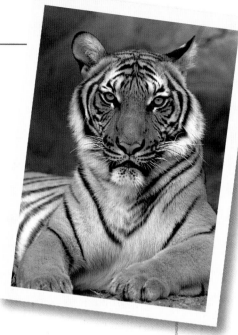

INDOCHINESE TIGER

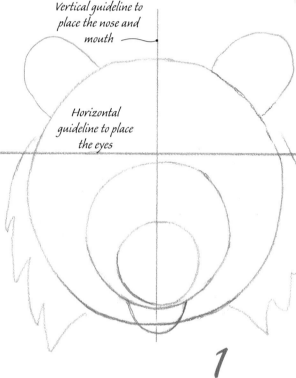

Vertical guideline to place the nose and mouth

Horizontal guideline to place the eyes

*1*

*2*

*1* **DRAW THE BASIC SHAPES**
Draw a circle for the head, then draw intersecting guidelines to help you place the ears, muzzle, nose and mouth.

*2* **BEGIN TO DEFINE THE FEATURES**
Position the eyes, ears, nose and mouth on the circles you established. At this point you should also begin to map out the placement of some of the stripes and the direction of the fur.

*3* **ADD DETAILS TO FINISH**
To finish, add about ten to fourteen long whiskers to the tiger's muzzle. Keep the whiskers spread out, not bunched up together. If you look closely at your reference photo, you will see that long whiskers will droop down while the shorter ones stay straight or even curve up. Use a sharp pencil and draw the whiskers in a variety of lengths.

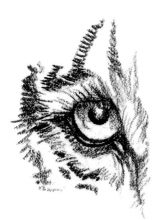

**DETAIL OF THE EYE**
Eyes give your animal life! The catchlight in the pupil shows how light is reflected from a round object. The black edge along the eye socket adds to the piercing quality of the tiger's glance. Notice the inside corner of the eye is lower than the outside corner.

Tigers, like all big cats, have round ears, unlike the pointed ears of housecats

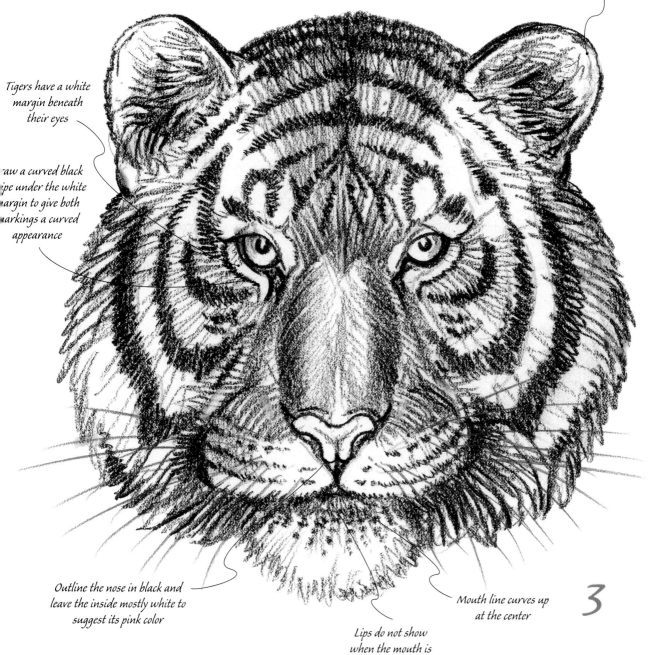

Tigers have a white margin beneath their eyes

...raw a curved black ...ipe under the white ...argin to give both ...arkings a curved appearance

Outline the nose in black and leave the inside mostly white to suggest its pink color

Lips do not show when the mouth is closed

Mouth line curves up at the center

*3*

# Seated Tiger

Drawing a seated animal may seem like a challenge, but your initial doodles of the basic shapes will go a long way toward helping you establish the final pose and proportions. It also helps to keep the pose simple. This is a Siberian tiger. Of all the tigers, Siberian tigers have the palest coats and the fewest stripes. Make sure your drawing reflects this. Accuracy and detail will make your drawing realistic.

*1 DRAW THE BASIC SHAPES*
*Make as many doodles as necessary to find a pose you like and achieve proportions that are fairly accurate.*

*2 REFINE THE BASIC FORM*
*Using tracing paper overlays, refine the basic-shapes drawing into a more realistic outline. At this point, your focus should be getting accurate proportions.*

*3 BEGIN ADDING DETAILS*
*Transfer the outline to the final surface and start to add details. Lightly pencil in the eyes, nose, mouth and the location of a few important stripes.*

*4 ADD THE FINISHING DETAILS*
*Fill in the remaining details of the face and pencil in the fur on the body. The stripes are the darkest part of the tiger's coat, darken those with a charcoal pencil. Apply the stripes in a zigzag fashion to give the impression of light and dark fur blending together. Let some of the paper show through your black pencil lines to give the fur a more realistic appearance.*

*Make sure that the rings in the tail are quite dark and that you shade in the tip. Tiger tails have dark rings and a dark tip. Clean the drawing of smudges, add whiskers and spray with fixative.*

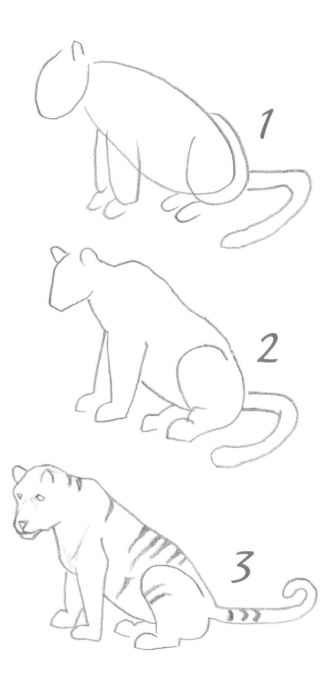

# ANIMAL SECRET

There are five tiger subspecies in the world: the Siberian (the largest), the Indo-Chinese, the Chinese, the Sumatran and the Bengal. (Three others are now extinct.) The Siberian tiger is the largest member of the tiger species. A mature male Siberian tiger can weigh over 600 pounds (270kg) and have a length of over 12 feet (366cm) from nose to tail. Although Siberian tigers are one of nature's deadliest predators, most of my drawings show them in resting or nonaggressive positions. Beneath the serene, relaxed image, however, resides an explosive fury!

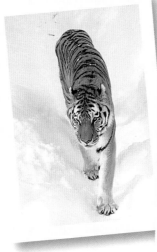

*SIBERIAN TIGER*

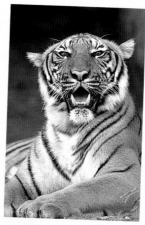

*INDO-CHINESE TIGER*

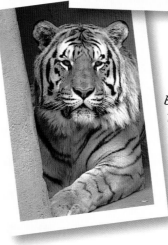

*BENGAL TIGER*

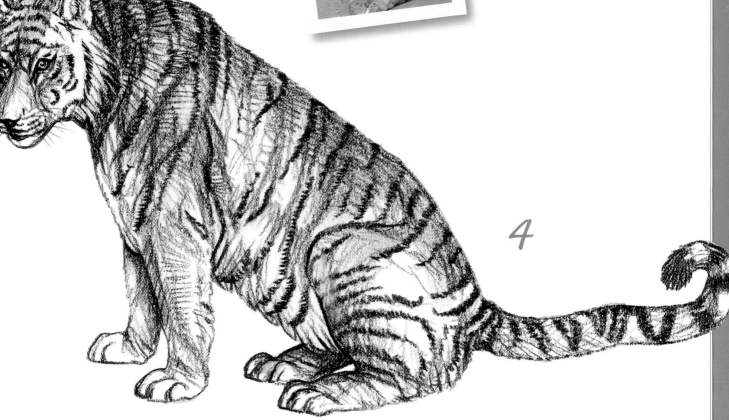

*4*

# Snow Leopard

The snow leopard is one of the world's most beautiful cats as well as one of the rarest. Its spotted whitish gray coat is tinged with yellow.

Snow leopards have very distinct spots. As you draw these spots, remember that few are perfect circles; rather they have more of an oval shape. The spots also vary in shape and size throughout the leopard's body. For large, detailed drawings, draw the spots with little pencil strokes instead of using circular pencil marks. Leaving a few light areas in the center of the spots also helps them look more natural.

## ANIMAL SECRET

An adult snow leopard weights 45 to 55 pounds (20 to 25kg), is 24 to 26 inches (61cm to 66cm) high and is 6 to 7 feet (183 to 214cm) long.

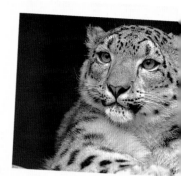

 STUDY

**DETAIL OF A SPOT**
*The body fur of leopards is covered with large, rosette-shaped markings, not solid spots. Be sure to draw them with individual pencil lines.*

**WHEN TO ADD SPOTS ON A LEOPARD'S BODY**
*Since they are the darkest marks on the leopard, the spots should be the last thing you draw.*

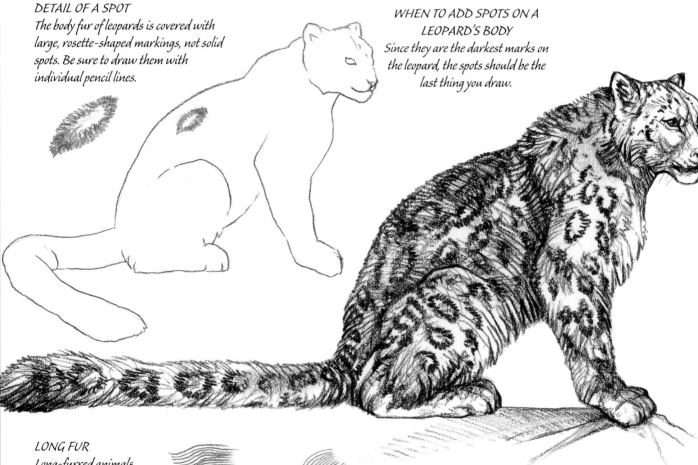

**LONG FUR**
*Long-furred animals require long, flowing pencil strokes.*

**FINAL DRAWING**
*Finish the other details of the fur before adding the spots. Leave enough of the paper showing through so that when you add the spots, they can be light in the middle. The rosette-shaped spots continue up into the tail, but I use zigzag pencil lines to indicate smaller spots on the face. Not only is this more realistic, but also the smaller spots won't detract from the leopard's face.*

Practice the strokes shown on page 44 for drawing spots and long fur before you begin this demonstration. You'll put those techniques together here to draw a realistic-looking snow leopard.

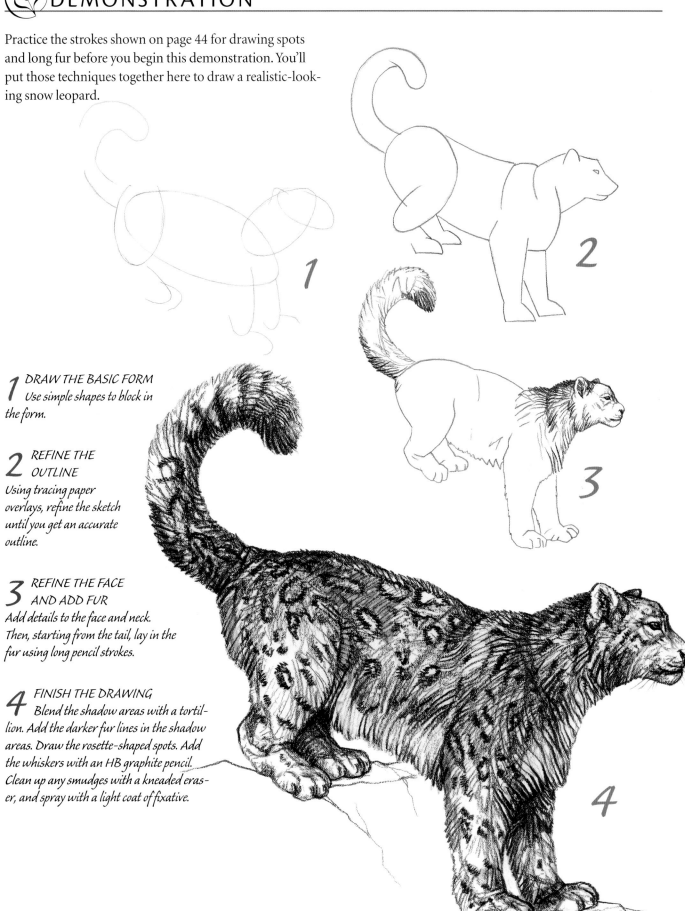

**1 DRAW THE BASIC FORM**
Use simple shapes to block in the form.

**2 REFINE THE OUTLINE**
Using tracing paper overlays, refine the sketch until you get an accurate outline.

**3 REFINE THE FACE AND ADD FUR**
Add details to the face and neck. Then, starting from the tail, lay in the fur using long pencil strokes.

**4 FINISH THE DRAWING**
Blend the shadow areas with a tortil-lion. Add the darker fur lines in the shadow areas. Draw the rosette-shaped spots. Add the whiskers with an HB graphite pencil. Clean up any smudges with a kneaded eras-er, and spray with a light coat of fixative.

# CHEETAH

The slender cheetah is the fastest land mammal in the world. When you draw the cheetah, remember that its claws do not retract like those of other cats, and its tail begins with spots and ends with rings. Draw the spots and stripes at the tip of the tail with individual pencil lines. Keep layering these lines until you get the darkness you desire.

**PHOTO OF A CHEETAH**
*The cheetah has a small head and a long, slender body. Its form and long, thin legs enable the cheetah to achieve incredible speeds when pursuing prey on the African plains.*

## DEMONSTRATION

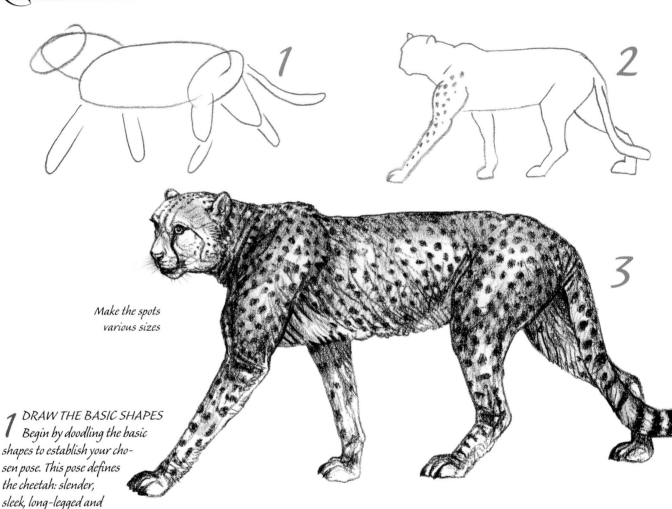

*Make the spots various sizes*

*1*  *2*  *3*

**1 DRAW THE BASIC SHAPES**
Begin by doodling the basic shapes to establish your chosen pose. This pose defines the cheetah: slender, sleek, long-legged and athletic.

**2 REFINE THE BASIC OUTLINE**
Continue to refine your sketch by laying tracing paper atop each refinement until you have acquired an accurate final outline. Lightly pencil in some spots. This will give you a rough idea of how they will look and can easily be erased, if necessary.

**3 FINISH THE DRAWING**
After you have your final outline sized correctly, position it properly on your paper and transfer the image onto your final surface. Fill in the values and facial details. Add the spots with a charcoal pencil, making them irregularly shaped and letting some of the white of the paper sparkle through. Add the whiskers, clean up any smudges and spray with fixative.

# LION

Like all cats, lions have bodies that are longer than they are high. Even though members of the cat family look different at first, they, in fact, have the same general body shape. Drawing this lion isn't too far removed from your pet cat.

## STUDY

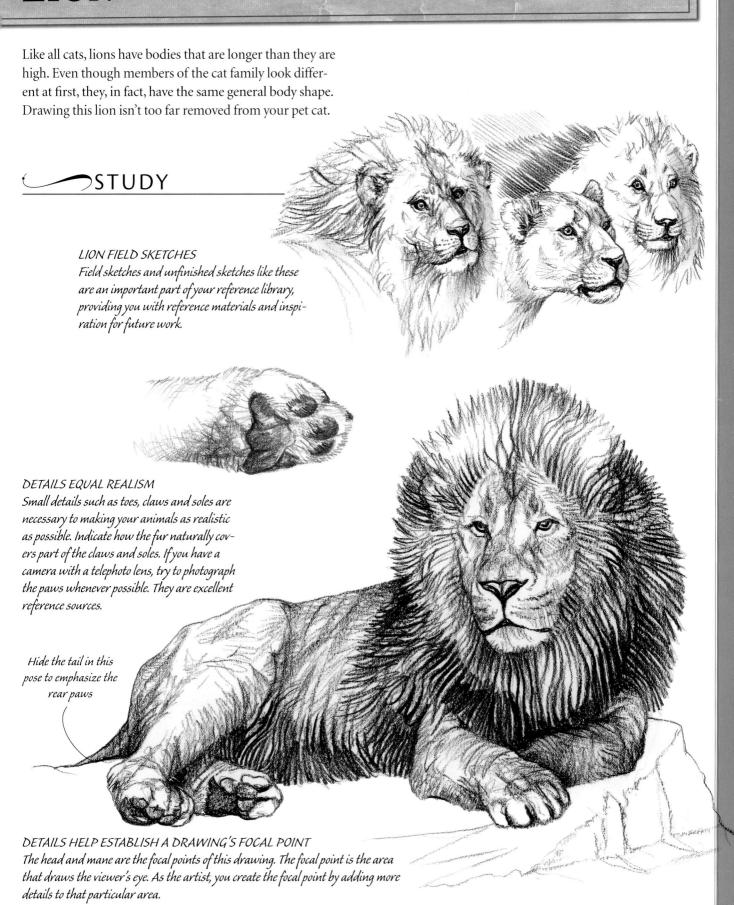

**LION FIELD SKETCHES**
*Field sketches and unfinished sketches like these are an important part of your reference library, providing you with reference materials and inspiration for future work.*

**DETAILS EQUAL REALISM**
*Small details such as toes, claws and soles are necessary to making your animals as realistic as possible. Indicate how the fur naturally covers part of the claws and soles. If you have a camera with a telephoto lens, try to photograph the paws whenever possible. They are excellent reference sources.*

*Hide the tail in this pose to emphasize the rear paws*

**DETAILS HELP ESTABLISH A DRAWING'S FOCAL POINT**
*The head and mane are the focal points of this drawing. The focal point is the area that draws the viewer's eye. As the artist, you create the focal point by adding more details to that particular area.*

# LYNX

Knowing the subtle differences between members of the same species is important if you want to draw them accurately. Lynx and bobcats are two animals that look very similar. The lynx, however, is larger than the bobcat and lives in a colder climate. This is important to know, especially in terms of background elements. While you wouldn't want to draw a bobcat with a glacier background, it would be perfectly acceptable to do this for a lynx.

## ANIMAL SECRET

An adult lynx weighs 25 to 40 pounds (11 to 18kg), is 14 to 16 inches (36 to 41cm) high and is 3 to 4 feet (92 to 122cm) long. An adult bobcat weighs 20 to 35 pounds (9 to 16kg), is 12 to 14 inches (30cm to 36cm)

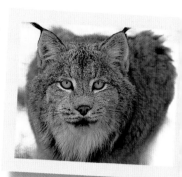

## STUDY

*LYNX FACIAL CHARACTERISTICS*
*Lynx possess broad face ruffs and their ears are tipped with long, black tufts.*

*Long ear tufts*

*Round face*

*Large face tufts*

*Black-tipped tail*

*THE LYNX'S BODY*
*A lynx has a black-tipped tail and its toes have slits into which the claws retract.*

*A black pencil line in the middle of each toe indicates claw slits*

*Use long pencil strokes to indicate the lynx's long fur*

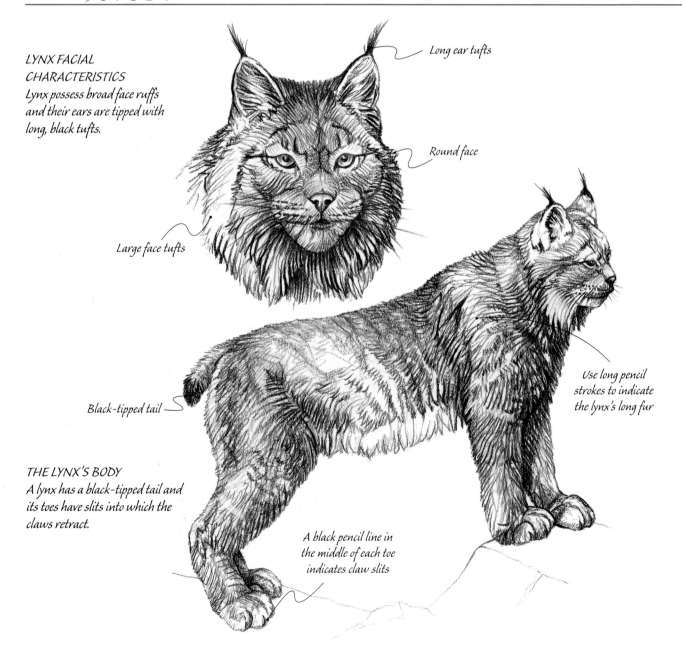

# BOBCAT

Bobcats are slightly smaller than the lynx, their ear tufts are less pronounced and their tails are longer. The bobcat's feet are large for its size (though a lynx's are even larger) and its face ruff isn't as big as that of a lynx. Bobcats have dark brown spots and dark bar-like stripes.

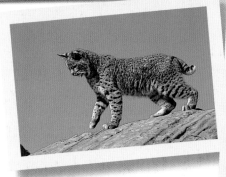
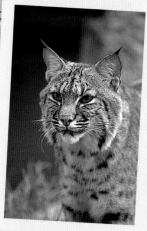

BOBCAT

## DEMONSTRATION

*1 DRAW THE BASIC OUTLINE*
*Draw a round circle, then guidelines to help you position the ears.*

*Scribble in a little shading to indicate that soft light is coming from the right side. This will help you as you refine the rest of the face.*

*2 REFINE THE SHAPE OF THE FACE*
*Using tracing paper overlays, add circles to help you map out the facial features.*

*3 ADD DETAILS TO THE FACE*
*Do another tracing paper overlay and add the facial details. Also outline the face ruff and and important fur markings.*

*4 FINISH THE DRAWING*
*Add the fur, letting some of the paper show through. Put in the dark shadow areas then add the spots using short, zigzag strokes.*

*Ear tufts are shorter than those of a lynx*

*Facial whiskers extend from the bobcat's follicle stripes*

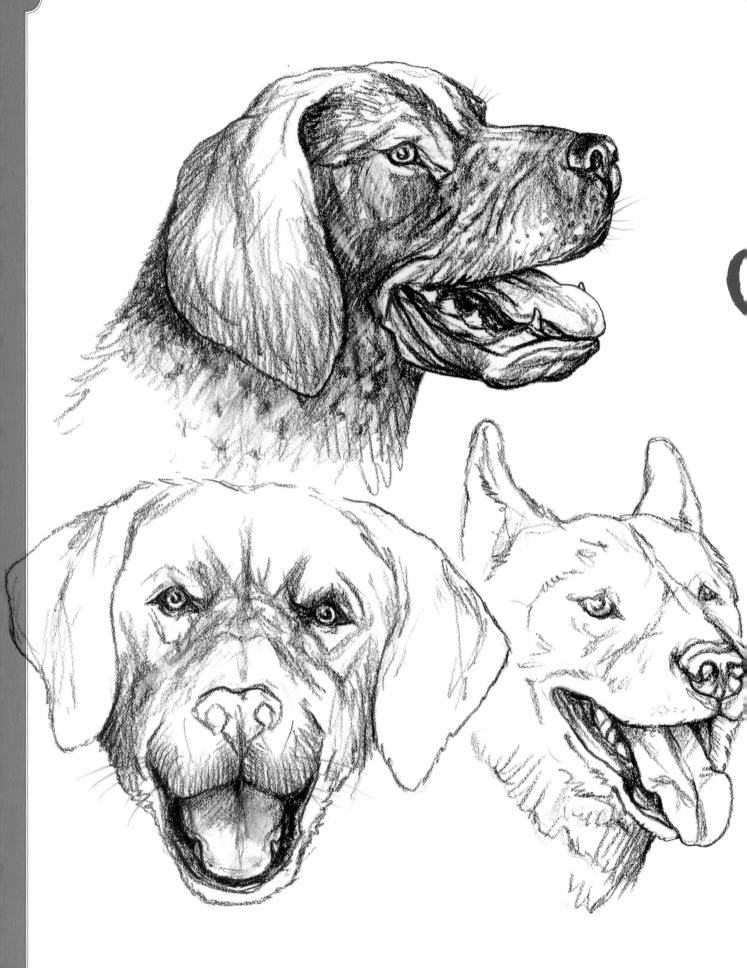

# 3 Dogs & Their Relatives

The canine (Canidae) family consists of a variety of doglike animals, from the tame and cuddly to the wild and ferocious. Dogs, wolves, coyotes and foxes are all members of the canine family. Canines are found throughout the world and come in all shapes and sizes. Most are characterized by long muzzles, pointed ears, bushy tails and long, slender legs.

Dogs have been living with humans for thousands of years and are one of the planet's most versatile and endearing creatures. Their friendly personalities make them a favorite subject for artists and they are rightly called "man's best friend."

**Panting Dog Study**
*HB charcoal pencil on bristol paper*
*14 ½" × 11" (37cm × 28cm)*

# DOMESTIC DOGS

Dogs come in a wide variety of breeds and are fun to sketch because most are good models that will happily sit, lie or stay while you sketch away. Occasionally you'll be lucky enough to find pets that just love to pose. Take advantage of these willing models to practice your sketching. The basic shapes of dogs are more angular than the more rounded cat family.

## DRAWING SECRET

Dog shows are great places to practice sketching dogs of all shapes, sizes and breeds.

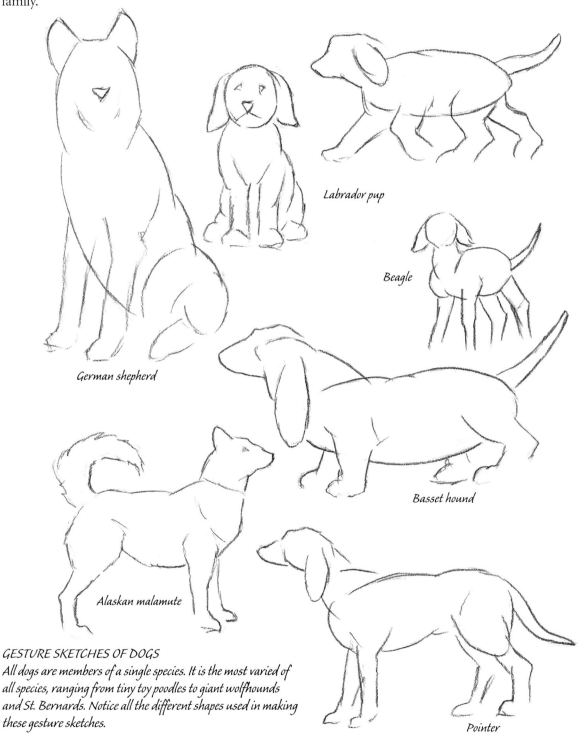

*Labrador pup*

*Beagle*

*German shepherd*

*Basset hound*

*Alaskan malamute*

## GESTURE SKETCHES OF DOGS
*All dogs are members of a single species. It is the most varied of all species, ranging from tiny toy poodles to giant wolfhounds and St. Bernards. Notice all the different shapes used in making these gesture sketches.*

*Pointer*

# Golden Retriever

The golden retriever is a member of the Sporting dog group and is one of the most popular dog breeds. Their instincts and pleasant personalities make them great companions.

Using vertical and horizontal guidelines when drawing a dog's face will help you center its features and space them correctly.

## ANIMAL SECRET

The major categories purebred dogs fall into are: Sporting, Terriers, Working, Toy, Hounds, Utility and Herding. Although dogs in each category share similar characteristics, always try to capture the uniqueness and individuality of the dog you are drawing.

*1 DRAW THE BASIC SHAPES*
*Sketch the basic shapes until you have a pose you like and accurate proportions. Use guidelines to center and correctly position the facial features.*

*2 REFINE THE OUTLINE*
*Refine your basic-shapes sketch with tracing paper overlays to achieve an accurate outline of the dog. Once you have correctly positioned the facial details, you won't need to re-create the guidelines. Map out the direction of the fur with light pencil strokes.*

*3 BEGIN TO ADD DETAILS*
*With another tracing paper overlay, define the facial details and the placement of the fur.*

*4 CONTINUE TO REFINE THE DRAWING*
*Make sure your drawing is as accurate as possible before transferring it to your final surface.*

*5 FINISH THE DRAWING*
*Add the finishing touches to the facial features. Indicate the fur with a series of light, quick strokes and then blend them together with a tortillion. Leave parts of the muzzle and tongue white to make them appear closer. Use long strokes for the neck, chest, hindquarters and tail. Add another layer of dark strokes in the shadow areas.*

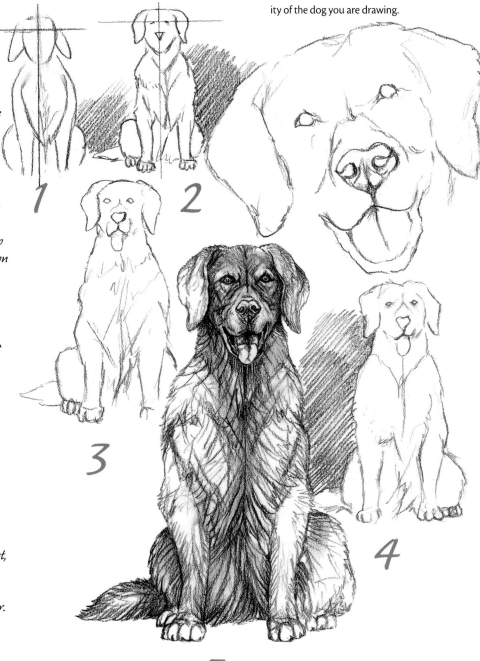

# Basset Hound

Basset hounds are distinguished by their long, floppy ears, leg wrinkles and short fur. Draw short fur with repeated short pencil strokes and let some white show through your pencil lines. Draw short-legged dogs like these carefully to keep them from looking like cartoons.

### 1 DRAW THE BASIC SHAPES AND CORRECT THE PROPORTIONS
*In the top sketch, the proportions are clearly wrong. Revise this with tracing paper overlays for a better start.*

### 2 REVISE YOUR OUTLINE
*Use tracing paper overlays to obtain a fairly accurate outline. Experiment with the placement of the tail. By doodling the tail variations on the body, you will be able to see your design choices more clearly. Choose a tail position that corresponds to the face—in this case, a raised tail to indicate alertness. Map out the major creases in the body.*

### 3 FINISH THE DRAWING
*Use an HB charcoal pencil to draw the coat. Apply an initial light layer with the charcoal pencil, then build up the darks until you have indicated the different colors on the dog's body. Apply the darkest marks to illustrate the darkest browns last. Blend some areas with a tortillion to soften the coat's look and to add more shading. Use very dark pencil marks to create the wrinkles. These sink deep into the hound's coat, making it difficult for light to penetrate.*

 ANIMAL SECRET

The basset hound belongs to the Hound group and is a superb hare and rabbit hunter. Basset hounds can weigh up to 50 pounds (23kg), making them heavy for such short legs.

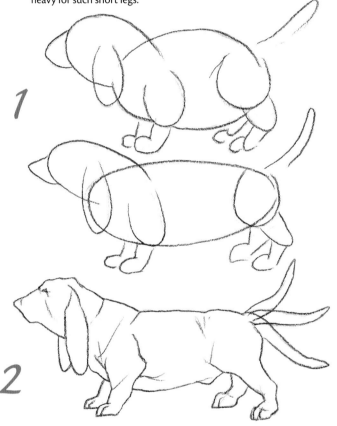

*1*

*2*

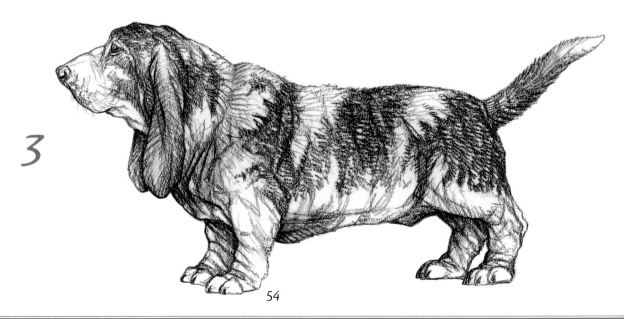

*3*

# German Shorthaired Pointer

Unlike cats, dog breeds are so different from each other that the techniques used to draw one breed will not necessarily transfer to other breeds. Learning to identify differences and similarities is a necessary, yet enjoyable, part of rendering the different dog breeds accurately.

A pointer's coat varies in coloration and spot markings. Its lean, athletic body has a muscular appearance that is evident beneath its short, coarse coat. Drawing this musculature is very important when illustrating any lean, shorthaired animal. The musculature usually is less evident in animals with longer fur.

## ANIMAL SECRET

The German shorthaired pointer is a member of the Sporting group. It is also referred to as a gundog in some countries.

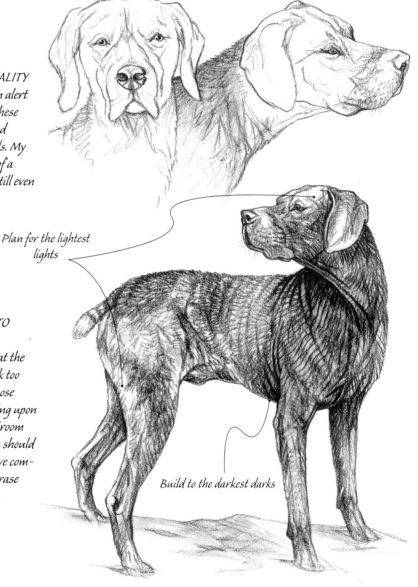

*POSE SHOULD REFLECT PERSONALITY*
*Sporting dogs are best portrayed in an alert posture, with their heads held high. These breeds are often hyper and fidgety, and therefore usually make difficult models. My model, Ezekiel, is the perfect example of a fidgety subject, as he would not hold still even for a photograph!*

*Plan for the lightest lights*

*BUILD VALUE CHANGE SLOWLY TO AVOID MISTAKES*
*Remember to add the darkest values at the end of your drawing. If you go too dark too soon, you may find that you needed those darkest darks somewhere else. Building upon light pencil marks leaves you plenty of room to layer a variety of darker values. You should also plan for the areas you wish to leave completely white because it is difficult to erase and achieve that degree of light again.*

*Build to the darkest darks*

# Alaskan Malamute

One goal of drawing Working dogs like the malamute is to express their strength and power. An open mouth and a panting expression indicate a dog trying to cool down, but it also suggests the air of happiness and friendliness that is so characteristic of these dogs.

## ANIMAL SECRET

A massively built dog that has been bred to pull heavy, weighted sleds across snow-covered terrain, the Alaskan malamute is in the Working group. They often weigh over 125 pounds (56kg) and have a shoulder height of about 30 inches (76cm).

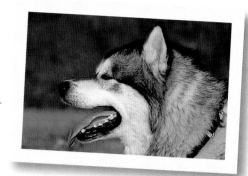

*ALASKAN MALAMUTE*

*1 DRAW THE BASIC SHAPES*
*Doodle the basic shapes of the dog until you get the proportions and pose you desire.*

*2 REVISE THE INITIAL SKETCH*
*Using tracing paper overlays, refine your basic-shapes sketch. Begin to add facial details and to map out the fur. This dog is sporting its winter coat, so be sure to outline the mass of the fur at this stage.*

*3 FINALIZE THE DRAWING*
*Transfer the drawing to your final surface and add the finishing touches. Use long strokes to denote the winter coat, blending where necessary. Suggest changes in fur length or indicate musculature by making the pencil strokes in rows on these areas of the body. Draw deep, black lines in the white areas to create the illusion of thick, heavy fur. Do not muddy these white areas with a tortillion. Add whiskers and spray with fixative.*

## DRAWING SECRET

Use reference photos to achieve a realistic drawing of your animal. When you're drawing from life, it can be difficult to capture all the details of an animal the way a good photograph can.

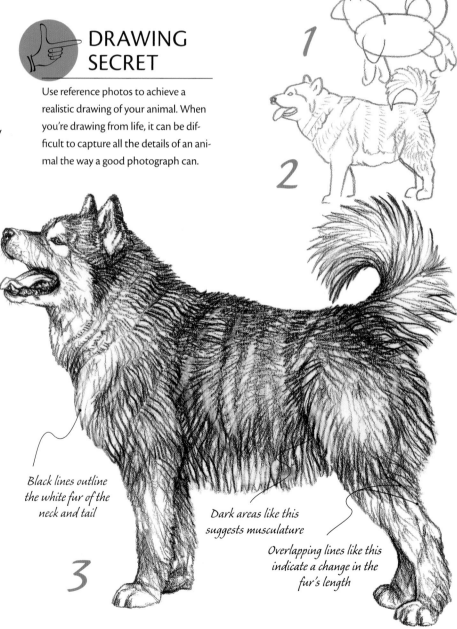

*Black lines outline the white fur of the neck and tail*

*Dark areas like this suggests musculature*

*Overlapping lines like this indicate a change in the fur's length*

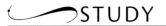

# Siberian Husky

Siberian huskies have a more wolflike appearance than other dogs; in fact, wolves and huskies often interbreed. Not all the dogs you'll draw will be purebred, so when drawing your friend's husky, for example, try to concentrate on its individual features and not just the characteristics of a purebred Siberian husky. After all, you should always try to capture the personality and spirit of your particular subject.

 **ANIMAL SECRET**

Siberian huskies are beautiful dogs that are also members of the Working group. They, like the larger Alaskan malamutes, are often harnessed and used for pulling sleds, though huskies are more valued for their speed than their strength. Dog "mushers" often drive teams of different breeds.

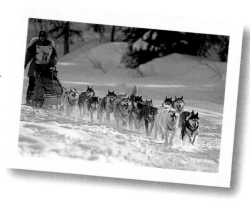

*Cross-directional strokes make the tail look round*

*Blending adds thickness*

**CAREFUL OBSERVATION WILL LEAD TO ACCURATE PROPORTIONS**
*Notice the different physical features that make up your animal subject. Pay attention to the placement of the head, legs, shoulders and hips. An awareness of your animal's basic anatomical structure will make it easier for you to achieve accurate proportions.*

**DRAWING THE HUSKY'S TAIL**
*The tails of Siberian huskies are often curled up over their backs. Use the pencil strokes for the fur to create the position of the tail.*

*Like those of Alaskan malamutes, the ears of Siberian huskies are always erect*

**DRAWING THE HUSKY'S EYES**
*Siberian huskies sometimes have blue eyes. To make their eyes look blue, don't add a great deal of tone to the irises.*

# Domestic Dog Head

Dogs are a varied species whose body structures and facial features differ between breeds. Look at the drawing of a basset hound on page 54 and compare it to the drawing of an Alaskan malamute on page 56 and you can easily see why learning to draw one type of dog will not necessarily make drawing another breed easier. And heads, of course, are the most important part of any animal drawing. Not only does it indicate what breed you're drawing, but it also demonstrates the character and personality of the dog.

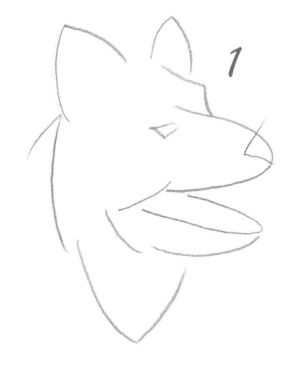

*1 SKETCH THE BASIC FORM*
*Although this initial doodle is very rough, it does capture the dog's proportions fairly well.*

*2 REVISE THE INITIAL SKETCH*
*Using tracing paper overlays, revise your sketch of basic proportions into an accurate outline of the dog's face. At this point you should also lightly outline the areas where the fur color changes from light to dark. Once you have this mapped out, you can transfer the drawing to the final surface.*

*3 ADD THE DARKEST DARKS AND FINALIZE THE DRAWING*
*Using an HB charcoal pencil, build up the medium-dark areas of the fur until you have a medium-gray tone. Add the darkest darks to the mouth, nostril and eye socket. Leave the teeth and tongue mostly white to distinguish them from the black tones of the mouth and lips.*

*Clean up your drawing with a kneaded eraser. Add the whiskers with a no. 4 extra-hard pencil. Spray with fixative and let it dry.*

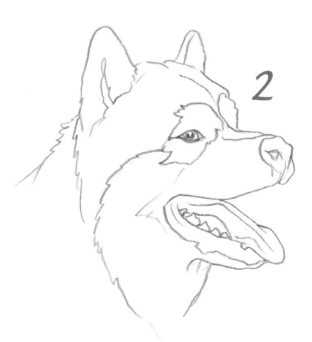

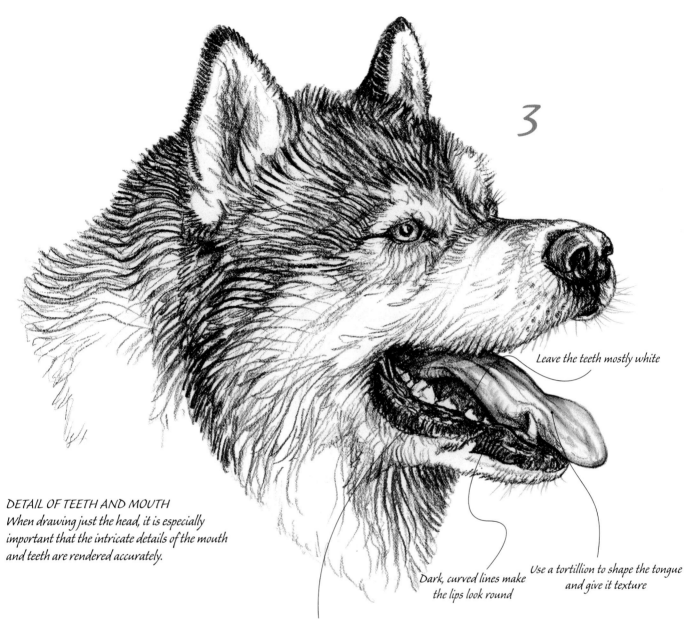

*3*

Leave the teeth mostly white

Use a tortillion to shape the tongue
and give it texture

Dark, curved lines make
the lips look round

A heavy, dark line divides
the tongue from the inside
of the mouth

**DETAIL OF TEETH AND MOUTH**
*When drawing just the head, it is especially
important that the intricate details of the mouth
and teeth are rendered accurately.*

 DRAWING
SECRET

Always add your darkest darks last.
If you include them too early in your
drawing, you limit your ability to add
the very dark pencil marks you may
need to add depth to your image. Once
you have reached your darkest dark,
you can't go darker, nor can you lift
these out to return to the clean, white
paper underneath.

# OTHER CANINES

Although domestic dogs differ greatly among the many breeds, most members of the canine family share the same basic features: pointed noses, pointed ears and bushy tails. Therefore, learning how to draw a wolf, for instance, will help you draw a fox. As you work through the following demonstrations, notice how similar the basic-shapes sketches are to each other.

## ANIMAL SECRET

Wolves, coyotes and foxes have five toes on their front paws, although one claw, the dewclaw, is located higher on the leg and does not show in the tracks. The hind feet have four toes. Claw marks for these animals will show in their tracks because they cannot retract their claws like most cats.

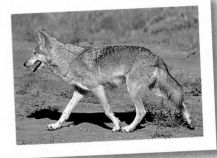

*MEXICAN WOLF (ENDANGERED SPECIES)*
*The Mexican wolf is smaller and rarer than the gray wolf. It lives in warm climates so it never develops a winter coat.*

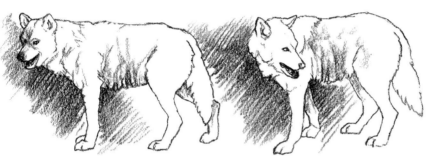

*Gray wolf*

*Wolf track*

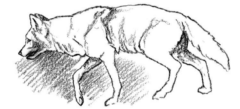

*Mexican wolf*

*Some dogs share the same characteristics as wolves, foxes and coyotes . . .*

*. . . others do not*

*Golden retriever*

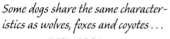

*Siberian huskies*

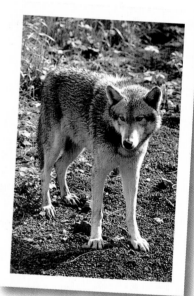

*GRAY WOLF*
*The gray wolf is a large wolf, weighing over 100 pounds (45kg). It lives farther north than the Mexican wolf, so it does develop a winter coat.*

*BORN TO BE WILD*
*Of course many dogs (like Siberian huskies) share the angular structures of their wild relatives. Emphasize the wildness of wolves, foxes and coytes by drawing them in alert poses.*

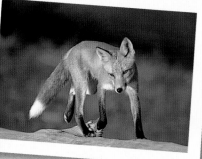

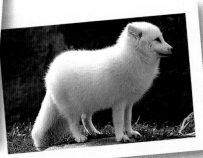

## ARCTIC FOX
Arctic foxes are small animals. They have grayish blue coats in the summer and white winter coats. The arctic fox's thick winter fur gives it a rounded appearance.

## RED FOX
Red foxes have large, pointed ears. Their feet, lower legs and backs of ears are black, and their tails are white-tipped. They are bigger than arctic foxes, weighing 7 to 15 pounds (3 to 7kg).

Red fox

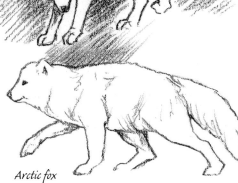

Fox track

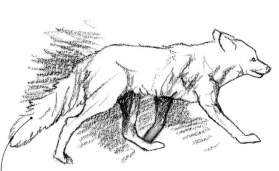

Arctic fox in winter

Bushy tails and pointed ears

Pointed noses

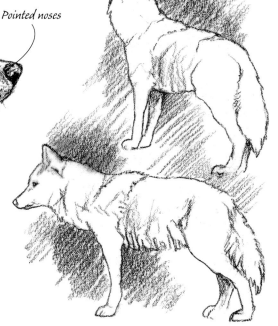

Coyotes

## COYOTE
Coyotes are often confused with gray wolves, though coyotes are only half their size. In addition to size, the more pointed ears and nose also distinguish the coyote from the wolf.

# GRAY WOLF

An efficient and deadly hunter, the gray wolf is a true symbol of the wilderness. Draw it in its thick winter coat to make it look regal.

*FRONT AND SIDE VIEW OF A GRAY WOLF*
*Notice how the wolf's face looks very triangular from the front. The profile gives you a good view of the teeth, tongue and lips.*

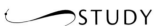STUDY

*SKETCH OF A GRAY WOLF*
*This outline has been transferred to the final surface and I have started filling in the fur. Heads and faces are the most important part of an animal drawing, so get into the habit of doing the face first. If you capture the face well, this will give you a little leeway for minor mistakes in the rest of your drawing.*

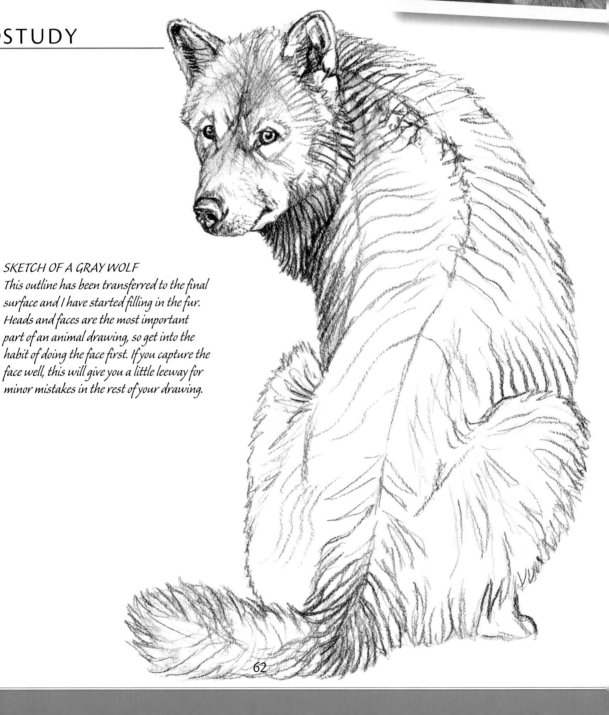

62

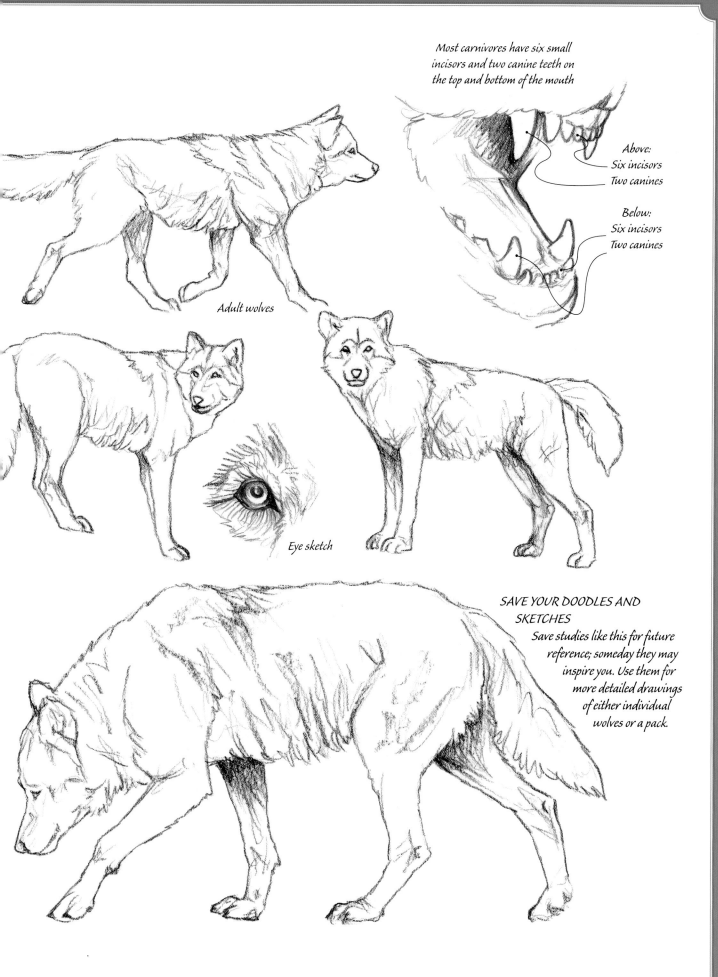

Most carnivores have six small
incisors and two canine teeth on
the top and bottom of the mouth

*Above:*
*Six incisors*
*Two canines*

*Below:*
*Six incisors*
*Two canines*

*Adult wolves*

*Eye sketch*

SAVE YOUR DOODLES AND
SKETCHES
   Save studies like this for future
reference; someday they may
inspire you. Use them for
more detailed drawings
of either individual
wolves or a pack.

# Wolf Head

Unlike dogs, whose breeds produce many different kinds of heads, wolves, coyotes and foxes have similar facial structures. Once you draw the face of one, you can draw the others!

*STUDY OF A GRAY WOLF'S HEAD AND FACE*
*To draw the thick fur on the wolf's neck, hold your drawing pencil more on its side. This allows more of the lead to touch the paper, creating bolder strokes. Use the tip of the pencil to draw the fur on the face, creating finer strokes to indicate shorter hairs.*

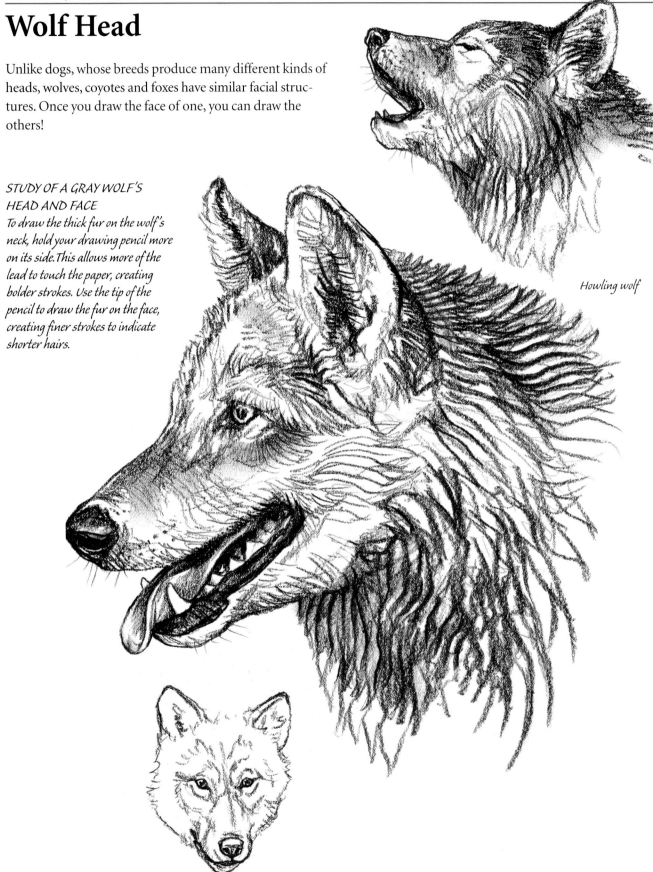

*Howling wolf*

# Gray Wolf in Its Autumn Coat

Gray wolves are among the most popular subjects for wildlife artists. Their fur color ranges from white to black, so adjust the values of your pencil marks accordingly. This wolf will have its autumn coat, so leave extra space between pencil lines to add volume to suggest their thicker fur.

## ANIMAL SECRET

Wolves are pack animals, meaning that they live and hunt together as a group. Pack sizes normally range from four to twelve individuals, most of whom are related. These packs form a social structure, which helps to eliminate a lot of turmoil among members. Dominant wolves will interact with less-dominant wolves by carrying their tails high. Submissive and low-ranking wolves will tuck their tails between their legs when confronting higher-ranking wolves.

*1 DRAW THE BASIC FORM*
*Sketch out the basic shapes to establish the pose and proportions.*

*2 REFINE THE OUTLINE*
*Refine the basic outline with tracing paper overlays into an outline accurate enough to transfer to your final drawing paper. Outline the fur's mass and add some face details.*

*3 ADD DETAILS TO FINISH THE DRAWING*
*Add the rest of the facial details, using short strokes to add the fur. Use long strokes to add the long fur of the neck ruff, belly and tail. Switch back to short strokes for the wolf's back and legs and add the claws with thick black lines. Clean your drawing with a kneaded eraser, add the whiskers, spray with fixative and let it dry.*

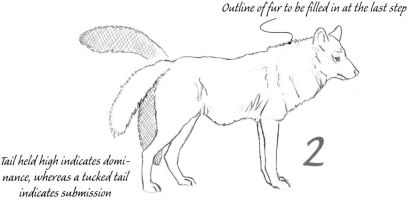

*Outline of fur to be filled in at the last step*

*Tail held high indicates dominance, whereas a tucked tail indicates submission*

*Short strokes*

*Long strokes*

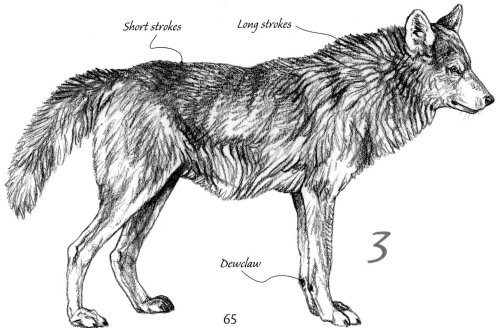

*Dewclaw*

# Prowling Wolf

Fur flows with gravity, so most of it will point down, especially if it's a long winter coat. Browse through animal photographs to see how hair and fur changes direction around the animal's body and you'll see how little of the fur actually points upwards. Remember the contours of the body under the fur need to be correct or you will end up with a misshapen animal.

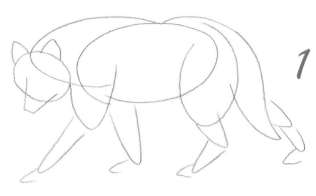

*1* DRAW THE BASIC SHAPES
Doodle the basic shapes until you get the desired pose and proportions.

*2* ESTABLISH THE OUTLINE
Refine the basic shapes with tracing paper overlays to get an accurate outline. Transfer the outline to the final surface and lightly add facial details and fur.

*3* FINISH THE DRAWING
Add the middle darks and the darkest darks to the face and body. This is a winter coat, so make the fur look thick and lush by leaving more space between the lines. The longest areas of the fur should be the neck ruff, trunk, hips and tail.

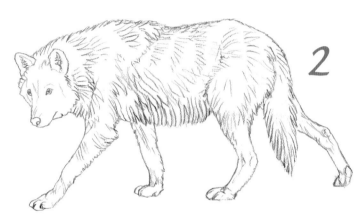

*Make sure the fur follows the contours of the body*

## DRAWING SECRET

Fur flows in a fixed direction regardless of the season. When the fur is longer, it is easier to see which direction it flows.

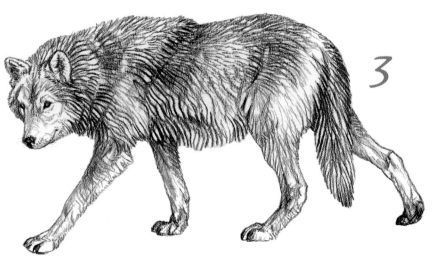

# RED AND MEXICAN WOLF

Red wolves and Mexican wolves are smaller than gray wolves, so their features should be proportionately smaller. The exceptions are their ears and muzzles, which seem large for their bodies. Their short coats make these features seem even bigger.

 ANIMAL SECRET

North America's endangered red wolves and Mexican wolves are smaller species than the gray wolf. Since they live in the warmer climates of Mexico and the American southwest, they have larger, more prominent ears (to help dissipate heat) and are often mistaken for coyotes.

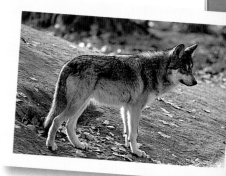

MEXICAN WOLF (ENDANGERED SPECIES)

RED WOLF (ENDANGERED SPECIES)

STUDY

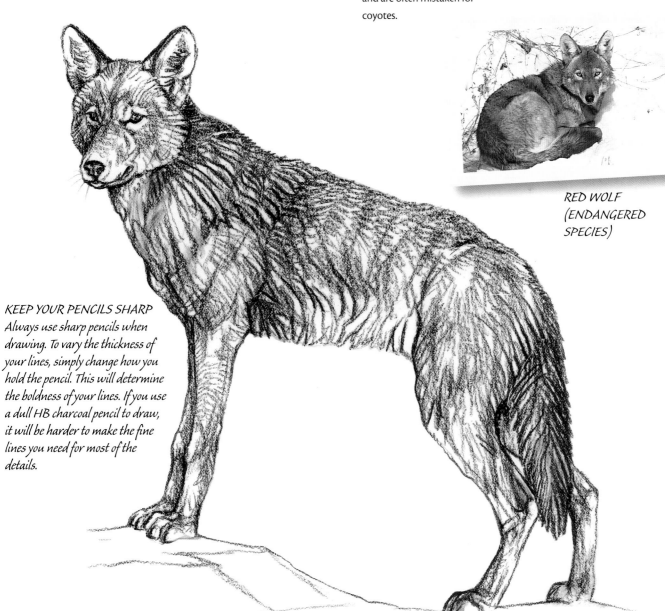

*KEEP YOUR PENCILS SHARP*
*Always use sharp pencils when drawing. To vary the thickness of your lines, simply change how you hold the pencil. This will determine the boldness of your lines. If you use a dull HB charcoal pencil to draw, it will be harder to make the fine lines you need for most of the details.*

# Fox

Foxes make wonderful subjects because of their cute and interesting mannerisms, their sleek, athletic bodies and their beautiful coats. Foxes are found throughout much of the world and their particular body characteristics match their specific environments. Generally, foxes in northern climates will sport lush winter coats, small ears and big, bushy tails, while foxes in warmer climates will have thinner fur and larger ears that help keep them cool.

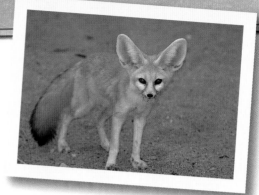

**FENNEC FOX**
*This small fox has large ears, which allow it to dissipate the heat of the Sahara desert in northern Africa.*

## STUDY

*SKETCHES OF FOXES*

Arctic fox (small ears and bushy tail)

Adult Red fox

Red fox kit

Fennec fox (large ears)

Swift fox

Red fox in its winter coat

Red fox in its summer coat

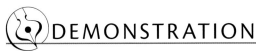
# Red Fox Kit in Summer

Young foxes are also called *kits*. Like all baby animals, fox kits are more than just miniature versions of adults. Their faces tend to be rounder, their eyes are larger in proportion to their faces, and they don't yet posses the lean, sleek bodies of their parents. The soft, fluffy fur of their summer coats are a nice drawing subject.

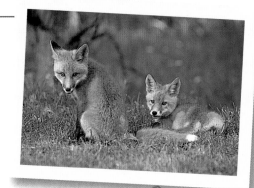

*FOX KITS IN JUNE*

**1 DRAW THE BASIC SHAPES**
Doodle the basic shapes to get the pose you like. Concentrate on proportions during this stage.

**2 REFINE THE OUTLINE**
Refine the basic shapes with tracing paper overlays to get an accurate outline. Transfer the outline to the final surface and lightly add facial details and fur. This will give you a rough guide as you make your final adjustments.

**3 FINALIZE THE DRAWING**
Add a few lines to the white areas of the chest and throat. Leave the tip of the tail mostly white. Continue to add fur over the rest of the body. Use a tortillion to blend areas where you want to suggest body shape or fur pattern. Add your darkest darks to the back of the ears, legs and shadow areas. Leave some white showing through for depth. Add the whiskers with an extra-hard no. 4 graphite pencil. Spray with fixative and let it dry.

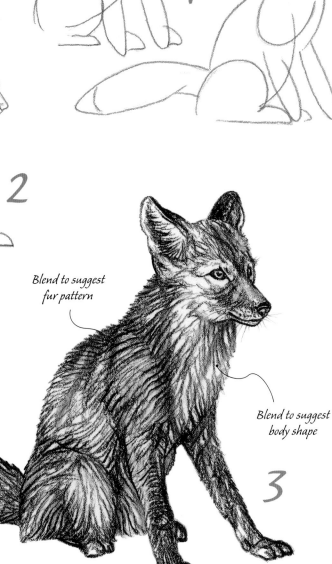

Blend to suggest fur pattern

Blend to suggest body shape

# Adult Red Fox

When most people think of foxes, they typically picture the red fox, a cunning, colorful animal found in many areas. Its fur is not always red, some foxes are cross (a brownish-gray), silver and black—though red is the most common coloration. Their bellies, throats and the tips of their bushy tails are always white. Besides its size, the most distinguishing feature of a fox is its tail, which is quite large when compared to its small body.

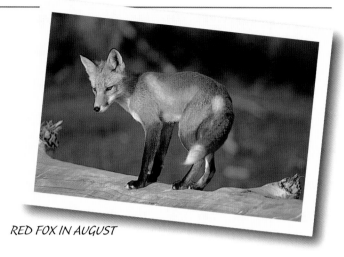

*RED FOX IN AUGUST*

*1* DRAW THE BASIC SHAPES
These initial sketches determine your animal's proportions, so keep doodling until you are satisfied with their accuracy before you begin to refine your drawing.

*2* REFINE THE INITIAL DRAWING
Refine the basic form with tracing paper overlays to establish an accurate outline.

*3* ADD DETAILS
Transfer the outline to the final surface. Lightly add the facial details and map out the fur. Remember to leave the tip of the tail mostly white, although you will need to outline its shape to distinguish it from the paper. As you're adding the fur, indicate its direction, noting how the direction changes around the fox's body.

*4* COMPLETE THE DRAWING
Complete the drawing using an HB charcoal pencil and a tortillion to shade where necessary. Add a few lines to the white areas of the chest and throat. Leave the tip of the tail mostly white. Continue to add fur over the rest of the body, using a tortillion to blend areas where you want to suggest body shape and fur pattern. Add your darkest darks to the back of the ears, legs and shadow areas. Leave some white showing through for depth. Add the whiskers with an extra-hard no. 4 graphite pencil. Spray with fixative and let it dry.

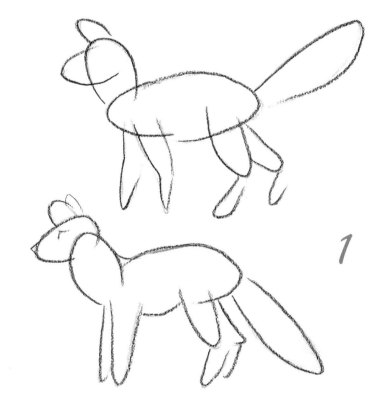

1

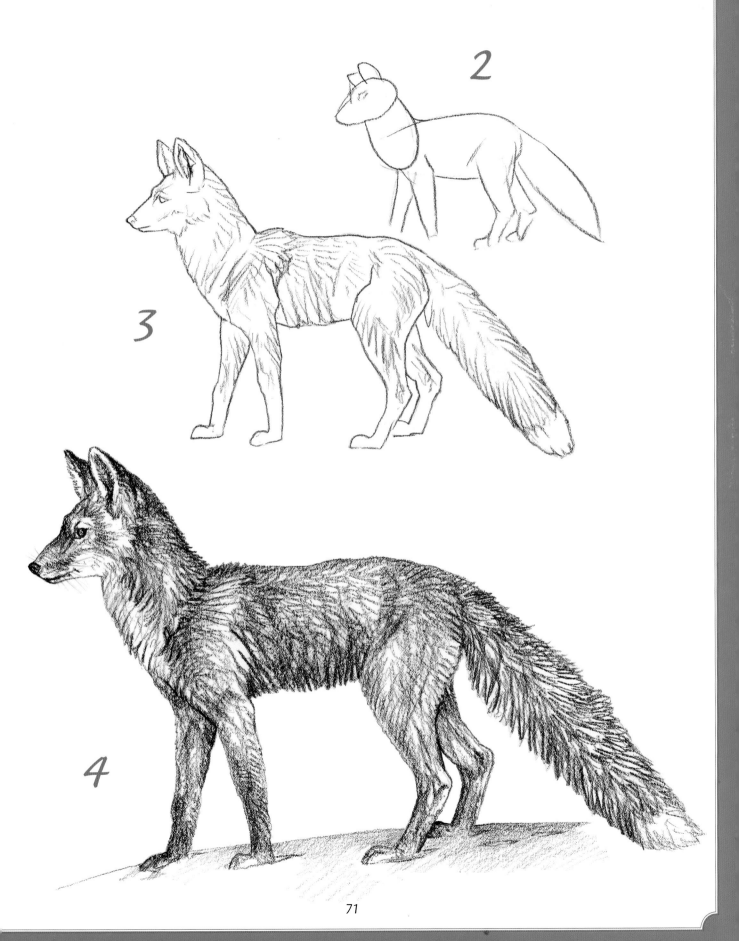

2

3

4

# Arctic Fox

White animals, such as the arctic fox, must be drawn with softer strokes in order to achieve a realistic image. Arctic foxes are stockier and have a rounder head than their southern cousins. These characteristics help the animal stay warm.

**MAKE SOFT, BROAD STROKES**
Make pencil strokes like these to lay down the patterns and direction of white fur. Tilt your pencil to create these soft, broad strokes.

**BLEND THE LINES**
Once you've created the lines, use your finger or a tortillion to blend and soften them. Use an eraser to lift out the highlights.

**USE DARK LINES SPARINGLY**
Dark lines like these should be used only to illustrate the arctic fox's eyes, nose and shadow areas.

## STUDY

**FINISHED DRAWING**
Once you've added most of the fur, blend the shadow areas with a tortillion to give the fur a softer look. Apply the darkest darks to the eyes, nose and deep shadow areas.

Short ears keep heat in

**REFINED OUTLINE**
Make light pencil strokes as guides for the fur direction of the arctic fox.

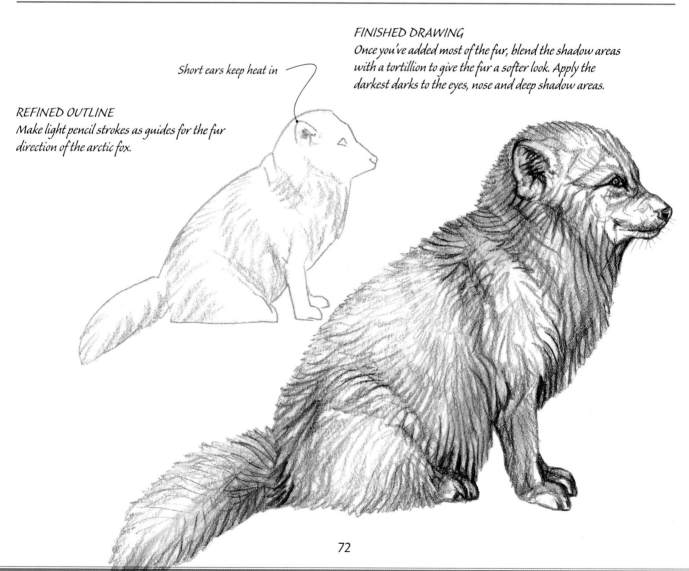

72

# SWIFT FOX

The swift fox is the smallest fox in North America. These foxes have a rusty tan coat, large eyes and long, pointed ears. This species of fox is also referred to as a kit fox by many.

 **ANIMAL SECRET**

The swift fox has a blackish spot between the eyes and nose. This tiny fox usually weighs 3 to 5 pounds (1 to 2kg).

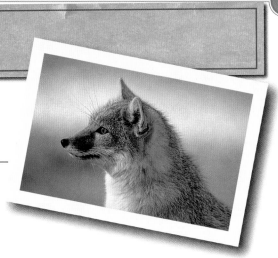

## STUDY

**USE FUR TO INDICATE THE BODY'S CONTOURS**
Use the point of the pencil to make short, zigzag strokes to show body contours and hair direction. Make a continuous series of these strokes around the fox's body. Then go back over the strokes to darken with a pencil or lighten with a tortillion. Save your darkest pencil marks until the end. Pencil strokes like these will enable you to cover a large area quickly.

**USE SHADING AND STROKE DIRECTION TO ADD FORM**
Use shading and the direction of your pencil strokes to maintain roundness in the fox's tail.

*Darken the areas where the hair changes direction to make the fur appear to fade into the recesses*

*Fur lines indicate body contours and hair lengths*

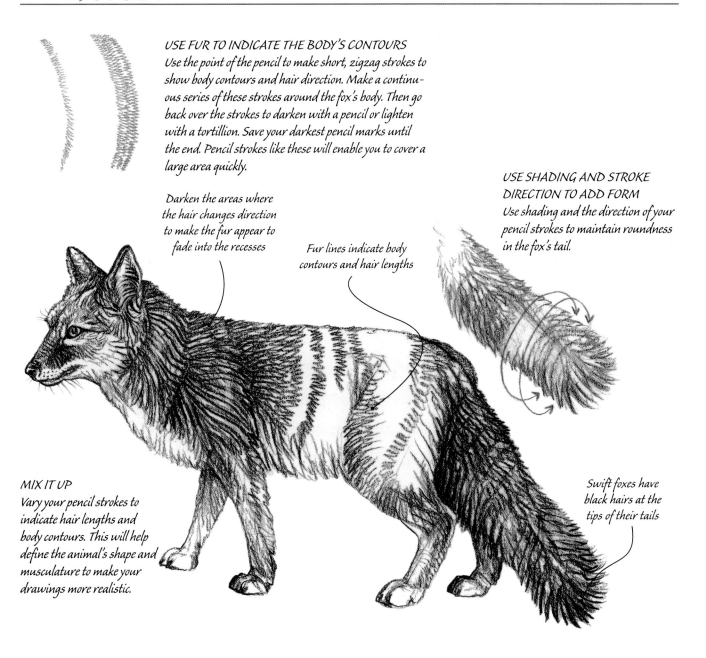

**MIX IT UP**
Vary your pencil strokes to indicate hair lengths and body contours. This will help define the animal's shape and musculature to make your drawings more realistic.

*Swift foxes have black hairs at the tips of their tails*

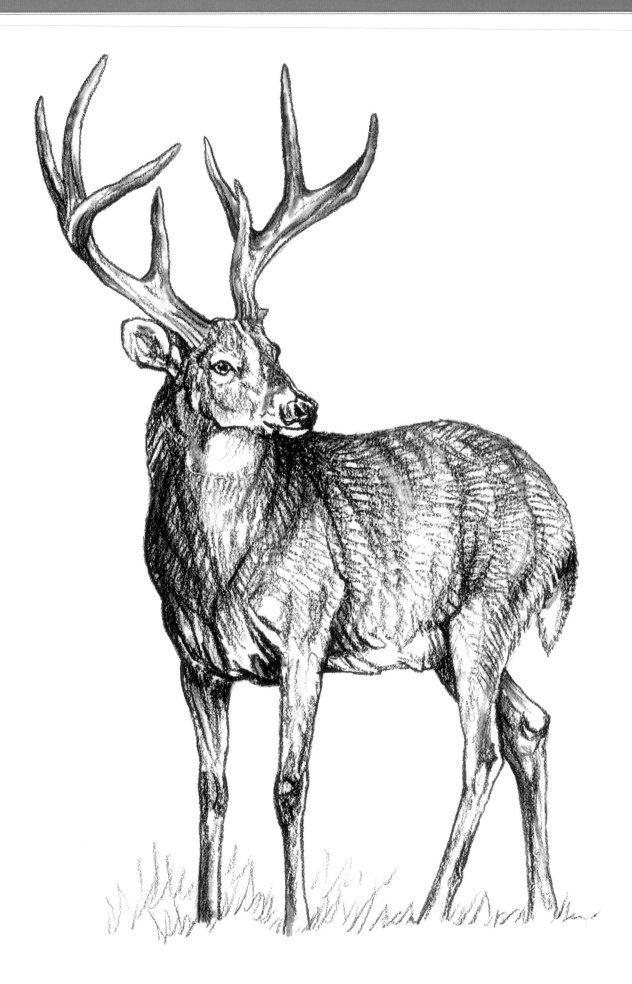

# 4 Deer & Sheep

Deer bring to mind grace and speed, while sheep suggest sturdiness and strength. Both species have thin legs and barrel-like bodies. Both species are fun yet challenging to draw, because no two individuals ever seem to look alike. This is mainly due to the varied environments they inhabit, as well as the vast changes they undergo as they age—particularly the males. In my work, I've concentrated mostly on the males of the species (bucks and rams). The magnificent antlers and horns they grow as they age make them preferred subjects for both artists and art collectors.

Very seldom will you have the opportunity to sketch these shy, elusive creatures in the field or at your leisure. Personally, I like to concentrate on rendering various aspects of these animals' specific environments (such as terrain, trees, ground cover and rocks) in my sketches. I use a camera to capture my elusive animal subjects, using long lenses to get closeups. I then re-create the scenes in my studio from both my sketches and the reference photos.

This white-tailed buck is in one of its many alert poses. Deer seldom look relaxed and always seem poised for flight.

**White-Tailed Buck (October)**
*HB charcoal pencil on illustration board*
*10" × 14" (25cm × 36cm)*

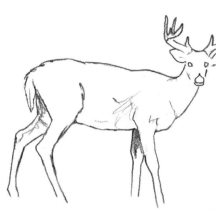

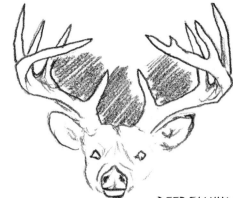

**THE BASIC SHAPE OF DEER**
Deer are sleek, delicately built animals with long, thin legs.

**DEER FAMILY ANTLERS**
Elk, caribou and moose also grow antlers. Antlers may vary greatly among members of the deer family. The only way to know them is to study and draw them.

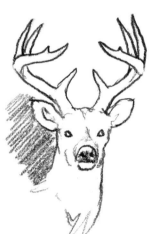

**DEER ANTLERS**
Deer grow and shed their antlers annually. While these antlers are growing, they are covered in skin (called "velvet") that protects and nourishes the bone.

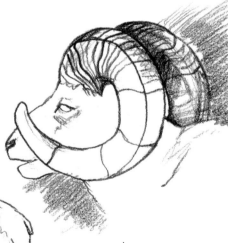

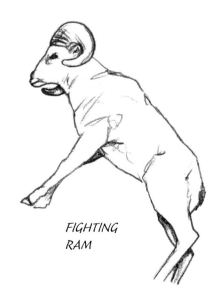

**SHEEP'S HORNS**
Sheep, bison, goats and gazelles are examples of animals who grow horns. Unlike antlers, horns are retained throughout a sheep's life and are never shed. They are made of keratin and normally grow bigger every year.

**FIGHTING RAM**

**THE BASIC SHAPE OF SHEEP**
Sheep are stocky, muscular animals. They are proud, magnificent high-country dwellers, and their wild nature and remote habitat make it challenging to take good reference photos of them.

# WHITE-TAILED DEER

The white-tailed deer has a broad white tail and a coat that is reddish tan in the summer and grayish brown in the winter. A mature white-tailed buck has antlers that sweep forward on a main beam, with tines pointing upward.

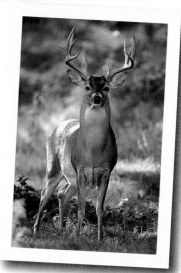

*WHITE-TAILED BUCK, OCTOBER IN TEXAS*
*I prefer to draw and paint deer (as well as sketch and photograph them in the field) when their coats and antlers are in their prime, normally during the fall and winter. Different climates result in different "prime times" for deer around the world, but October and November seem to work well for obtaining references. Of course, spring is when the fawns are born, and you don't want to miss that!*

## ANIMAL SECRET

The white-tailed deer ranges from the southern half of the Canadian provinces down throughout most of the U.S. (except for parts of the Southwest). It can weigh as little as 50 pounds (22kg) to over 200 pounds (90kg). The whitetail is normally nocturnal, but in remote or unpeopled areas it's active any time of the day or night.

## STUDY

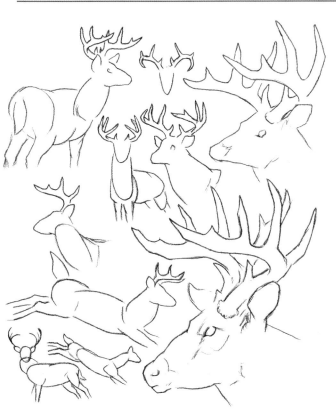

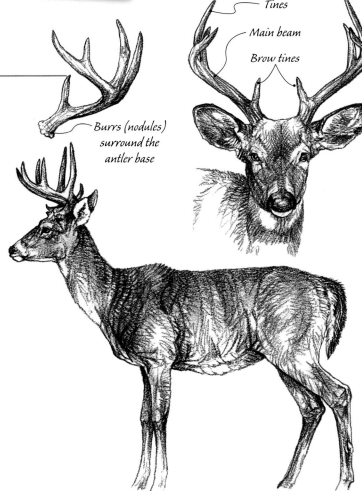

Tines
Main beam
Brow tines

Burrs (nodules) surround the antler base

**CATCHING POSES**
This is a sketch of a deer moving about in a field in Oklahoma. I was trying to capture different poses for reference.

**SKETCHING THE WHITETAIL**
I sketched this whitetail with a charcoal pencil and blended the shaded areas with a tortillion. Be careful in rendering individual hairs—make them more obvious in the areas where the hair is slightly longer and darker such as the neck, shoulder and tail. For contrast, let some paper show through in these areas.

# Face and Antlers

A whitetail's antlers usually grow in a circular direction. That is, the main antler beams normally curve outward from their base and then back inward, thus forming something of a hoop that you could drop a ball into. All antler forms vary, but thinking of them holding a round ball can help you visualize their general form.

New antlers grow during the spring and summer months and are shed after the deers rut in late fall or winter. The antlers grow from pedestals on top of the buck's skull. The base of the antlers is usually surrounded with burrs or nodules.

Use a tortillion to shade and round the antlers. Remember, when light strikes a round object (like an antler) from the front, the round object will have the darkest shadows on its top and bottom. In antlers, this will be where they curve around to the back. If the light source is higher, the shadow will be confined primarily to the bottom. A tortillion helps to soften these shadows as they merge from light to dark.

## ANIMAL SECRET

Deer have no upper front teeth, merely a tough pad. They have incisors only on the bottom and therefore tear off most of their food rather than biting it off cleanly.

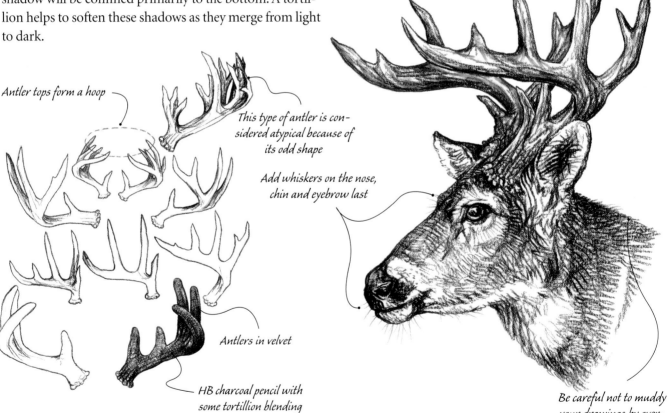

Antler tops form a hoop

This type of antler is considered atypical because of its odd shape

Add whiskers on the nose, chin and eyebrow last

Antlers in velvet

HB charcoal pencil with some tortillion blending

Be careful not to muddy your drawings by overdoing your pencil strokes

*DRAWING ANTLERS*
*Remember, all antler formations are different. This study is a quick sketch of various shapes. Not much detail or shading was done—it's primarily an exercise in the antlers' forms.*

*CAPTURING A DEER'S FACE*
*This white-tailed deer is one of my original sketchbook efforts and was drawn with an HB charcoal pencil. A tortillion was used to shade the antler.*

# ANIMAL SECRET

White-tailed deer and mule deer (page 86) coats are normally a reddish tan during the summer months and a grayish tan during the rest of the year. Northern North American species are larger than those found in the south. Deer reach their antler and body size peak around five to six years of age. Only bucks grow antlers; their size and characteristics are determined by heredity and diet.

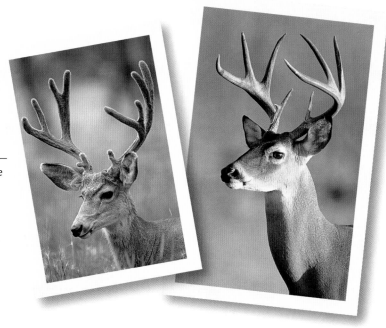

*This is how the antlers will look after the velvet is shed*

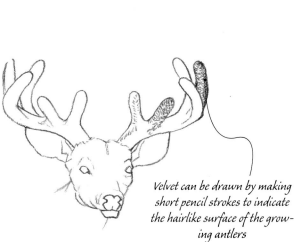

*Note how the antler points are rounded due to the velvet covering, which also gives them a softer, padded appearance*

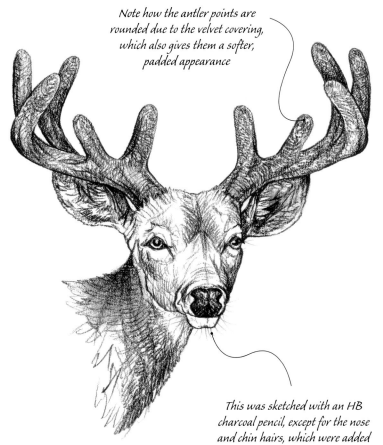

*Velvet can be drawn by making short pencil strokes to indicate the hairlike surface of the growing antlers*

*This was sketched with an HB charcoal pencil, except for the nose and chin hairs, which were added with a no. 4 extra-hard pencil*

# DRAWING SECRET

Begin your drawing session with plenty of sharp pencils ready. Stopping to resharpen pencils can sometimes disrupt the flow of your art.

 DEMONSTRATION

# White-Tailed Buck

The white-tailed deer is the most plentiful and widely distributed big game animal in North America. Its suberb senses have enabled it to live and thrive near humans. This buck is in his prime: his antlers have come out of velvet and he has a thick winter coat.

 ANIMAL SECRET

The deer (Cervidae) family includes deer, moose, elk and caribou. Males grow and shed antlers annually. With the exception of the caribou, females do not grow antlers.

*1 DRAW THE BASIC SHAPES*
*Capture a rough pose to work on through a field sketch or other quick gesture drawing.*

*2 REFINE THE BASIC FORM*
*Use tracing paper overlays to correctly proportion and size the head, body and legs.*

*3 ESTABLISH A FINAL OUTLINE*
*Continue with the overlays to establish the final outline.*

*4 ADD TONES AND FEATURES*
*Position the outline on your drawing paper and transfer it. Add a few tones for shading, then draw the eyes and nose. Use light pencil strokes to indicate the direction of the hair.*

*5 FINISH THE DRAWING*
*Complete the drawing with an HB charcoal pencil, eraser and tortillion. Leave the lower mouth, a patch in the upper neck, and the belly white. Shade the rest as though the whitetail is standing in an area filled with patches of both sunlight and shadows, as in a forest. After your drawing is completed, erase all the smudges and unwanted marks before adding the chin whiskers and spraying it with fixative.*

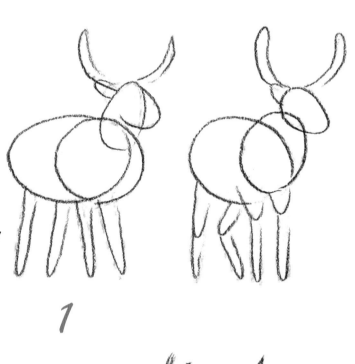

1

2

# ANIMAL SECRET

Deer have long, slender legs designed for speed and jumping. Just like human athletes, animals keep a little natural flex in their legs should a quick get-away become necessary. In the animal kingdom, standing too stiff-legged and flat-footed could result in becoming someone's dinner!

*SHAPE AND HAIR DIRECTION*
*This is the basic body shape of the white-tailed deer. Notice how the hair curves around the deer's trunk and how the hairs gradually turn down. Use an eraser to create a highlight.*

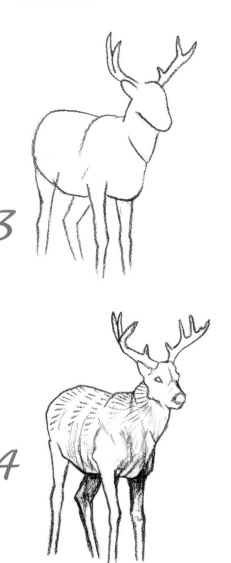

*3*

*4*

*5*

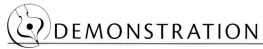
# White-Tailed Doe

This is a classic deer pose; it shows the animal's features well and is easier to draw realistically than a pose that depicts the animal in a twisted or awkward position.

 **ANIMAL SECRET**

The tail of a whitetail is dark on top and white underneath. When the animal is spooked or alarmed, it raises its tail, exposing the flared white side as a warning of possible danger to other deer. Except when the deer is running, the tail is kept tucked against the body.

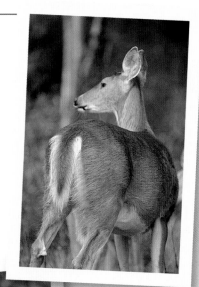

*WHITE-TAILED DOE*

*1 DRAW THE BASIC SHAPES*
*Capture a rough pose to work on through a field sketch or other quick gesture drawing.*

*2 REFINE THE BASIC FORM AND ADD DETAILS*
*Revise your basic sketch until you have created a final outline. Transfer the outline to your drawing paper. Adding facial features first, then shade the areas that need to be darker.*

*3 FINISH THE DRAWING*
*Finish the facial details and continue to define the light and medium values throughout the body. Go back and add the darkest tones to the tail, neck, face, belly and legs, paying special attention to how the legs bend at the knees. Make sure to leave a white space showing on the deer's rump and on the underside of its tail.*

*Clean up your drawing and spray it with fixative. Be sure to keep a record of this classic pose, be it a photograph or a black-and-white copy. You may want to use this reference drawing later for a sketch or painting.*

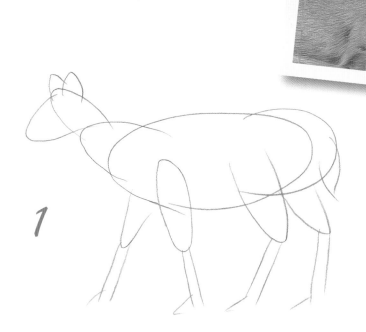

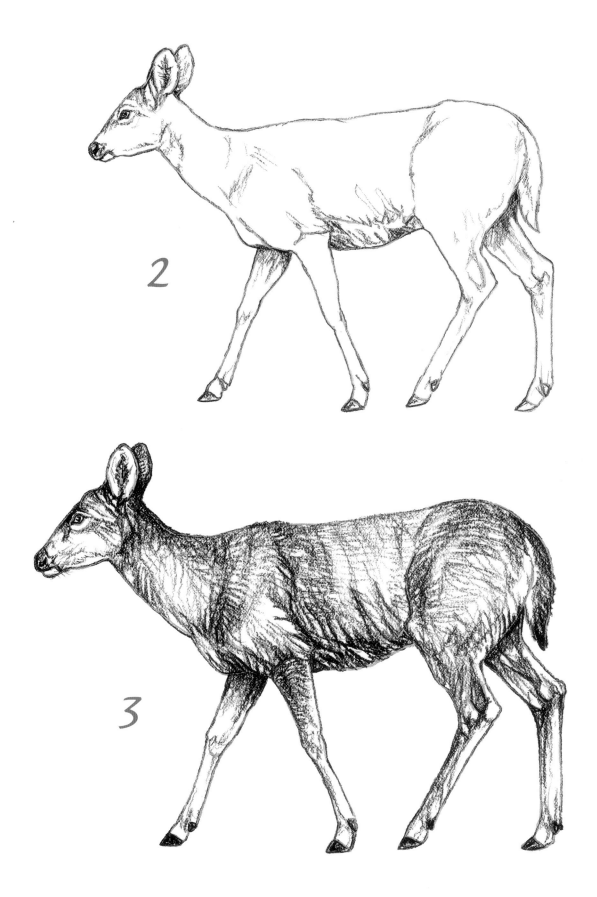

# White-Tailed Fawn

This is another classic deer pose. Although many artists prefer the magnificent bucks as subjects, others choose fawns because of their beautiful coloration and overall cuteness.

During the early weeks of a fawn's life, it often may be found apart from its mother, hiding from predators in brush or long grass. A fawn will lose its spots within a few months of birth, rendering it less appealing to artists.

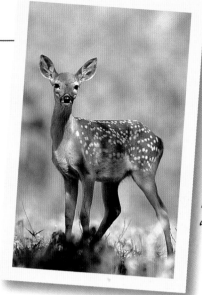

*REFERENCE PHOTO*
*From this photograph of a fawn, you can see how important it is to keep your whites their whitest in areas that are in sunlight.*

*1* **DRAW THE BASIC SHAPES**
*Keep the rounded shapes that make up the deer in mind as you draw and shade.*

*2* **ESTABLISH THE FINAL OUTLINE**
*Use tracing paper overlays to establish a final outline and transfer it to your drawing paper. Then lightly pencil in the fawn's facial details and spots. The spots are the lightest part of the fawn, so plan them to ensure that they will be as white as possible.*

*3* **COMPLETE THE FAWN**
*Gradually darken the hair of the fawn, building your pencil strokes from light to dark. Blend with your tortillion as you layer the pencil markings. Add the darkest darks last. Slightly darken the white spots in the shadows with a tortillion, and leave the spots in direct sunlight pure white. Use a tortillion to blend and soften the areas between white spots.*

*Although hair direction shows on many parts of the fawn, keep the directional strokes on the spotted area of the trunk to a minimum or it will appear too busy. Be sure to add the metatarsal gland and dewclaws before you clean up the smudges and spray with fixative.*

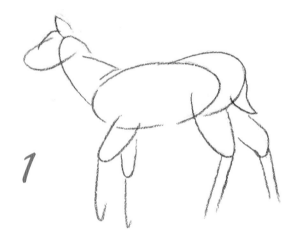

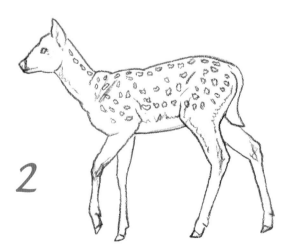

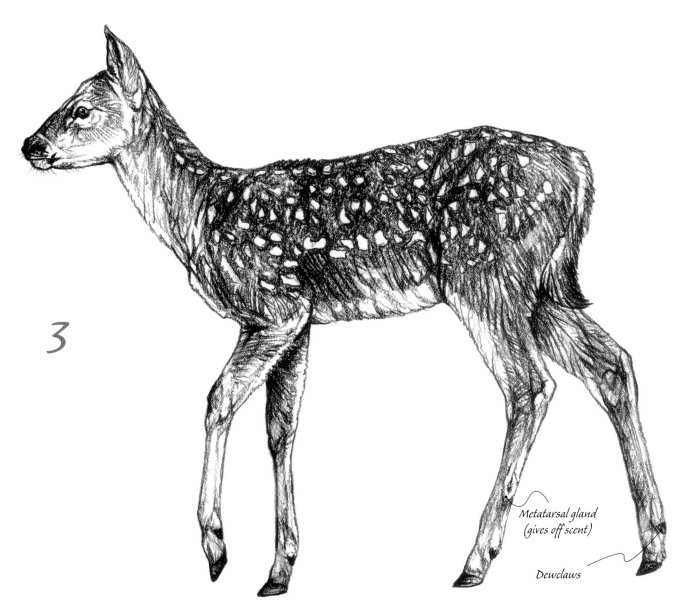

*3*

Metatarsal gland
(gives off scent)

Dewclaws

## DRAWING SECRET

Overworking a drawing is not an uncommon occurrence. Unfortunately, an artist seldom knows when he or she has overdone it until it's too late. A good rule of thumb is: Better too little than too much!

# MULE DEER BUCK

The mule deer buck has a different tail, antler configuration and gait than the white-tailed deer. It is considered a more "western" deer than the white-tail, but their ranges do overlap in certain places in North America.

The antlers of mule deer have main beams that branch into two beams, each of which will branch again as the deer matures.

## ANIMAL SECRET

Mule deer are normally larger and stockier than white-tailed deer. Large specimens can weigh 400 pounds (180kg).

*REFERENCE PHOTOS*

## STUDY

*A deer's first set of antlers usually forms "spikes" (one point per side), but "forkhorns" (two points per side) are not uncommon*

*THE TAIL END*
*Mule deer have a ropelike, black-tipped tail. Its basic shape is that of a cylinder, so shade it accordingly, depending, of course, on the direction of the light source. The hair grows downward. Notice also how the white hairs of the tail blend into the black tip.*

*Large ears*

*Small, ropelike tail*

*MULE DEER BUCK*

86

# BULL ELK

Elk have a reddish brown body, yellow-white rump and dark, chestnut-colored neck. This bugling elk (a *bugle* is the elk's traditional rutting call) was sketched with an HB charcoal pencil and shaded with a tortillion. A sketchbook full of animals in different poses and from different angles will be invaluable to you in your artistic future. Sometimes, a quick doodle becomes the inspiration for a later painting or drawing.

STUDY

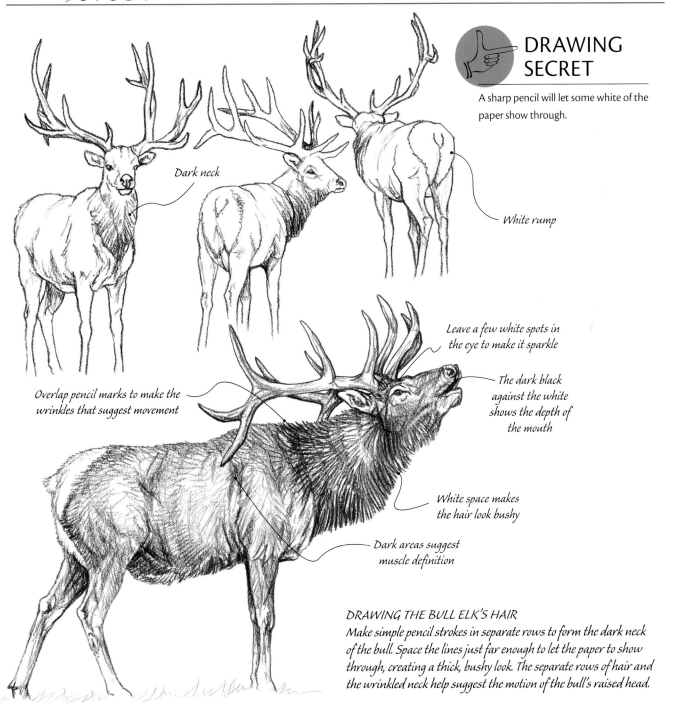

Dark neck

## DRAWING SECRET

A sharp pencil will let some white of the paper show through.

White rump

Leave a few white spots in the eye to make it sparkle

The dark black against the white shows the depth of the mouth

Overlap pencil marks to make the wrinkles that suggest movement

White space makes the hair look bushy

Dark areas suggest muscle definition

### DRAWING THE BULL ELK'S HAIR
Make simple pencil strokes in separate rows to form the dark neck of the bull. Space the lines just far enough to let the paper to show through, creating a thick, bushy look. The separate rows of hair and the wrinkled neck help suggest the motion of the bull's raised head.

# PRONGHORN

Pronghorns are medium-sized, deerlike mammals with long, nimble legs that make them the fastest animal in the Western Hemisphere. Their remarkable vision enables them to spot predators from miles away.

When drawing pronghorns, use techniques similar to those you would use to draw deer; they share body shape, coats and proportions. Learning to draw one easily translates into drawing the other.

 ANIMAL SECRET

The horns of a pronghorn are shed and regrown yearly. The sheaths fall off the permanent cores after the autumn breeding season. This shedding makes these horns different from the horns of other North American horned animals (such as sheep and goats). Pronghorns are commonly (and mistakenly) called antelope by many.

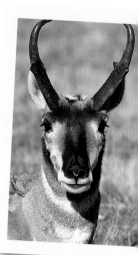

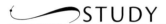 STUDY

Horns are 14 to 20 inches (36cm to 51cm) when fully grown on a mature buck

Females also have horns but they seldom grow over 5 inches (13cm) in length

PRONGHORN HEAD

Drawing the mouth open creates the look of exertion after running

Basic light and dark areas on a pronghorn's neck

Add a little cross-hatching for texture

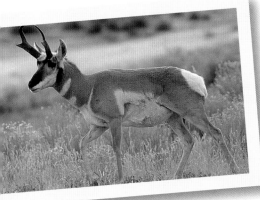

PRONGHORN BUCK IN SEPTEMBER
By September, most animals will be in their prime coats and antlers. This makes their appearance more appealing than it would be in the summer months when their coat is thinner and they are still growing their horns.

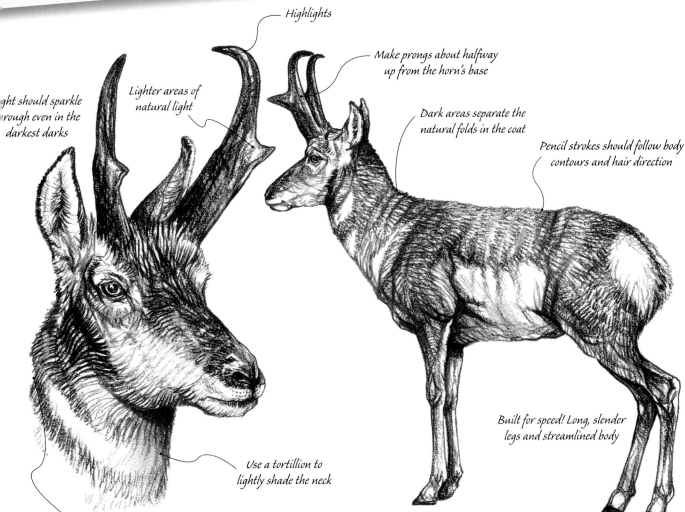

Highlights

Make prongs about halfway up from the horn's base

*Lighter areas of natural light*

*...ght should sparkle ...rough even in the darkest darks*

Dark areas separate the natural folds in the coat

Pencil strokes should follow body contours and hair direction

Use a tortillion to lightly shade the neck

Built for speed! Long, slender legs and streamlined body

*Line directions give the impression of folds and ripples in the animal's neck*

A THREE-QUARTERS VIEW OF PRONGHORN HEAD
Even though the pronghorn's horns are black, they must be drawn and shaded with a range of value changes to accurately simulate their look in natural light. Let the white of your paper be your lightest light and save your darkest darks for the shadows, letting a little white of the paper sparkle through even in these areas.

KEEP THE LIGHT AREAS LIGHT
When drawing pronghorns, leave the cheeks, side, rump and parts of the throat white. Even if your drawing is large, don't fill in your light areas too much. Shade into these areas with a tortillion or your fingertip, and don't add many pencil strokes in the lightest areas.

89

 DEMONSTRATION

# Pronghorn in the Wind

Sometimes you may want to draw your animal with a little bit of wind ruffling the coat. This can provide a unique take on your subject. Here you'll sketch in windblown hair on the pronghorn's rump, shoulder and mane. Keep your pencil strokes to a minimum and try using some crosshatching in the shadow areas. Reserve the darkest markings for the eye, nostril, neck, shoulder and the farthest back leg.

This pose suggests that the pronghorn could bolt at any moment. Perhaps it smells a predator in the wind?

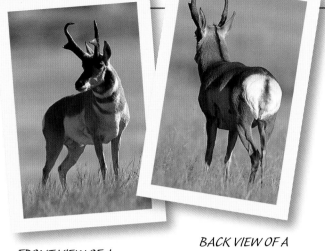

FRONT VIEW OF A PRONGHORN BUCK

BACK VIEW OF A PRONGHORN BUCK

*1 DRAW THE BASIC SHAPES*
*Use a graphite pencil to draw the basic shapes to get the pose you want.*

*2 REFINE THE OUTLINE AND ADD VALUES*
*Use tracing paper overlays to refine the basic shapes into an accurate outline. Map out the lights and darks.*

*3 ADD THE FINAL DETAILS*
*Size the image, as necessary and transfer the drawing to the final surface. Use an HB charcoal pencil to add the basic darks on the head and neck. This will emphasize that area, making it the focal point of your drawing. Finish the face and the rest of the body with a charcoal pencil. Add the dark shadows and blend them with a tortillion or your finger. Keep your blending to a minimum to avoid graying down your subject. Clean up any smudges with a kneaded eraser and spray with fixative.*

 DRAWING SECRET

Horns vary in shape and size. Don't make them too large or different, as that will create an unnecessary distraction.

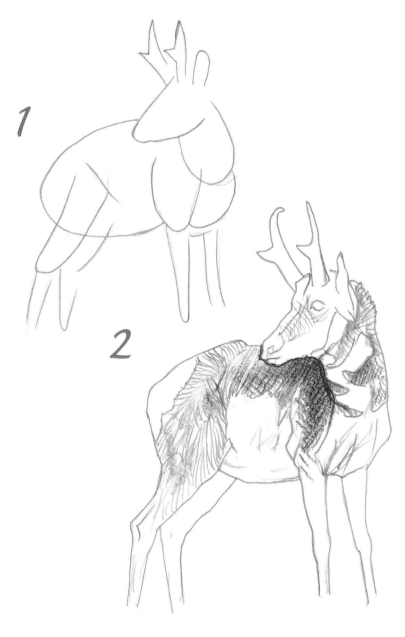

*Too long*

*Better*

*Just right!*

*REALISTIC HAIR REQUIRES THE RIGHT KIND OF PENCIL MARKS*
*Don't make your hair strokes too long; instead, make them shorter and*
*crosshatch them at times. Overlap the crosshatched lines in the darker*
*shadow areas. This will allow little sparks of white paper to show*
*through.*

## DRAWING SECRET

Just about every artist who uses animals in their art will keep a file of photographs, notes and field sketches for reference. These collections are often referred to as *morgues*. You should begin your own morgue and add to it every time you run across a photo or illustration that shows some particular gesture or detail that may possibly be of future interest to you. The purpose of these files is surely not to copy another artist's or photographer's work, but to aid your eternal search for knowledge of your subjects.

*Add windblown areas to the*
*tail, rump, back of the head*
*and lower neck*

3

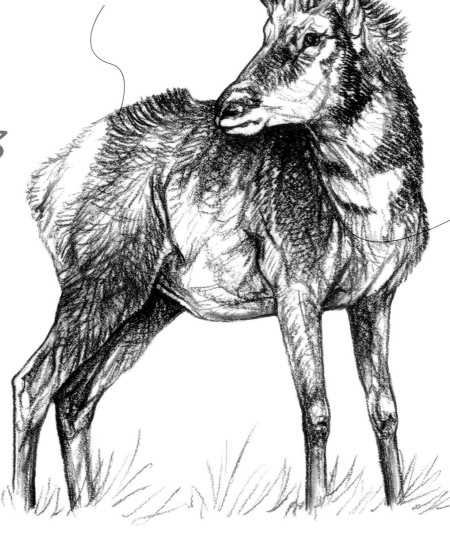

*Make this the darkest area*
*so the head pops out*

# ROCKY MOUNTAIN ELK

The Rocky Mountain elk is a large North American deer, second in size only to the moose. Their antlers are more massive than those of white-tailed and mule deer.

Elk antlers have main beams that can reach up to 5 feet (153cm) long on mature bulls. Normally, mature bulls will have six tines on each side, but a few record-book bulls sport seven or even eight. A set of elk antlers can weigh 50 pounds (23kg). Bull elk usually grow their largest antlers in their prime years, which begin at age five and a half years.

## ANIMAL SECRET

An adult bull is about 8 feet (245cm) long, 4½ feet (137cm) high at the shoulder and can weigh 700 to 850 pounds (315kg to 383kg). Siberia has a stag that's very similar to the American elk.

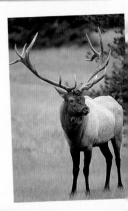

STUDY

# Rocky Mountain Elk Antler

*ANTLER WEIGHT AND SUPPORT*
*Because elk antlers weigh so much, make sure your elk's neck and body look sturdy enough to support them. Elk bulls, like their moose relatives, sometimes have to sway their necks back and forth to move through brush and woods due to their wide antlers.*

*An elk's antlers, like those of a deer, are sometimes irregularly shaped. Drawing these atypical antlers may look odd. It's up to you whether to keep this realism or use your artistic license to create a more classic pose and antler formation.*

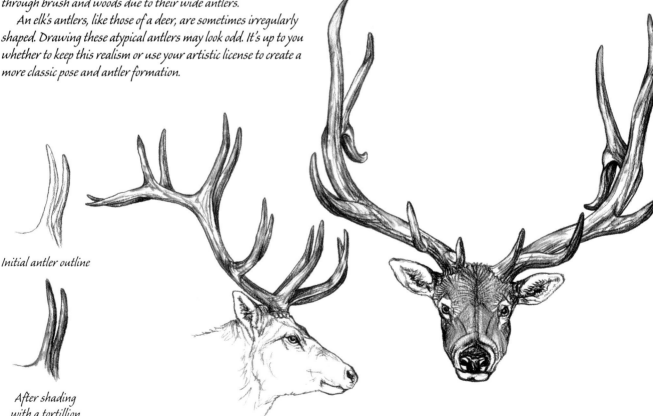

*Initial antler outline*

*After shading with a tortillion*

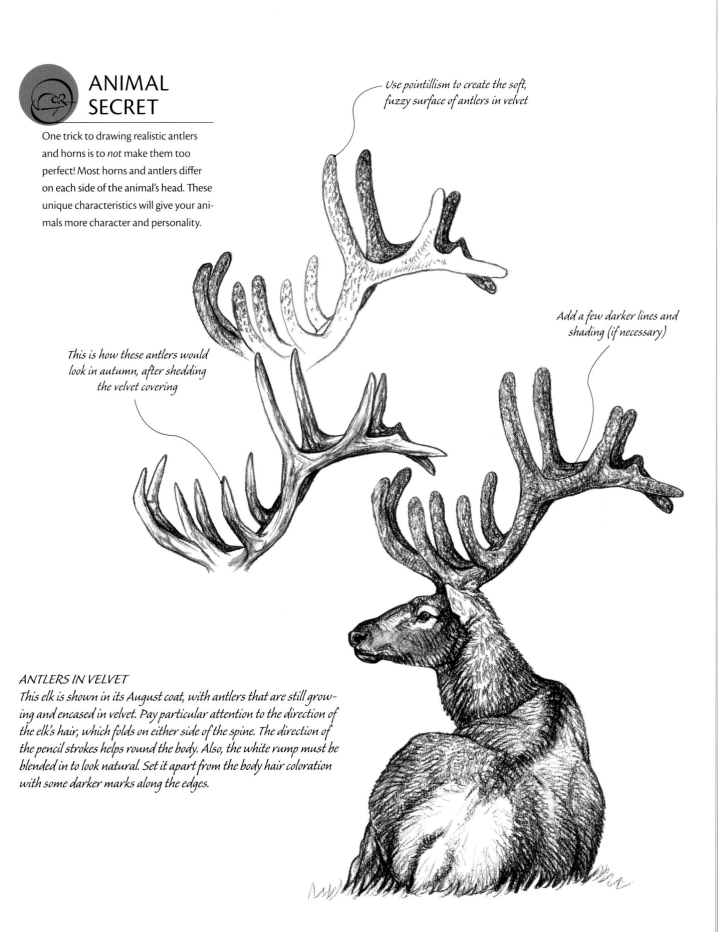

# ANIMAL SECRET

One trick to drawing realistic antlers and horns is to *not* make them too perfect! Most horns and antlers differ on each side of the animal's head. These unique characteristics will give your animals more character and personality.

*Use pointillism to create the soft, fuzzy surface of antlers in velvet*

*Add a few darker lines and shading (if necessary)*

*This is how these antlers would look in autumn, after shedding the velvet covering*

## ANTLERS IN VELVET

*This elk is shown in its August coat, with antlers that are still growing and encased in velvet. Pay particular attention to the direction of the elk's hair, which folds on either side of the spine. The direction of the pencil strokes helps round the body. Also, the white rump must be blended in to look natural. Set it apart from the body hair coloration with some darker marks along the edges.*

# Bugling Elk

Bugling elk make great drawing subjects. Sportsmen often think of this bugling pose when they think of elk. The bugle defines the essence of the North American Rocky Mountain bull elk. Although you should consider the entire animal as you draw, try to identify what will catch the viewer's eye first and pay special attention to that area.

In this demonstration, the bugling face framed with the elk's impressive antlers is the focal point. You can almost see the mountain scene behind it.

*1 MAKE SOME INITIAL DOODLES*
*Try to capture the pose of the animal with rough sketches.*

*2 ESTABLISH PROPER PROPORTIONS*
*Using tracing paper overlays, work to establish the elk's proper proportions.*

*3 REFINE THE FORM*
*Continue to refine the shape of the animal with tracing paper overlays. At this point, the pose and proportion should be fairly accurate.*

*4 CREATE THE FINAL OUTLINE*
*Size the drawing as needed and transfer your outline to the final paper. Begin lightly penciling in the hair direction. Make sure the features are correctly positioned. Add details and the darkest tones.*

*5 FINISH THE DRAWING*
*Use bold pencil strokes of an HB charcoal pencil to indicate the long, dark hair on the bull's neck. Leave the chin white to project the bugling mouth forward.*

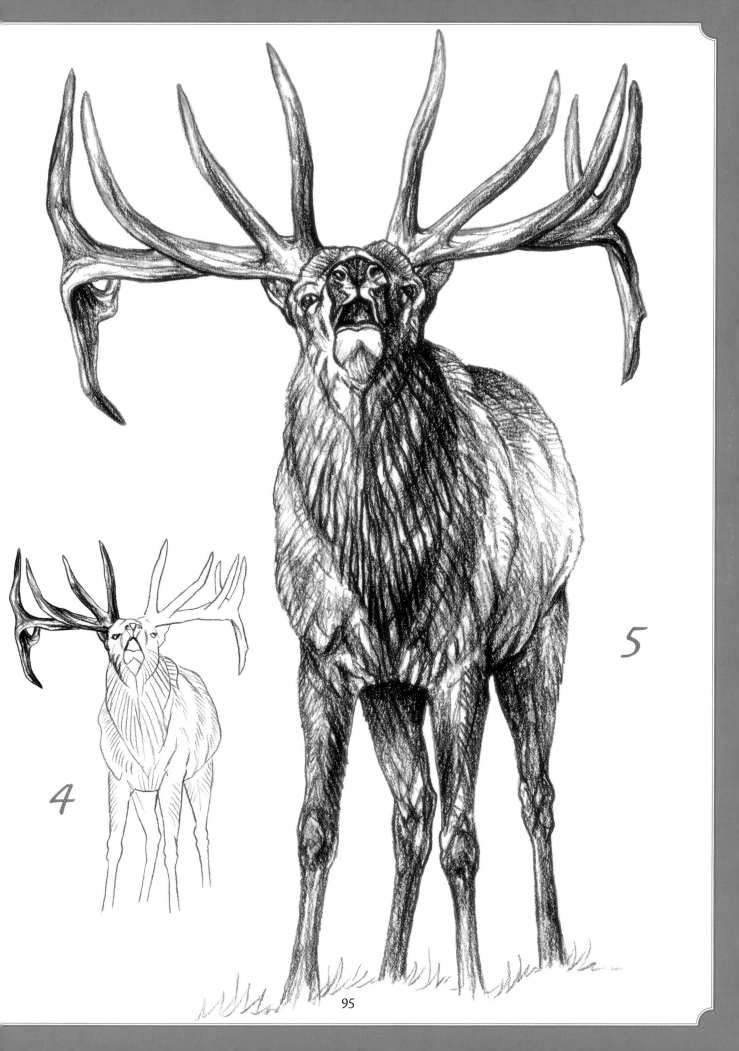

5

4

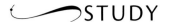

# Rocky Mountain Elk Cow and Calf

Although bull elk make great subjects, don't neglect the females, or *cows*. They work well in serene, peaceful settings, whereas bulls are often portrayed as aggressively fighting or bugling.

If you begin your doodles with a trunk that is about one and a half times the length of the neck and head, you'll have a good starting point. Then you can revise according to the pose and proportions of your subject.

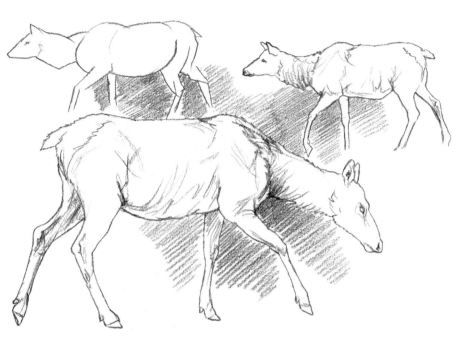

*COW STUDY*
*These drawings are refinements of field sketches. Refine your sketches shortly after an outdoor drawing session when the images are still fresh in your mind; your accuracy will be better. A reference photo will help you with small details such as leg positioning. Once you have these accurate sketches, you can transfer them to better drawing paper or just file them for reference.*

*Stick to simple, classic poses as they best show the animal's trunk, neck, head and legs and will help you become familiar with an animal's proportions.*

Calf track

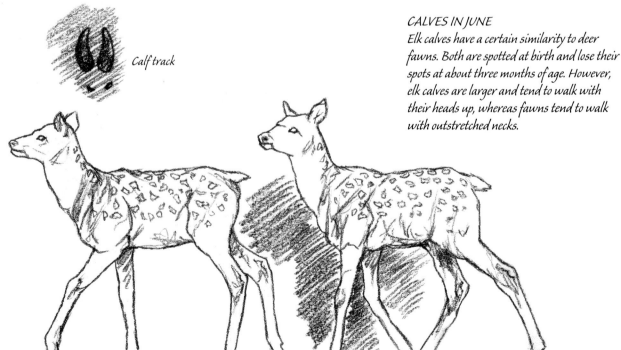

*CALVES IN JUNE*
*Elk calves have a certain similarity to deer fawns. Both are spotted at birth and lose their spots at about three months of age. However, elk calves are larger and tend to walk with their heads up, whereas fawns tend to walk with outstretched necks.*

# ROCKY MOUNTAIN BIGHORN SHEEP

## STUDY

Wild sheep are members of the horned Bovidae family. Males are called *rams*, females are referred to as *ewes*, and the young, *lambs*. Both male and female sheep grow horns, but the males' horns are more curved and massive.

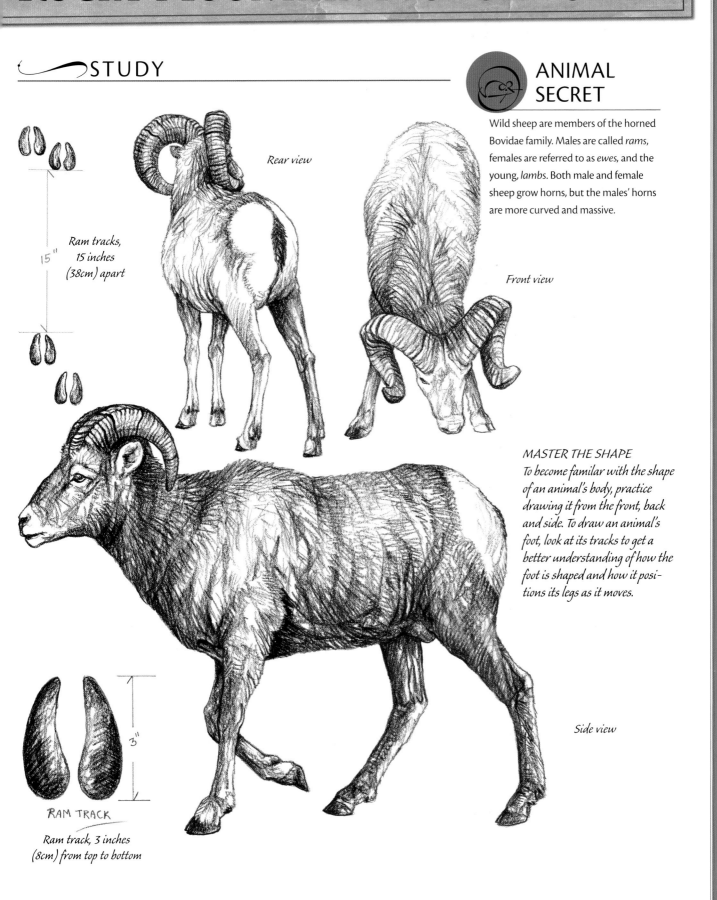

Rear view

Front view

Ram tracks, 15 inches (38cm) apart

15"

*MASTER THE SHAPE*
*To become familar with the shape of an animal's body, practice drawing it from the front, back and side. To draw an animal's foot, look at its tracks to get a better understanding of how the foot is shaped and how it positions its legs as it moves.*

Side view

3"

RAM TRACK

Ram track, 3 inches (8cm) from top to bottom

# Bighorn Head

A Rocky Mountain bighorn ram has massive, curved horns and can weigh over 300 pounds (135kg). A mature ram has a shoulder height of over 3 feet (91cm) and a length of about 6 feet (183cm). A large, heavy-horned ram is one of nature's most impressive wild creatures, and drawing one is both a joy and a challenge. Practice drawing the horns from various angles to understand their curvature and flare. The horns are truly a difficult subject. Gathering as much reference material as you can on them will be a great help to your drawing.

## ANIMAL SECRET

*Unbroomed* (intact or undamaged) horns can hinder the peripheral vision of rams, so they often purposely break the tips on rocks. The edges of the horns are often chipped or cracked due to fighting, falls or both. Bighorn rams never shed their horns; they grow longer with age.

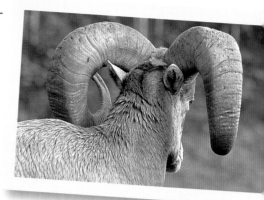

**RAM IN SEPTEMBER**
*This photo shows the rear of the ram's horns.*

*A ram's bottom teeth will show when its mouth is open. Sheep have no upper front teeth*

**CREATING THE ILLUSION OF DEPTH**
*These illustrations of a bighorn's head show that even the faces of animals have curves, ridges and creases. Draw the hair in different directions to suggest these facial structures.*

*The illustration at the bottom shows how to project the ram's horns forward by heavily shading the face. Study how the horns curve not only in a C-shaped pattern, but also curve outward.*

*Horn tips are often broken off (broomed) on older rams*

*You can determine the age of a sheep by counting the winter (dark) growth rings on the horns*

*Heavy shading makes the horns appear to come forward*

# Bighorn Ewe

The bighorn sheep ewe has slender, short horns and can weigh up to 200 pounds (90kg). Mature ewes have a shoulder height of over 30 inches (76cm) and a length of about 5 feet (152cm).

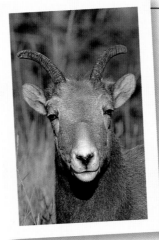

*EWE HORNS*
*Ewe horns don't grow longer than a half curl, whereas ram horns are often longer than a full curl.*

*PAY ATTENTION TO THE TIPS*
*Horn tips are normally dulled and the ridges on the horns are less noticeable toward the tips.*

*SAVE THE DARKS FOR LAST*
*When drawing bighorns, save your darkest pencil strokes for the nose, hooves, tail and deep shadow areas around the body.*

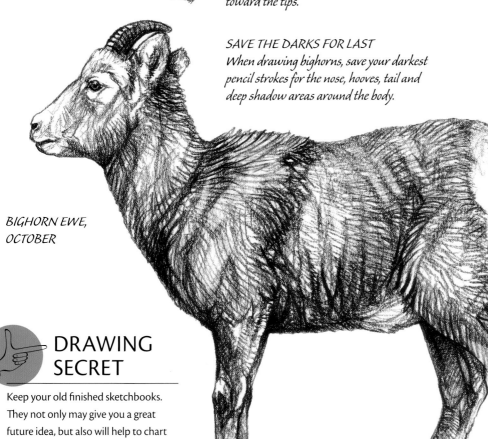

*BIGHORN EWE, OCTOBER*

## DRAWING SECRET

Keep your old finished sketchbooks. They not only may give you a great future idea, but also will help to chart your progress as an artist. You will be amazed at how much difference there is between the quality of your first sketches and your later work.

# Bighorn Ram

Bighorns are stocky, somewhat block-shaped animals, and although circles are used here, you could just as easily use squares and rectangles to begin your sketch. This pose shows a majestic, mature ram in an alert pose with well-defined muscles. This is an example of an animal in its prime. Its strong, muscular body indicates that it lives in steep, tough country. Your final drawing will be a great reference for a future larger painting; the shading, pose and body definition are pretty realistic.

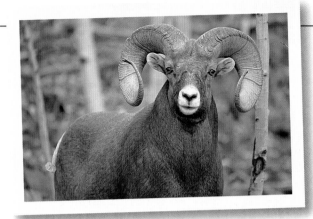

REFERENCE PHOTO

**1** *MAKE A ROUGH SKETCH*
*Don't move on from this step until you are comfortable with the basic shape, pose and proportions.*

**2** *REFINE THE FORM*
*Use tracing paper overlays to refine the shape of the ram. Map out the direction of its hair with short strokes.*

**3** *FINISH THE DRAWING*
*Size the drawing, if needed and transfer it to your drawing paper. Sheep are very muscular animals, so suggest the muscles underneath the ram's hide by indicating hair direction with your pencil markings and by using light and dark tones. Create the appearance of the various curves and ridges of the ram's body, letting some paper show through. Darken the areas you want to recede such as the horns behind the ram's ears, the neck and the tail. Leave light values in the areas you want to seem to advance toward the viewer's eye, such as the ram's face and its rump.*

*Add the darkest blacks and clean up the drawing with a kneaded eraser. Add a few highlights to the neck, shoulder and front leg for interest and spray with fixative.*

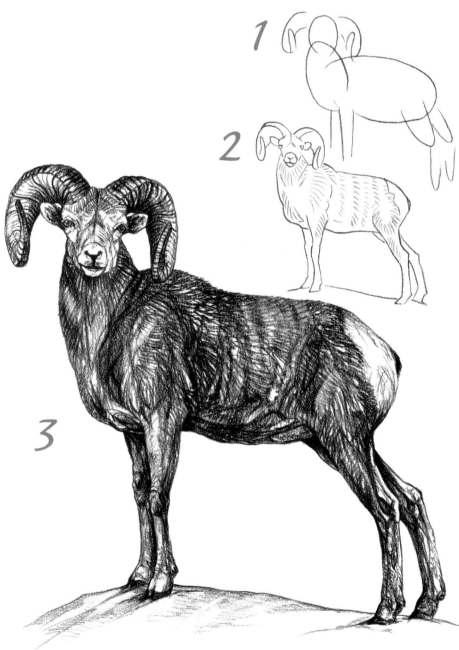

## DEMONSTRATION
# Dall Ram Horns

Horns are much harder to draw than antlers, and only repeated drawings and studies can help you to master their difficult form. Keep your field sketches and photographs from various angles with your reference material to help you as you practice.

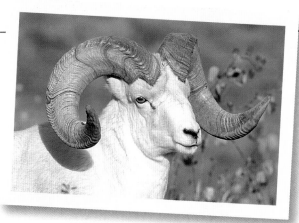

REFERENCE PHOTO

**1** *CAPTURE THE CURVE*
*Try to capture the natural curve of the ram's horns from a head-on perspective.*

**2** *DRAW THE BASIC SHAPES*
*Using tracing paper overlays, rough out the basic shape of the horns and head and establish the horns' correct proportions to each other.*

**3** *REFINE THE OUTLINE*
*Use the overlays to finish the outline of the horns.*

**4** *BEGIN TO ADD DETAILS*
*Indicate the growth rings on the ram's horns in their correct curvature.*

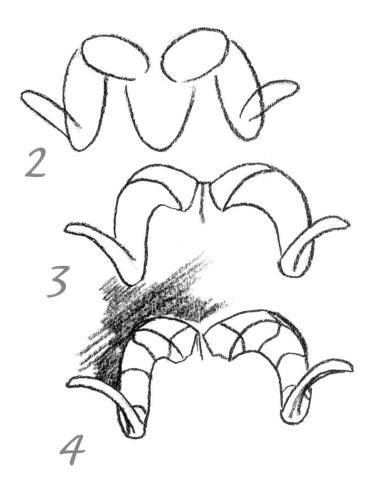

# Dall Ram

North America's Dall sheep are confined mainly to Alaska and the Yukon. They are referred to as thin horn sheep because their horns are slender, less massive and more flared than the bighorn's. Their coats are white, so they don't have the distinctive white rump of the brown-coated bighorn. The Dall's horns are a yellowish brown, and their body weight is about a third less than the bighorn's.

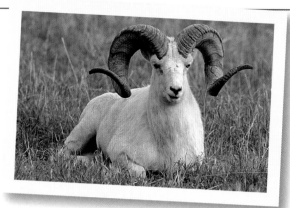

*DALL RAM, SEPTEMBER*

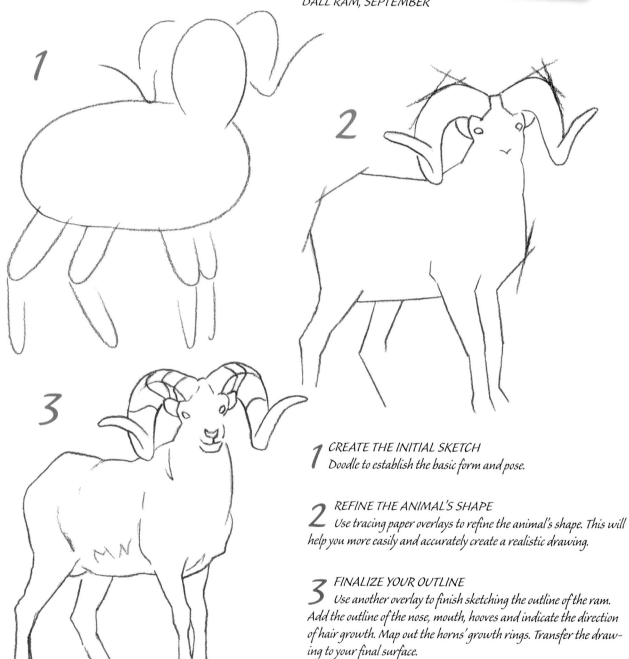

*1* CREATE THE INITIAL SKETCH
*Doodle to establish the basic form and pose.*

*2* REFINE THE ANIMAL'S SHAPE
*Use tracing paper overlays to refine the animal's shape. This will help you more easily and accurately create a realistic drawing.*

*3* FINALIZE YOUR OUTLINE
*Use another overlay to finish sketching the outline of the ram. Add the outline of the nose, mouth, hooves and indicate the direction of hair growth. Map out the horns' growth rings. Transfer the drawing to your final surface.*

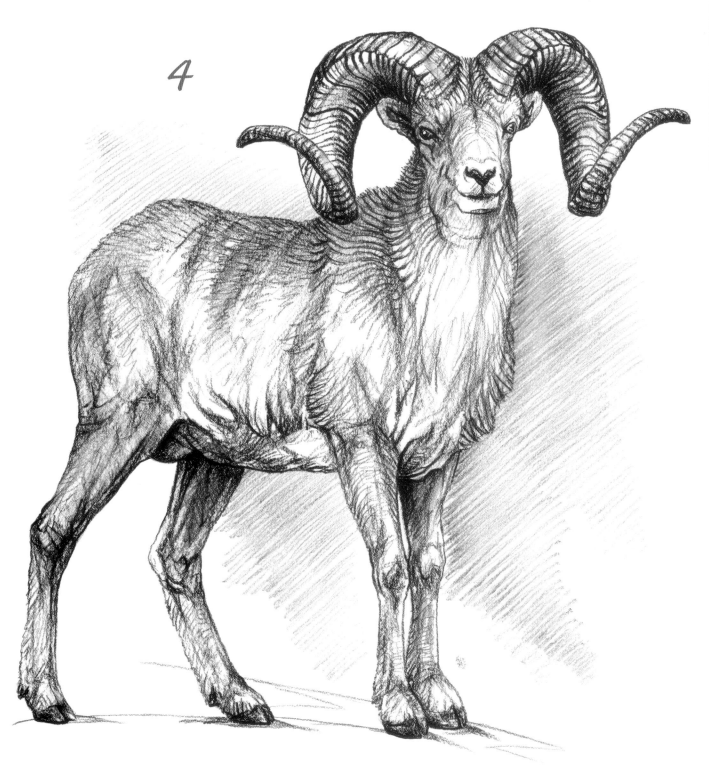

4

## 4 FINISH THE DRAWING

Keep pencil lines to a minimum on the white coat, but use dark, heavy lines to indicate the hair's direction and thickness and to suggest musculature. Blend where appropriate. Pull out highlights with a kneaded eraser, using only the clean parts of the eraser so you do not muddy the white coat. Add the darkest darks to the shadow areas, clean up any smudges and spray with fixative.

# MARCO POLO SHEEP

Marco Polo and Altai argali sheep are the two largest horned sheep in the world. Although a Marco Polo ram's horns have a smaller base circumference (normally 14" to 15" [36cm to 38cm]), they are often larger than those of the Altai argali, with exceptional horns growing to over 65 inches (165cm) in length.

A mature Marco Polo ram is one of the most impressive and desired trophies in the world. It is found primarily in the mountains of Tajikistan and is therefore a wild sheep seldom seen by artists. This Marco Polo sheep was sketched from a mounted animal. Don't overlook the opportunity to sketch in schools and museums that have stuffed and mounted animals on display. If possible, try to move around the mount to draw it from various angles.

## STUDY

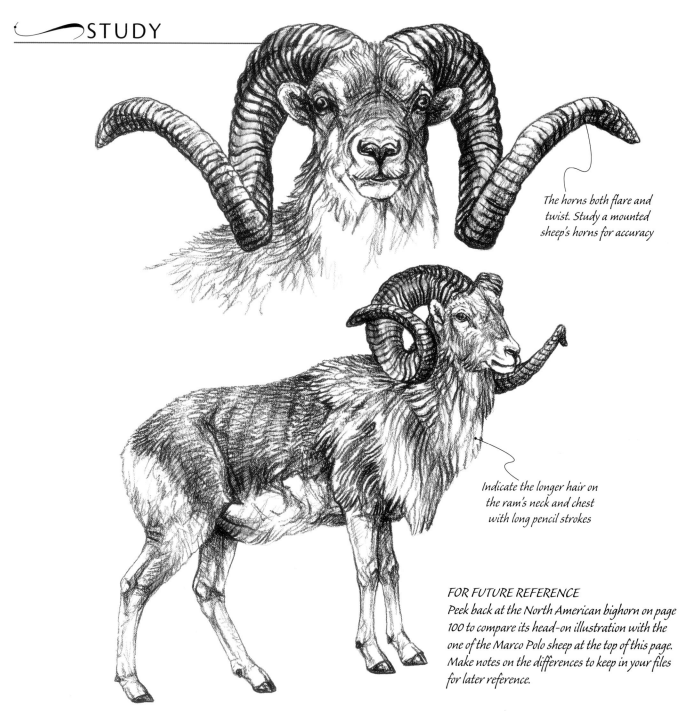

*The horns both flare and twist. Study a mounted sheep's horns for accuracy*

*Indicate the longer hair on the ram's neck and chest with long pencil strokes*

### FOR FUTURE REFERENCE
*Peek back at the North American bighorn on page 100 to compare its head-on illustration with the one of the Marco Polo sheep at the top of this page. Make notes on the differences to keep in your files for later reference.*

104

# ALTAI ARGALI SHEEP

The Altai argali is found in the West Altai mountain range of Mongolia. One of the largest of all wild sheep, both in body weight and horn size, trophy-sized rams can have horns as long as 56 inches (142cm) and base circumferences of up to 18 inches (46cm).

These magnificent creatures appear to be declining in number and are considered threatened throughout their limited region. This Altai argali was sketched from a mounted animal at a museum. Emphasize the impressive mass of the horns, without making them too large.

## DEMONSTRATION

**1** SKETCH THE SHAPE
Draw the shape of the Altai argali's horn accurately. You should also indicate the annual growth rings, but do not space them equally—a horn's yearly growth is regulated by the sheep's food supply and nutrition during that particular year.

**2** ADD DETAILS
Use tracing paper overlays to develop the horn's creases and ridges. Once you've established proper proportions, transfer the image to your final paper. Blend with a tortillion to smooth out value variations as you develop the shape.

**3** FINISH THE DRAWING
Continue refining the horns, using value variations to create the creases and ridges. Now that the hardest part is complete, draw the face and neck, letting your pencil strokes indicate the hair's direction. Clean up smudges and spray with fixative.

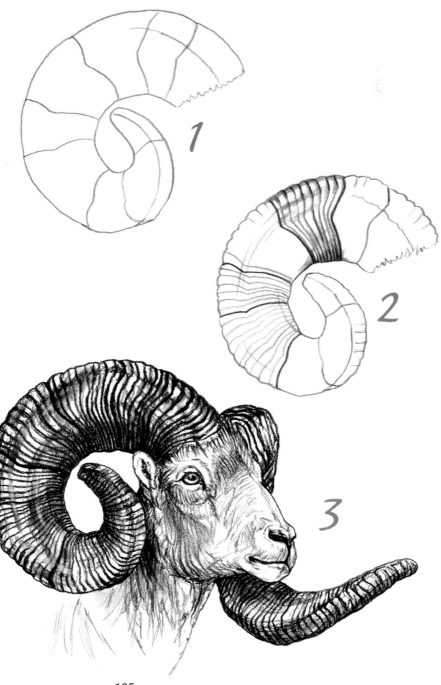

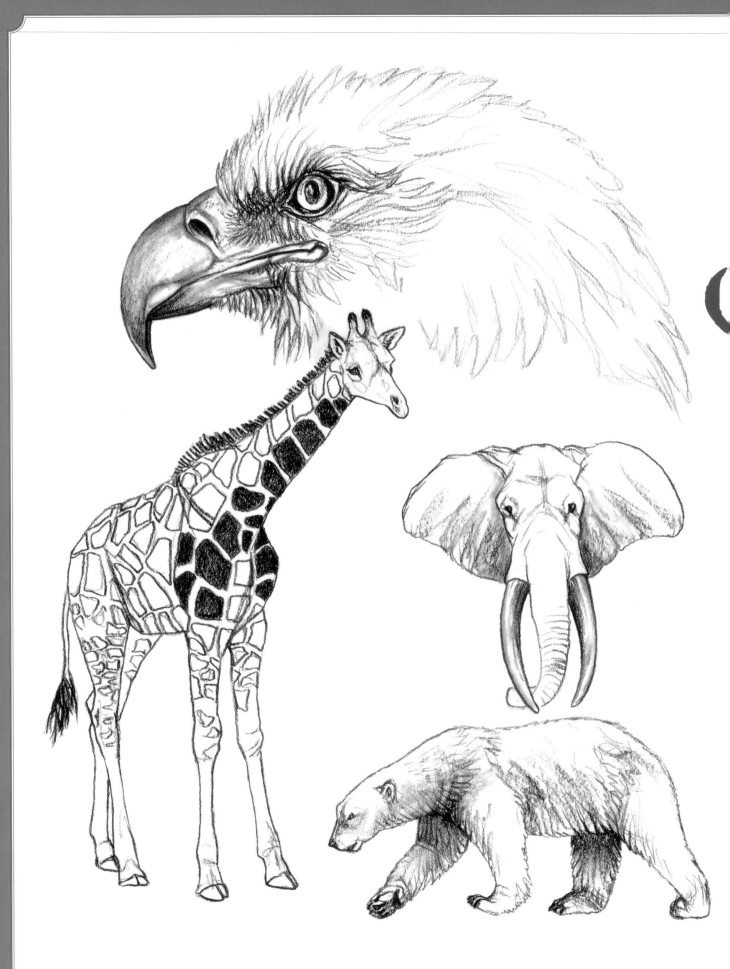

# 5 *Other Animals, Large & Small*

Animals are a challenging subject because each species is different from another. With practice and perseverance, however, your pencil can capture each species realistically. Drawing animals accurately requires the study of their basic shapes and proportions. Examining the textures of different animals is another worthwhile exercise that will help you see important similarites and differences among your subjects. As you become more adept at drawing different animals, it will become easier and quicker for you to turn your doodles of basic shapes into realistic animal drawings.

**Texture Study: Fur / Feathers / Hide**
*Charcoal on bristol paper*
*14 ½" × 11" (37cm × 28cm)*

# HORSES

The horse has long been a favorite subject for artists. They are large, muscular animals that are distinguished by their long tails and manes, long snouts and semicircular hooves.

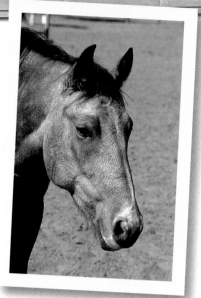

*WILD HORSE IN COLORADO*
*A few areas of North America still have regions where wild horses roam. They are some-times rounded-up and "adapt-ed" by people.*

*STUDY OF FIGHTING MUSTANGS*
*Practicing your quick sketching will help you capture important gestures and positions of your subject.*

*HORSE HEAD STUDY*

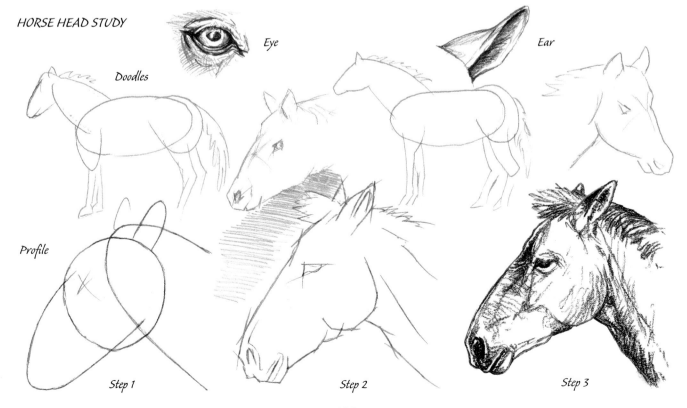

Doodles

Eye

Ear

Profile

Step 1

Step 2

Step 3

108

# STUDY

Horses vary widely in appearance between individuals. Capturing the uniqueness of each horse is important in drawing them accurately. Visualize horses as solid, muscular creatures with long, thin legs. Most horses have short body hair that is often best illustrated with shading rather than penciling in individual hairs.

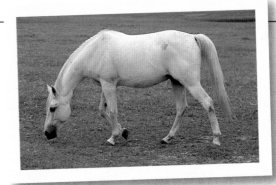

*HORSE IN TEXAS*

*ACCURATE OUTLINE*

*Add the blackest blacks last*

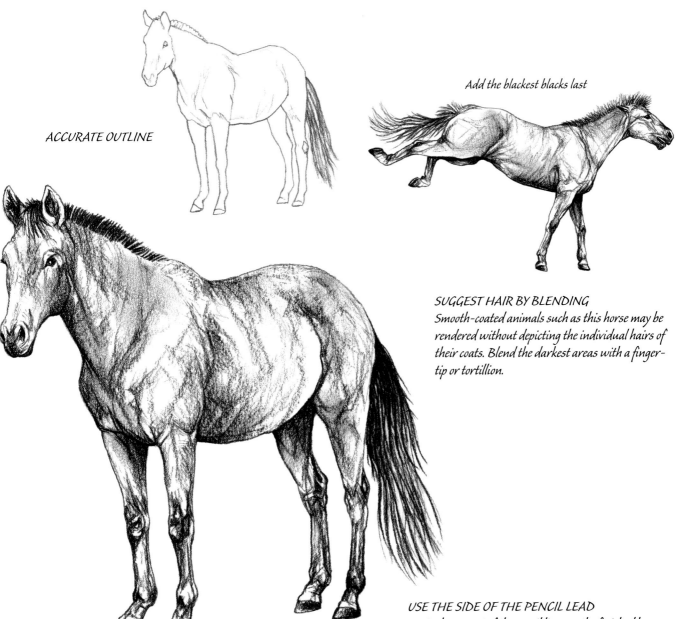

*SUGGEST HAIR BY BLENDING*
*Smooth-coated animals such as this horse may be rendered without depicting the individual hairs of their coats. Blend the darkest areas with a fingertip or tortillion.*

*The shadow areas were created by rubbing some of the pencil lines with my fingertip*

*USE THE SIDE OF THE PENCIL LEAD*
*Notice how most of the pencil lines on the finished horse were drawn with the pencil held more on its side, thus using more of the lead surface than just the point. This rough pencil look helps give a natural, textured appearance to the horse's coat.*

# Zebra

A zebra is essentially a horse with stripes. Notice, however, that zebras have proportionally larger heads, shorter, heavier necks, smaller hooves and shorter tails and manes than horses do. Learning to draw zebras, such as the young Grant's zebra shown here, will help you learn to draw horses more accurately.

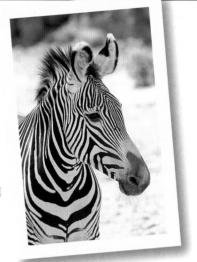

*ADULT ZEBRA*

*Wild horse*

*Crosshatching on top of the zigzag pattern*

*Initial zigzag pattern*

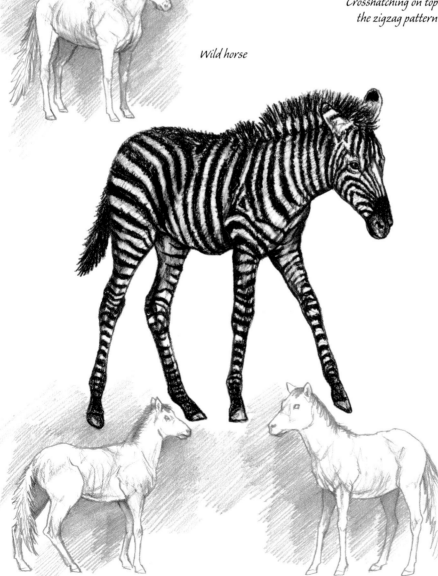

*MAKING ZEBRA STRIPES LOOK REALISTIC*
Once you have curved your zigzag stripes according to the animal's body, add another layer of zigzag marks to darken them. Add a little more character by finishing off the stripes with some crosshatching.

*ADD STRIPES, THEN BLEND*
This Grant's zebra foal was sketched with an HB charcoal pencil and shaded with a tortillion. Add the stripes right before you make the final shading strokes.

Zebra stripes vary among species and among individual animals. Be sure to study their individual characteristics before you pencil them in. In the actual coat, the dark stripes seem to bleed into the white areas, creating a zigzag pattern along the edges.

*Wild horses sketched with a no. 2 pencil*

# Three-Quarters View of a Horse

This rear three-quarters view with the horse looking back toward the viewer is a popular angle for artists, as it emphasizes the friendly, intelligent gaze.

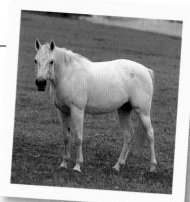

REFERENCE PHOTO

**1 ESTABLISH AN ACCURATE OUTLINE**
Once you've sketched the basic shapes, refine them with tracing paper overlays. Map out the lines that define the angle of the horse's head and neck.

**2 PENCIL IN THE MANE**
With another tracing paper overlay, pencil in the mane and map out some of the shadows along the head and neck.

**3 ADD THE SHADOWS AND FINISH**
With another overlay, add more detail to the face and transfer the drawing to the final surface, resizing it if necessary. Finish shading the face and blend in some of the shadow areas. To achieve smooth gray pencil lines, lay your pencil on its side and drag the lead across the rough texture of the paper. This will let some of the white paper sparkle through, giving the horse's coat a shiny, smooth appearance. Add the body and shade it using the same techniques you used for the face. Add the tail, but don't rush it with a bunch of random pencil strokes. Think of the flow of the tail first and then pencil this shape in lightly. Only then should you use long, dark strokes to finish it. Erase all smudges and spray with fixative.

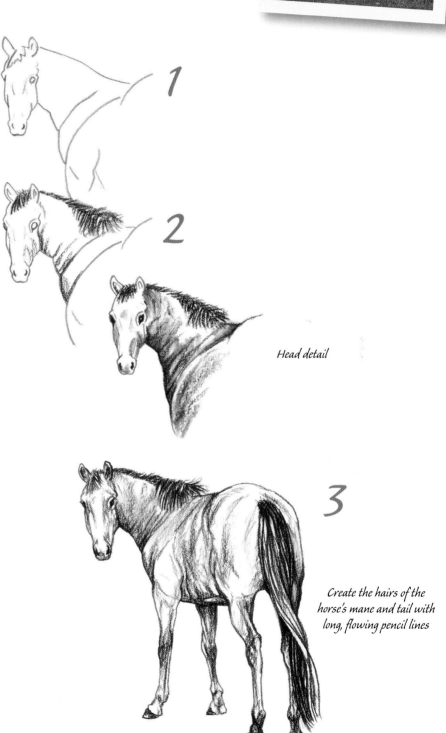

Head detail

Create the hairs of the horse's mane and tail with long, flowing pencil lines

# Appaloosa Horse

Horses come in all sorts of shapes and sizes. Some are truly "old nags," others are bulky, powerfully-built animals and still others are sleek, magnificent creatures such as the Appaloosa. The Appaloosa is a wonderful horse to draw and its spots help make it an interesting challenge, too.

*1* INITIAL APPALOOSA DOODLES
Draw the basic shapes and begin to refine them.

*2* ESTABLISH THE OUTLINE
Use tracing paper overlays to establish the outline. Add the position of the eye, nose and mouth. Outline the hair on the mane and tail, as well as the major muscle lines.

*3* ADD DETAILS
Transfer the outline to your drawing paper and add shadows and details to the nostrils, ear, eye and mouth. Show the placement of the hooves and begin to refine the tail.

*4* FINISH THE DRAWING
Add the shading and gray coloring with pencil lines and blend them with a tortillion. Make a few hair squiggles to give the impression of hair, but use blending to indicate the smooth surface of the coat. Short-haired animals can be drawn realistically with this technique, but long-haired animals generally require more detailed strokes.

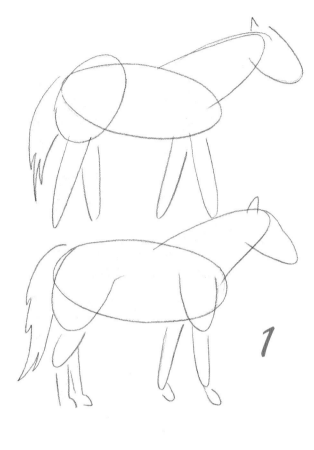

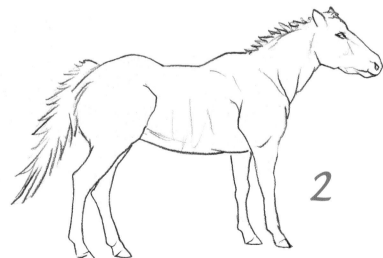

 DRAWING SECRET

Do quick sketches in sketch pads with a hard-leaded pencil to minimize smudging.

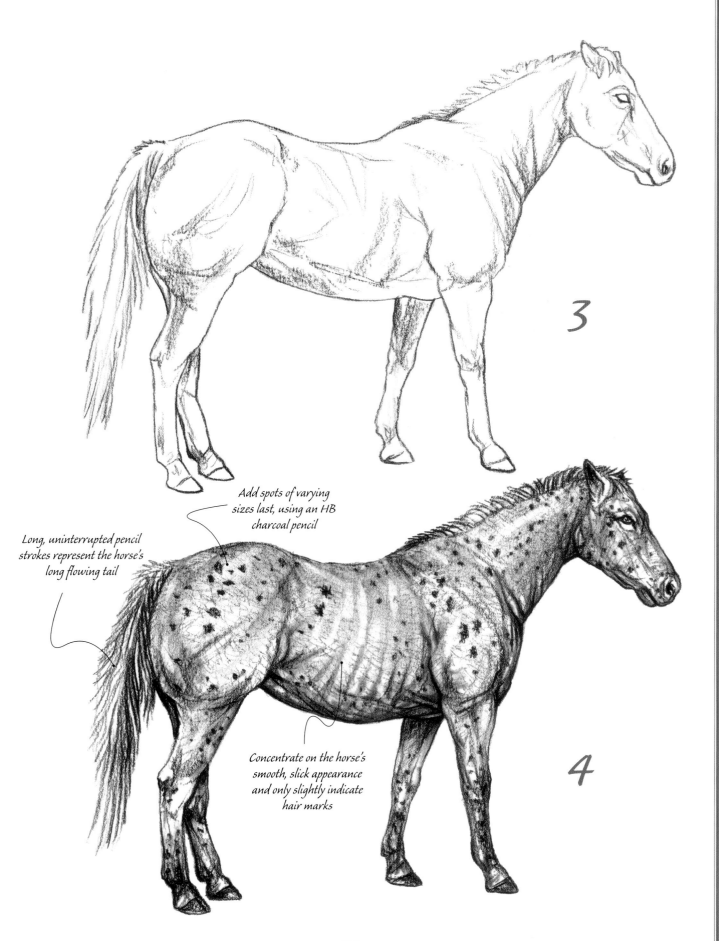

3

Add spots of varying
sizes last, using an HB
charcoal pencil

Long, uninterrupted pencil
strokes represent the horse's
long flowing tail

Concentrate on the horse's
smooth, slick appearance
and only slightly indicate
hair marks

4

# GIRAFFES

The giraffe is one of nature's most unique mammals. Its long neck, long legs and wonderfully spotted coat make it fun to draw. Giraffes are a common zoo animal, so you don't have to go all the way to Africa to find them. Remember, drawing anything will help you draw everything, so don't avoid drawing more exotic animals such as giraffes and elephants just because they are unusual. Cherish the challenge and trust that it will help you grow as an artist.

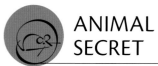

## ANIMAL SECRET

The giraffe's long legs give it a graceful gait when running. In addition, its legs are lethal weapons against many predators.

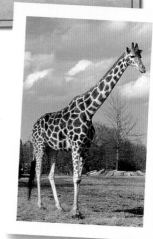

*ADULT GIRAFFE*

*GIRAFFE SKETCHES*

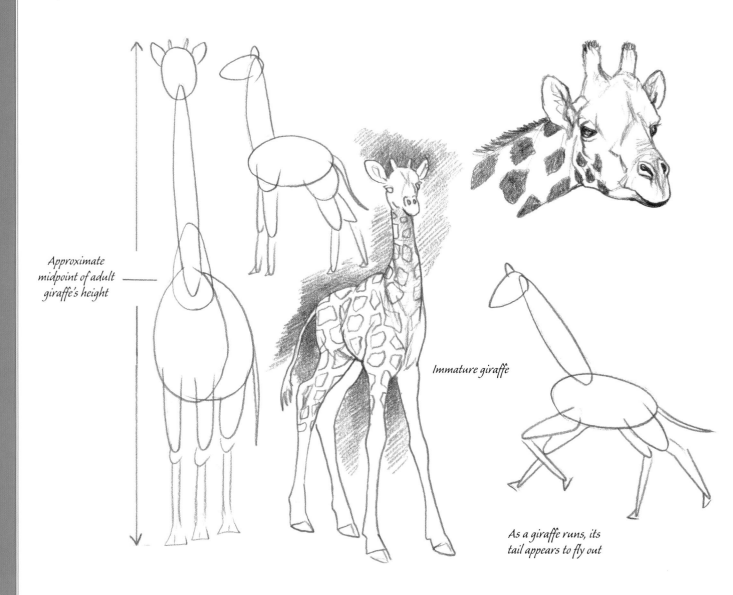

*Approximate midpoint of adult giraffe's height*

*Immature giraffe*

*As a giraffe runs, its tail appears to fly out*

Use gesture sketches to capture the essence of how animals move. In this exercise you can see how the legs support the giraffe. Notice how a front leg must move forward to keep the giraffe from tipping over every time it lowers its neck. Play with your initial doodles before you begin a large, detailed drawing. Draw the giraffe with different leg placements and head and neck positions to decide what looks accurate. Using tracing paper to make these changes will make this much easier because you will be able to see the change as your move the transparent paper.

## ANIMAL SECRET

A giraffe, like all mammals, has seven vertebrae in its neck. Because of their long necks, giraffes often have to position themselves in awkward, spread-legged poses in order to eat or drink.

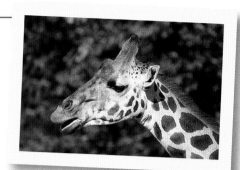

*THE HEAD AND NECK OF A GIRAFFE*

*Running doodles capture the giraffe in motion*

*When drawing any animal, always be aware of where the animal's center is. Here, this is mapped out by the line drawn up the giraffe's back from head to tail*

*Use irregularly shaped spots and markings to add interest to your drawing*

*CAPTURE THE ESSENCE OF THE GIRAFFE'S MOVEMENTS*

*As the head goes lower, the front leg (or legs) must move forward to keep it balanced*

*The tail is spotted, too*

*Head stays high to keep the giraffe balanced as it runs*

*Giraffes have a very smooth gallop that almost looks like it is running in slow-motion*

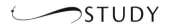

# Giraffe Spots

This study evolved from a few pages of sketchbook doodles done at a wildlife park. The pattern and shape of the spots will vary among giraffes. It's a good idea to do some sketches that focus mostly on the giraffe's spots before you begin a detailed drawing. Do not completely fill in the spots. Using a paper with a lot of tooth will allow some white to show through without the need for any special pencil strokes.

*GIRAFFE LEGS AND KNEES*
*Create creases in the giraffe's knees with dark lines blended into the white of the paper to simulate folds.*

*Giraffes need a solid base to support their long necks, so make the hooves large and broad. The hooves should be mostly dark, with light bouncing off their curved surfaces to add depth and shape.*

 DRAWING SECRET

When drawing the long hairs of the tail, make long, individual strokes. This allows bits of white paper to show through as highlights.

*Sketched with 4B charcoal pencil*

*Spots occur on the face, too*

*Sketched with an HB charcoal pencil*

*Legs must support the animal, so position them properly*

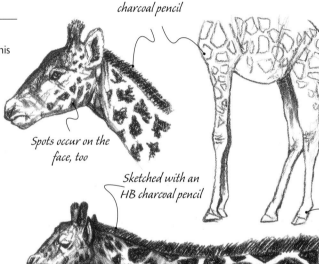

*Make the spots irregular*

*STUDY OF GIRAFFE SPOTS*
*Outline the spots first, then fill them in.*

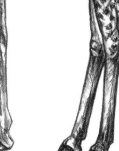

*Outline sketched with a no. 4 extra-hard pencil*

# Giraffe's Head and Face

Large drawings, especially those that focus on the face, require intricate details. Try to capture the individual features that define the giraffe. Reference photos are especially good for this and will help you illustrate details such as the eyelashes, mane and the pattern of the facial hair. Reference photos will also allow you to carefully map out the facial creases for shading.

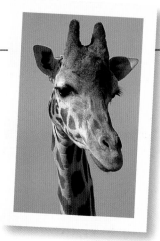

REFERENCE PHOTO

*1* **DRAW THE BASIC SHAPES**
*Make doodles of the basic shapes to get the form you want.*

*2* **REFINE THE OUTLINE**
*Refine the shapes to get an accurate outline. Map out the facial features and the spots.*

*3* **FINISH THE DRAWING**
*Resize the image, if necessary, and transfer it to your final surface. Add the hair on the giraffe's face. Use the direction and length of the hair to give shape to the face. Add the longer hairs of the neck, making single pencil strokes to allow the necessary white spaces to show through. Add the darkest darks, including the spots, the dark hairs on top of the horns and the shadow areas. Clean your drawing of unwanted marks and smudges, then add the whiskers and eyelashes. Spray the drawing with fixative.*

Note the long eyelashes and the hair-covered horns

A few swipes with a tortillion will add the creases to the nose and forehead

Do a few more swipes of the tortillion to define and shape the face

 **DRAWING SECRET**

Using textured paper for your drawing will allow little white "sparks" to show through the tones—unless you wish to intentionally blacken them out via extra lines or smudging.

# Adult Giraffe

This adult giraffe displays a common pattern of spots. Of course, they are not really spots, but more like variously shaped mosaic pieces. Markings can vary greatly in giraffes from different areas of Africa.

ANIMAL SECRET

Both male and female giraffes have horns.

**1** *DOODLE TO ACHIEVE THE CORRECT PROPORTIONS*
Draw the basic shapes to determine the correct proportions and pose. Keep doodling until you have a fairly accurate shape.

**2** *REFINE THE OUTLINE AND BEGIN TO ADD DETAILS*
Once your outline is complete, transfer it to the drawing paper. Lay in important details such as the eye and muzzle.

**3** *FINISH ADDING THE DETAILS*
Begin to lightly pencil in the giraffe's markings and features such as the eye, ear, mane and horns. Using light strokes will make it easier for you to erase mistakes, if necessary. Outline the spots with irregular edges. Keep layering in the spot pattern until you have covered the entire giraffe.

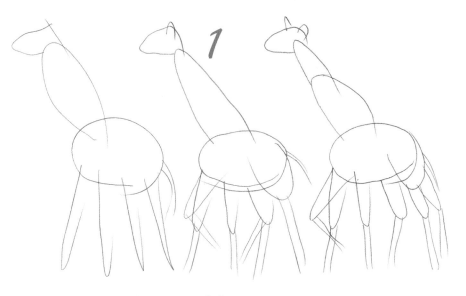

*1*

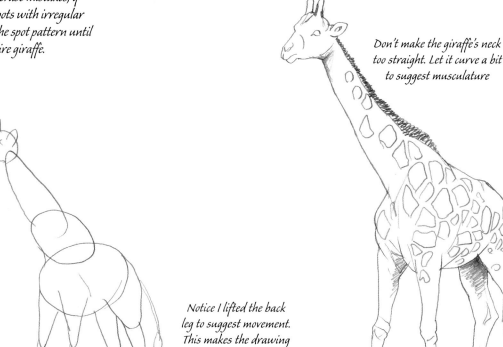

Don't make the giraffe's neck too straight. Let it curve a bit to suggest musculature

Notice I lifted the back leg to suggest movement. This makes the drawing more interesting than if the giraffe were standing flat-footed

*2*

*3*

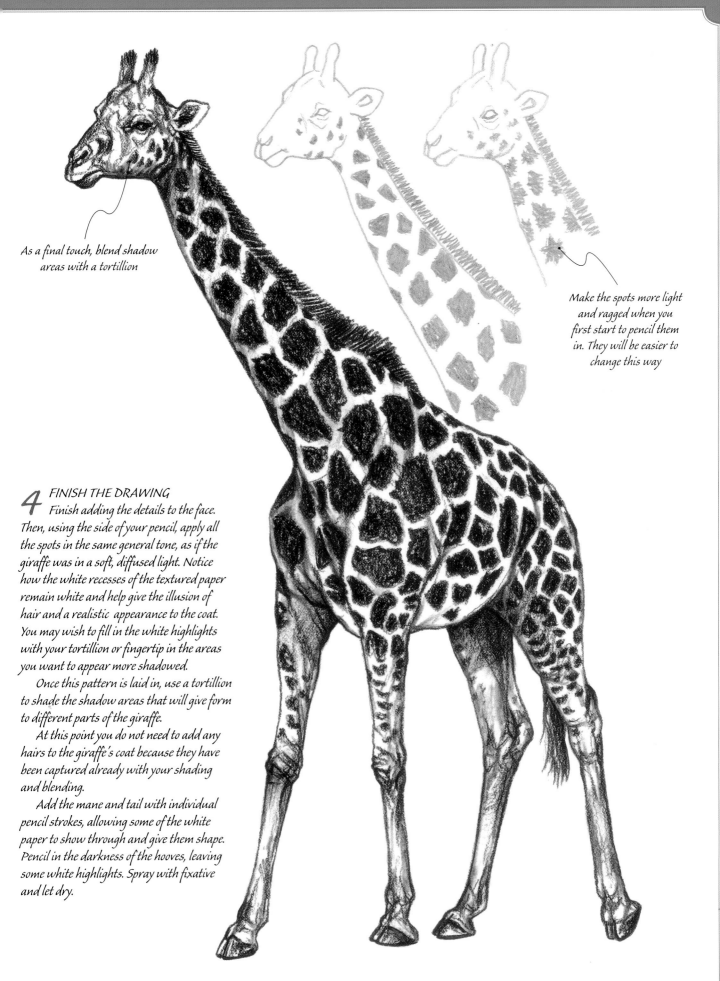

As a final touch, blend shadow areas with a tortillion

Make the spots more light and ragged when you first start to pencil them in. They will be easier to change this way

## 4 FINISH THE DRAWING

Finish adding the details to the face. Then, using the side of your pencil, apply all the spots in the same general tone, as if the giraffe was in a soft, diffused light. Notice how the white recesses of the textured paper remain white and help give the illusion of hair and a realistic appearance to the coat. You may wish to fill in the white highlights with your tortillion or fingertip in the areas you want to appear more shadowed.

Once this pattern is laid in, use a tortillion to shade the shadow areas that will give form to different parts of the giraffe.

At this point you do not need to add any hairs to the giraffe's coat because they have been captured already with your shading and blending.

Add the mane and tail with individual pencil strokes, allowing some of the white paper to show through and give them shape. Pencil in the darkness of the hooves, leaving some white highlights. Spray with fixative and let dry.

# ELEPHANTS

Elephants, like giraffes, are fun and challenging to draw because they truly are unique. These massive animals are the largest land mammal in the world. A mature bull can weigh 5 to 6 tons (4500 to 5400kg) and have a shoulder height of 12 feet (366cm). There are two species of elephants: the Asian and the larger African.

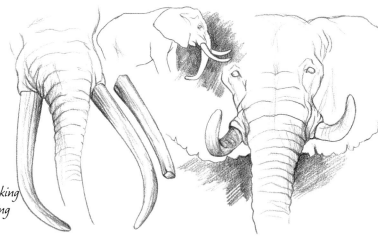

*STUDY OF AN AFRICAN ELEPHANT BULL (MALE)*
*You could add character by breaking off the tip of one tusk or by making the tusks asymmetrical.*

*See how the wrinkles are farther apart at the top of the trunk than they are at the bottom*

*FACE OF AN AFRICAN ELEPHANT BULL*
*On the right ear I just penciled in the ear's outline (and a few creases); on the left ear I took similar pencil marks and rubbed them with a tortillion and my fingertip. I then added a few darker pencil marks and lifted out a few highlights with an eraser to add depth and shape.*

*Ear edges on wild elephants are often ragged with rips and tears*

*SIDE VIEW OF AN AFRICAN ELEPHANT BULL*
*Adult male African elephants have heavier and usually longer tusks than adult females.*

*DRAW A TUSK*
1 | *Draw the initial outline*

2 | *Shade the outline with a tortillion*

3 | *Add marks to give the tusk character*

*SIDE VIEW OF AN AFRICAN ELEPHANT COW (FEMALE)*
*After I finished drawing in the wrinkles and creases on this female African elephant, I shaded the drawing by rubbing the pencil lines with my fingertip. Then I sprayed it with fixative.*

120

# African Elephant Face and Trunk

When drawing the front view of an elephant's face, think of a triangle as its basic shape. This will make your illustration much easier to execute. I recommend using the side of your pencil lead when drawing elephants; it's especially good for portraying their rough-textured gray skin. Elephants do have sparse hairs on their bodies, but these are insignificant enough to ignore.

*DRAWING AN AFRICAN ELEPHANT'S EAR*
*The bottom part of this ear is rendered by holding the pencil at a slight angle. The side of the ear is also penciled in, then blended with a tortillion.*

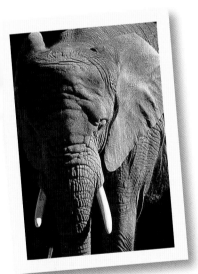

## ANIMAL SECRET

Both male and female African elephants sport tusks. The elephant's tusks are actually elongated incisor teeth; they will grow to lengths of over 10 feet (305cm) and weigh 200 pounds (90kg). Tusks usually aren't absolutely symmetrical, so don't make them too perfect.

*DRAWING AN ELEPHANT'S TRUNK*
*1 | Draw in the wrinkles and ridges of the elephant's trunk with an HB charcoal pencil.*

*2 | Add tone by blending the pencil marks with your fingertip to gray over the area.*

*3 | Add dark lines to the shadow areas and lighten the highlighted areas with a few strokes of a kneaded eraser.*

# African Elephant Cow

This illustration portrays an adult cow in a pose that shows off its individual features well. This is particularly true of the smooth-looking ears, the long trunk and the wrinkled hide. Pay special attention to the wrinkles and note how they are more evident at the elephant's lower body than at the smoother upper body. Although the skin is shaded to a gray, there is still a lot of white evident. Muddying pencil drawings is a common mistake. Remember, too little is better than too much!

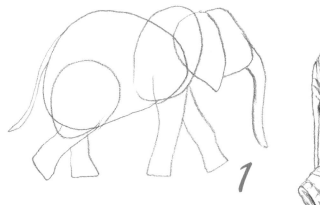

*1*

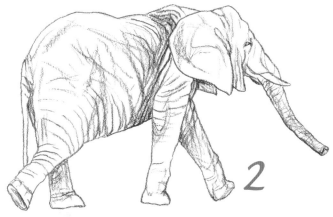

*2*

*1* **DRAW THE BASIC SHAPES**
Doodle to get the character and shape you want.

*2* **DRAW THE FINAL OUTLINE**
Once you have your outline established, transfer it to your drawing paper and mark in the eyes, ears and some of the more prominent creases and shadows.

*3* **FINISH THE DRAWING**
Slowly add details and darker shades to the face before moving on to the rest of the body. After you have penciled in the wrinkles and spaced them correctly, go back over many of them with a charcoal pencil to darken. Holding your pencil a little on its side will give you a broader line and a more realistic wrinkle fold. Clean up any smudges and spray with fixative. Let this dry.

*Fewer wrinkles and more blending toward the top*

*Shade behind the head to make it pop*

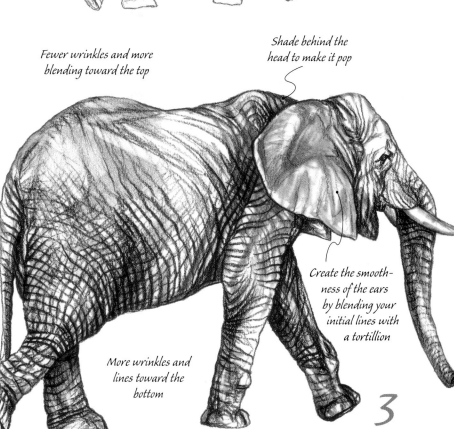

*Create the smoothness of the ears by blending your initial lines with a tortillion*

*More wrinkles and lines toward the bottom*

*3*

# Asian Elephant

Asian elephants are much smaller than their African relatives. Their ears and tusks are also smaller, and they have smoother skin and convex backs.

*BASIC SHAPES OF AN ASIAN ELEPHANT*

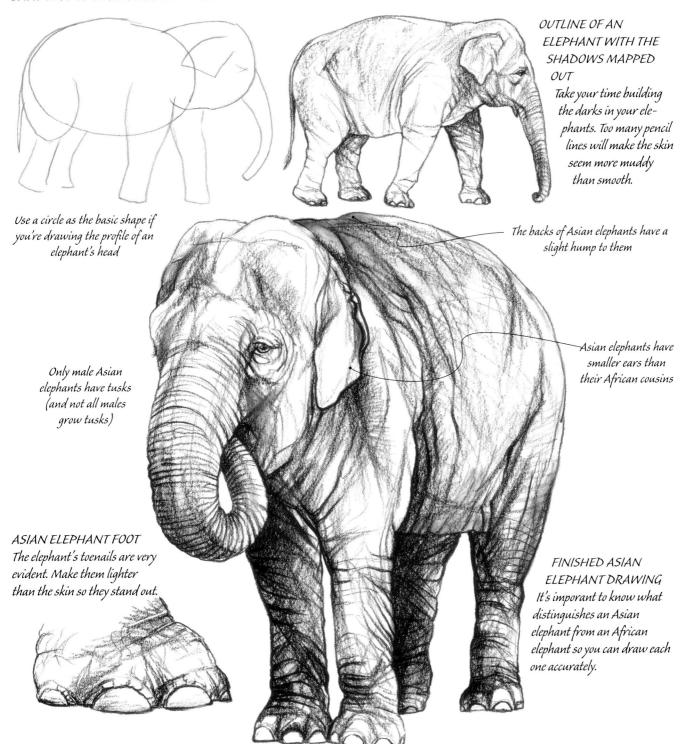

*OUTLINE OF AN ELEPHANT WITH THE SHADOWS MAPPED OUT*
Take your time building the darks in your elephants. Too many pencil lines will make the skin seem more muddy than smooth.

Use a circle as the basic shape if you're drawing the profile of an elephant's head

The backs of Asian elephants have a slight hump to them

Only male Asian elephants have tusks (and not all males grow tusks)

Asian elephants have smaller ears than their African cousins

*ASIAN ELEPHANT FOOT*
The elephant's toenails are very evident. Make them lighter than the skin so they stand out.

*FINISHED ASIAN ELEPHANT DRAWING*
It's important to know what distinguishes an Asian elephant from an African elephant so you can draw each one accurately.

# BEARS

Bears are members of the Ursidae family, which comprises nine different species in the Americas and Eurasia. Although they are all distinctly different, they also share many common characteristics. Drawing realistically means including the small but necessary details that distinguish individual animals. Grizzly bears have a muscular, densely furred body, small rounded ears and a concave, or dish-shaped, face. They possess a prominent shoulder hump and have long, slightly curved claws. They can range in color from almost white to almost black, depending on heredity, sun bleaching and molting.

 ANIMAL SECRET

The grizzly bear often stands on its hind legs to improve its view or to smell the air.

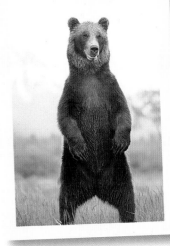

*The ears are more prominent when the bear is in its thinner summer coat*

*Grizzly's shoulder hump*

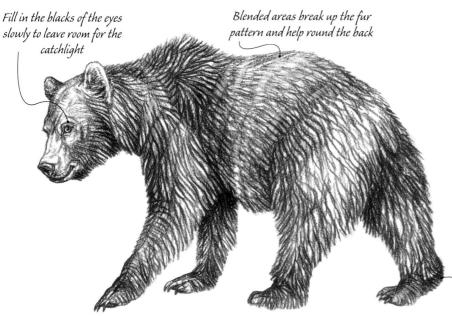

*GRIZZLY BEAR FINAL OUTLINE*
*This final outline indicates fur direction and the darkest value areas.*

*Fill in the blacks of the eyes slowly to leave room for the catchlight*

*Blended areas break up the fur pattern and help round the back*

*GRIZZLY FINISHED DRAWING*
*This final drawing was sketched with an HB charcoal pencil. Before it was sprayed with a fixative, I made a few swipes with an eraser to lighten the bear's back. These slight highlights help to round the animal's body. Also, a slight rubbing with a tortillion darkened the area under the bear's head and helped add depth to the drawing. This bear is in its summer coat, so I didn't draw the fur as full and thick as I would have had the bear been in its winter coat.*

*Lifting the bear's front and back foot gives the impression of movement and makes for a more interesting pose*

# Grizzly Bear

This grizzly's interesting pose can work for almost any purpose, whether as a simple illustration or as a reference for a painting. It is a difficult pose to draw accurately because of the complex shading required by the turned head. Profile drawings are easier, but not as interesting. Moreover, this pose emphasizes the grizzly's distinguishing features: the humped shoulder, the round, dish-like face and the long front claws. As you draw the fur, keep your individual pencil lines as clean and distinct as possible to illustrate how the bear's fur changes direction around its body.

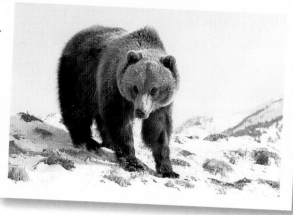

*GRIZZLY BEAR*

*1*    *2*    *3*

**1** ESTABLISH AN ACCURATE OUTLINE
Once you've used basic-shapes sketches to establish correct proportions, use tracing paper overlays to create the outline. Lightly transfer this to the final surface.

**2** ADD THE FIRST LAYER OF FUR
Lightly pencil in the bear's fur, making sure it follows the direction of the bear's body.

**3** FILL IN MORE FUR
After you have the first layer of fur lightly applied in the proper direction, you can begin to overlay more fur. As you fill in your drawing, slightly change the angle of your fur strokes to make your image look more natural.

**4** FINALIZE THE DRAWING
Add the facial details and the paws before adding any shading. Notice the face is lighter on the left side to show the direction of the light. Put in the darkest areas, which are the shadows behind the face, under the chin and under the back legs. Making these areas the darkest darks will emphasize the head.

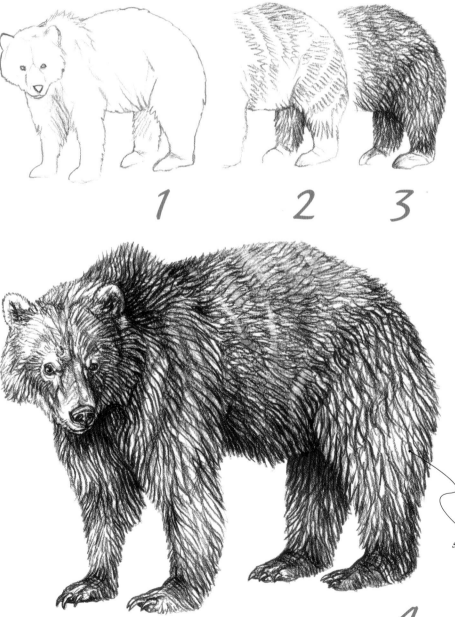

*The final fur lines are not straight but are more squiggly*

*4*

# POLAR BEAR

Light-colored animals such as the polar bear are a challenge because you need to strike a balance between adding lines and tones to suggest the texture of the fur and leaving enough white space to define the color. Animals with white fur are a definite case for the "less is more" attitude, so consider this an exercise in illustrating an animal with a minimum of lines and tones. As with other animals with white fur, don't muddy the coat of polar bears by drawing too many pencil lines. Instead, use lines sparing and shade with your fingertip or a tortillion.

## ANIMAL SECRET

Grizzly bears and polar bears both evolved from a common ancestor and have somewhat similar weights. Brown bears belong to the same species as grizzlies, but are distinguished mostly by their locations. Grizzlies normally live inland, while "brownies" live near the coast. Due to better food sources, coastal bears normally grow much larger than interior bears.

*POLAR BEAR SOW AND CUB IN NOVEMBER*

## DRAWING SECRET

When polar bears are dry, their individual hairs are less noticeable than when they are wet. When the fur is wet, draw the fur in clumps that are a little separated from one another. When the bear is dry, keep your linework to a minimum and use shading to suggest texture.

 **STUDY**

*POLAR BEAR CHARACTERISTICS*
*Their whitish coats, streamlined bodies, smaller ears, longer necks and large paws distinguish polar bears from their grizzly relatives.*

*Make sure to leave enough light areas in the bear's coat to suggest natural highlights*

*Polar bears are more streamlined than other bears*

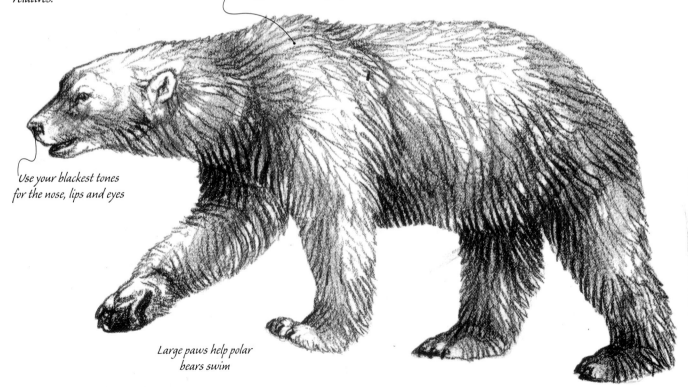

*Use your blackest tones for the nose, lips and eyes*

*Large paws help polar bears swim*

 DEMONSTRATION

# Polar Bear Cub

Polar bear cubs are not as sleek and streamlined as the adults. Their round faces and bodies and soft fur make them adorable creatures to draw.

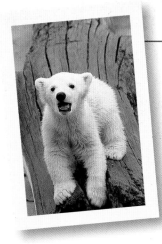

*POLAR BEAR CUB*
*Wild polar bear cubs are born between November and January. They weigh only about 1 pound (45g) at birth, but grow quickly.*

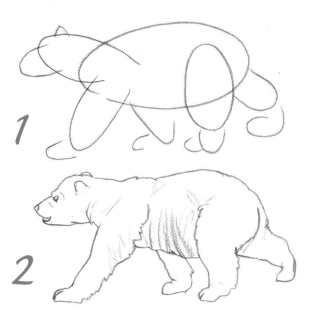

*1* *DRAW THE BASIC SHAPES*
*Doodle to establish the basic form and to capture the cub's proportions and pose.*

*2* *REFINE THE OUTLINE*
*Use tracing paper overlays to refine the shapes into an outline and transfer it to your drawing paper. Transfer it lightly so you can still modify the details as you fill in the image. Begin to map out the shadow areas.*
*As you can see, once I got to the final paper I slightly lifted the back foot. The adjustment was easily made because of the light pressure I had used to transfer the drawing.*

*3* *ADD THE FINISHING DETAILS*
*Keeping your lines to a minimum, fill in the fur on the face and body. Shade the cub's far legs with a tortillion and use the blackest tones for the claws, nose, mouth, eye and shading on the far legs. Clean up any smudges and spray with fixative. Let it dry.*

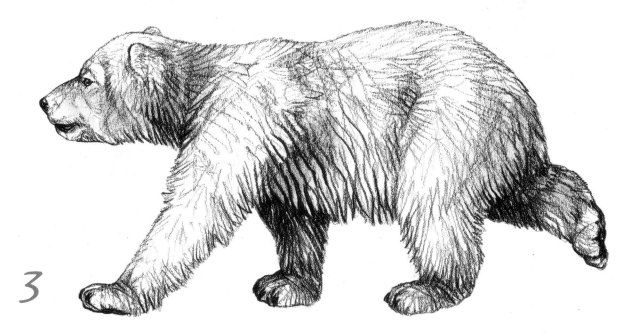

# BIRDS OF PREY

Birds of prey are perhaps the most recognized and majestic birds in the world. These hunters of the sky display sharp beaks and talons, beautiful feather patterns and stern, penetrating eyes. They are also the birds most often drawn and painted by artists young and old.

## DRAWING SECRET

Photographs are very important to artists who draw birds as they capture the details necessary to illustrate birds accurately. Mounted birds can often be found at taxidermy shops and skins can often be seen at museums or at Fish & Game Departments.

*HARRIS' HAWK*

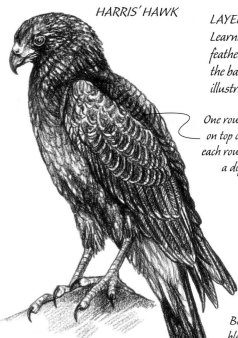

*LAYERS OF FEATHERS*
*Learning how layers of feathers fit together is half the battle of learning to illustrate birds.*

*One row of feathers lies on top of another, and each row has feathers of a different size*

*Blend to distinguish different areas of the body*

*PEREGRINE FALCON*

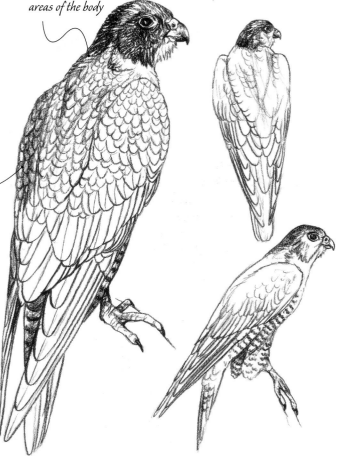

*Build the darks, then blend and soften them with a tortillion to simulate a smooth feather pattern*

**1** *ESTABLISH THE BASIC LAYOUT OF THE FEATHERS*
*Draw the basic shape, then outline the feathers.*

**2** *SOFTEN THE LINES*
*Use a tortillion to soften the lines and create shadows between layers.*

**3** *ADD MARKINGS AND DETAILS*
*Start with light values, then add the markings unique to the bird and finish with darks.*

*LAYERING FEATHERS*

*1*        *2*        *3*

# DEMONSTRATION

# Female Snowy Owl

This is a very common pose for an owl. I like it because it shows off the owl's interesting face and bright, intelligent eyes. In your drawing, add a minimum of feather markings or you will make the snowy owl look too dark.

## ANIMAL SECRET

Snowy owls are not all white. Adult male snowy owls are much whiter than the heavily barred females, while immature owls have the most markings. Keep this in mind when drawing a family of snowy owls.

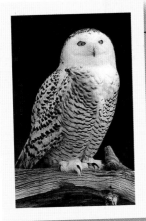

## 1 DRAW BASIC SHAPES
Doodle to establish the basic form and to get a pose you like.

## 2 REFINE THE OUTLINE
Use tracing paper overlays to refine your outline.

## 3 BEGIN TO ADD DETAILS
Lightly transfer the outline to your drawing paper. Notice how I changed the position of the face. Simply erase the light lines you initially drew and reposition the eyes, beak and major feather markings. Also map out the outline of the wing, the mass of the feathers, the tail feathers and the legs.

## 4 FINISH THE DRAWING
Add the details to the face. Snowy owls have bright yellow eyes, so leave the irises mostly white. Put in the short feathers of the face, using the most detail for the feathers around the beak and the eyebrows. Add spots to the face. Add the body feathers using the process on page 128. Add the bar markings last.

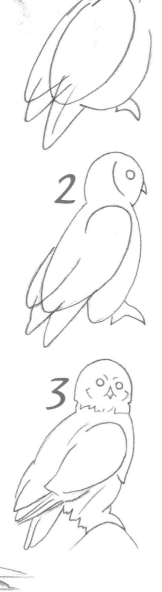

# Great Horned Owl

Owls have always been of interest to artists. They are a symbol of wisdom and knowledge and are thought to possess supernatural powers. Since they are usually nocturnal, you will probably have to rely on photographs, zoos or mounted animals for your reference sources.

The head will determine the success of your owl drawing, as an owl's character seems to rest in its big-eyed face. The arrangement and pattern of the feathers on its face must also be mastered to draw owls successfully.

*GREAT HORNED OWL*

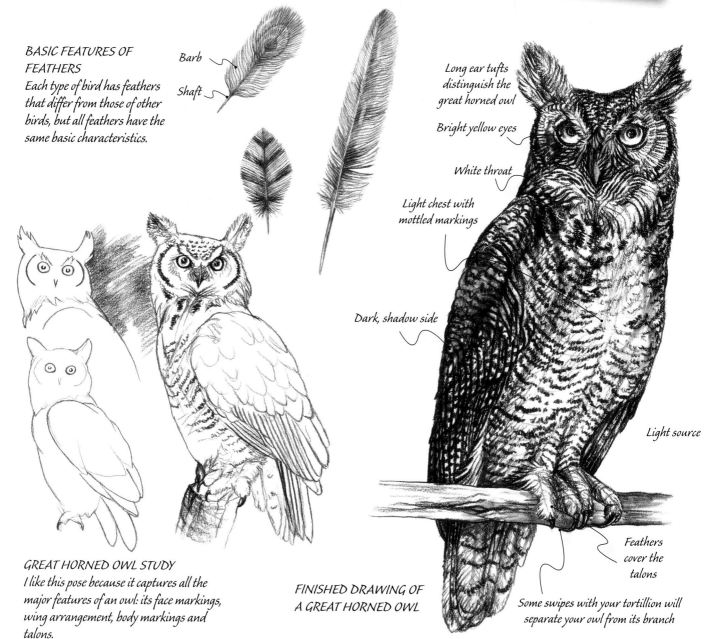

*BASIC FEATURES OF FEATHERS*
*Each type of bird has feathers that differ from those of other birds, but all feathers have the same basic characteristics.*

Barb

Shaft

Long ear tufts distinguish the great horned owl

Bright yellow eyes

White throat

Light chest with mottled markings

Dark, shadow side

Light source

Feathers cover the talons

Some swipes with your tortillion will separate your owl from its branch

*GREAT HORNED OWL STUDY*
*I like this pose because it captures all the major features of an owl: its face markings, wing arrangement, body markings and talons.*

*FINISHED DRAWING OF A GREAT HORNED OWL*

# Eagle

The eagle is a majestic bird of prey that has an independent, free spirit and a fierce, intimidating gaze. It is one of the greatest hunters and rules the sky on wings that can reach 6 feet (183cm). Its colors, features and symbolism make the eagle a frequent subject for artists.

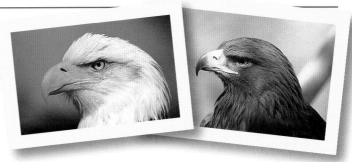

**ADULT BALD EAGLE**
*Bald eagles acquire their white heads and tails after about five years of age.*

**ADULT GOLDEN EAGLE**
*Mature golden eagles are slightly smaller than bald eagles. They get their name from their golden nape.*

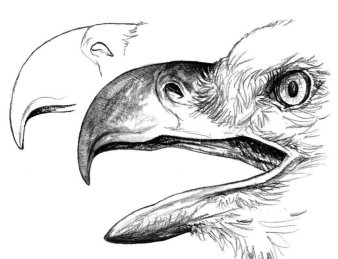

**BEAK STUDY**
*Rub the pencil marks with a tortillion to shape the bald eagle's beak. Take your time to shape the beak correctly. By rubbing along your pencil lines with your finger or tortillion, you can give the beak the curved look it requires.*

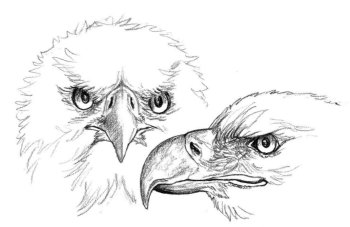

**ADDING GOLDEN EAGLE FEATHERS**
*1 | Draw the Outline*
*Doodle to establish an accurate outline.*

*2 | Lay in the Feather Lines*
*Outline the feathers in a balanced pattern. This will make the feathers look separate from one another.*

*3 | Blend the Feathers and Add the Finishing Details*
*Add feathers to the head, then move on to the body.*

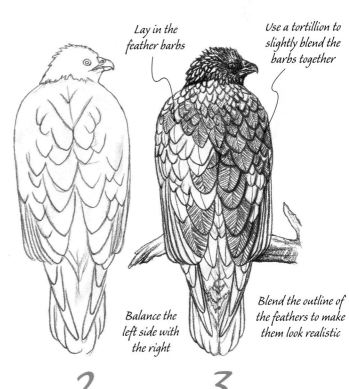

*Lay in the feather barbs*

*Use a tortillion to slightly blend the barbs together*

*Balance the left side with the right*

*Blend the outline of the feathers to make them look realistic*

*1*    *2*    *3*

# Bald Eagle

A profile is relatively easy to draw, but it is a particularly good pose for the bald eagle because it makes it look so dignified. This pose also shows the wing's layout, face profile and talon stance.

REFERENCE PHOTO

*1* **DRAW THE BASIC SHAPES**
Doodle to capture your pose and proportions.

*2* **REFINE THE OUTLINE**
Use tracing paper overlays to clarify the proportions and basic features. Begin to map out the wing and tail feathers as well as some facial features.

*3* **FURTHER REFINE THE OUTLINE**
Use another overlay to further refine the outline. Lay in features such as the feather arrangement of the wing and the details of the face, particularly the beak.

*4* **ADD DETAILS**
Lightly pencil in the eyes and add further detail to the beak. Begin to outline the direction of the head feathers. Lay in the outline of the wing, chest and tail feathers. Keep your strokes light so you can easily fix mistakes. Transfer this to your drawing paper.

*5* **FINISH THE DRAWING**
Starting with the head, finish the eye and beak. Add a few light lines to suggest feathers and shading, but leave most of the head white. Blend the outline of the feathers (see detail, page 133). Then darken the lines, following the direction of the barbs and shafts. Continue to build darker layers, placing shadows according to the direction of the light. Then lift out the highlights with a kneaded eraser. Add the darkest darks last.

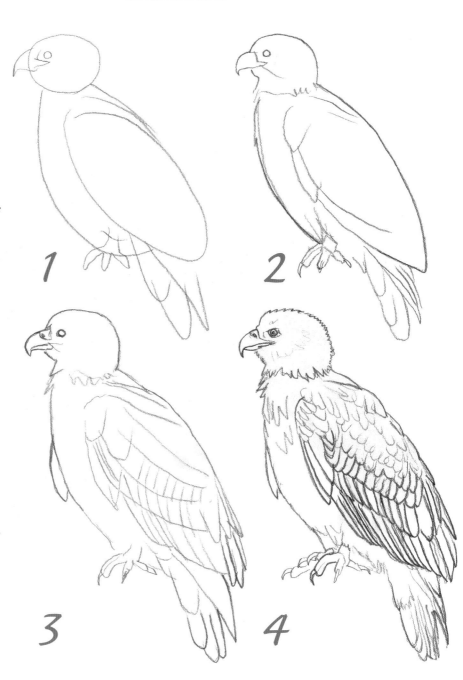

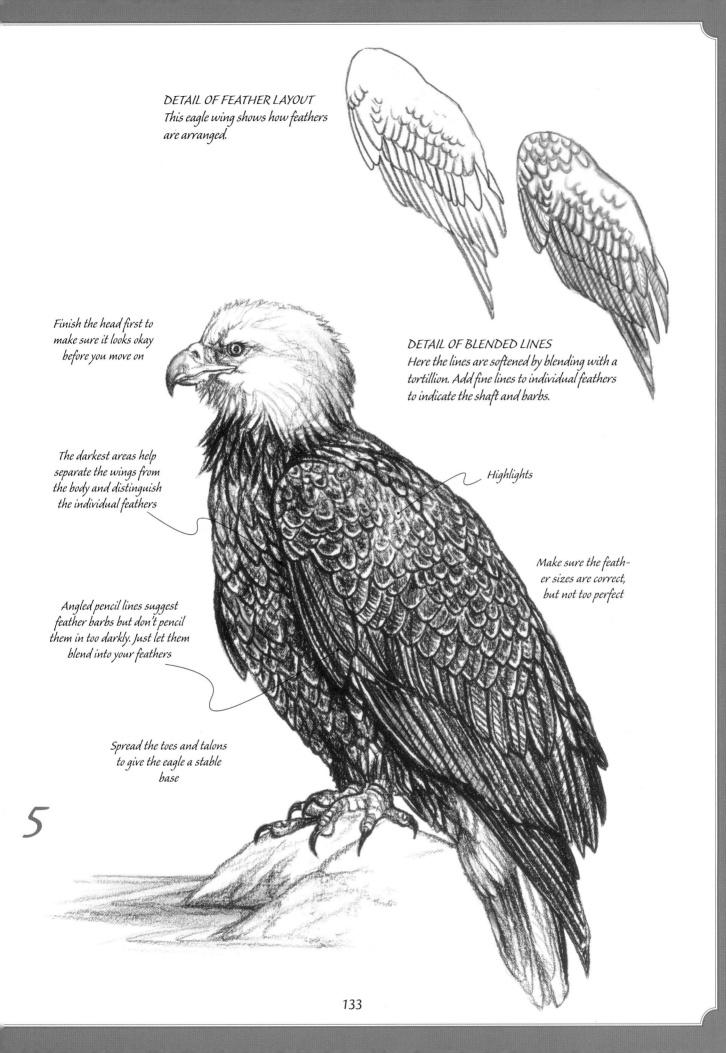

DETAIL OF FEATHER LAYOUT
This eagle wing shows how feathers are arranged.

Finish the head first to make sure it looks okay before you move on

DETAIL OF BLENDED LINES
Here the lines are softened by blending with a tortillion. Add fine lines to individual feathers to indicate the shaft and barbs.

The darkest areas help separate the wings from the body and distinguish the individual feathers

Highlights

Make sure the feather sizes are correct, but not too perfect

Angled pencil lines suggest feather barbs but don't pencil them in too darkly. Just let them blend into your feathers

Spread the toes and talons to give the eagle a stable base

5

133

# WATERFOWL

Waterfowl drawings and paintings are very popular among hunters and sportsmen—both male and female. Ducks are a particular favorite because of their interesting colors and their worldwide distribution.

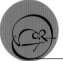

## ANIMAL SECRET

Male ducks are normally referred to as *drakes* and females are called *hens*. Male and female ducks have vastly different colorations. Males are brighter, while females are more drab.

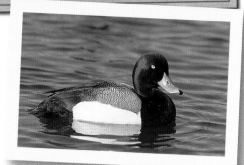

*MALE GREATER SCAUP*

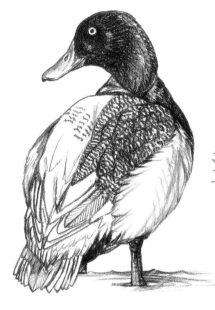

*THE PROCESS OF APPLYING FEATHERS*
1 | *Start with a small smount of squiggles*

2 | *Build up the marks*

3 | *Add the final squiggles, but let some paper show through*

*1 2 3*

*CREATING REALISTIC DUCK FEATHERS*
*Feathers are soft and should not have hard edges. Although one row of feathers is distinguishable from another, on close inspection they still appear to blend together. Use a tortillion and eraser to soften and blend.*

*Separate the head and chest with a white neck ring*

*MALE MALLARD DUCK*

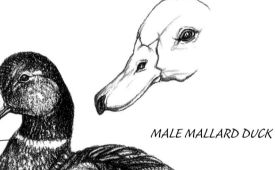

*Create the illusion of different textures as you fill in the feathers*

*The beak has a dark tip*

*Use a charcoal pencil at an angle to lay in the broad, rough details of the chest*

*Feather sizes will vary from one area of a duck's body to another*

*Blend with a tortillion for highlights*

*Indicate the feather barbs with somewhat random strokes*

*FEMALE MALLARD DUCK*

*After outlining each feather, go back and add a bit of tonal variation to each one*

# Emperor Goose

The emperor goose is a beautifully colored large goose that many artists have found intriguing. Its white tail, white head and gray body make it ideal for pencil drawing. Unlike ducks, male and female geese are identical in their coloration. Use the photograph to help you render the details of this magnificent bird.

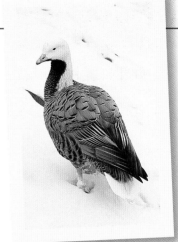

*EMPEROR GOOSE*
*Notice the gray feathers are edged in white, with black markings along the border.*

*1* **DRAW THE BASIC SHAPES**
*Doodle to establish the basic form and pose.*

*2* **REFINE THE OUTLINE**
*Refine with tracing paper overlays. Outline important feathers and facial features.*

*3* **ESTABLISH THE MAJOR FEATURES**
*Transfer the outline to the drawing paper and begin to establish the major features. Add an eye, a nostril to the beak and a line separating the upper part of the beak from the lower part. Starting at the head, make a detailed outline of all the different feather types and outline the legs and feet.*

*4* **FINISH THE DRAWING**
*Use the photograph to help you render the details accurately. Finish the eye and beak and suggest feathers with a few light strokes. Blend for shape with a tortillion. Starting from the neck and moving down, fill in the black areas of the body feathers with charcoal and leave the tips white. Put in details to the legs and feet, using lines to suggest ridges and blending to suggest areas of smooth texture. Clean up any smudges and spray with fixative. Let this dry.*

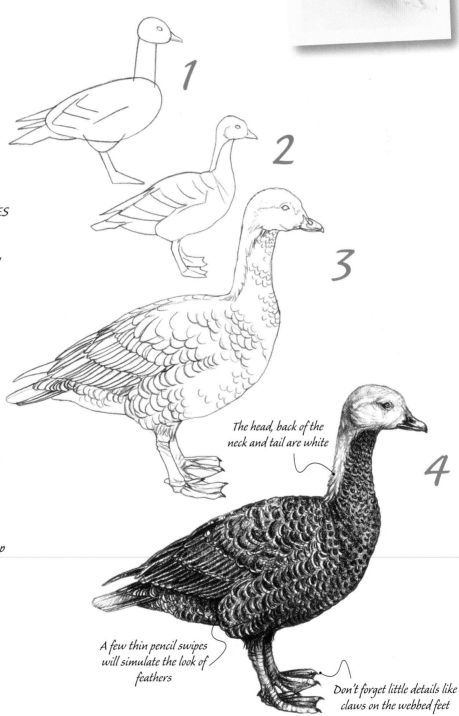

*The head, back of the neck and tail are white*

*A few thin pencil swipes will simulate the look of feathers*

*Don't forget little details like claws on the webbed feet*

135

# SMALL ANIMAL STUDIES

Squirrels, rabbits, chipmunks, raccoons and prairie dogs are common small animals that have become favorite subjects for artists. Many of us have grown up with animals such as these running around in the backyard. Small animals are often best illustrated with some sort of background, such as tree branches, flowers or grass.

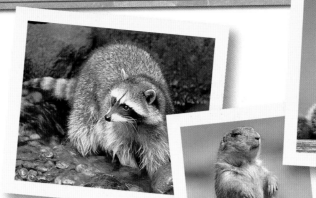

RACCOON

SQUIRREL

PRAIRIE DOG

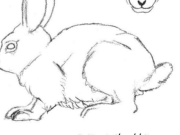

COTTONTAIL RABBIT

STUDY

Prairie dog

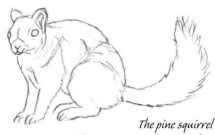

Pine squirrel

The pine squirrel is smaller and sports a less bushy tail than the fox or gray squirrel

Gray squirrel

The raccoon has very dexterous hands and are distinguished by its striped tail and masked face

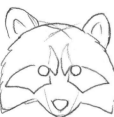

Cottontail rabbit

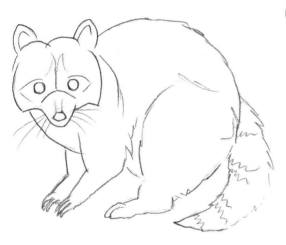

136

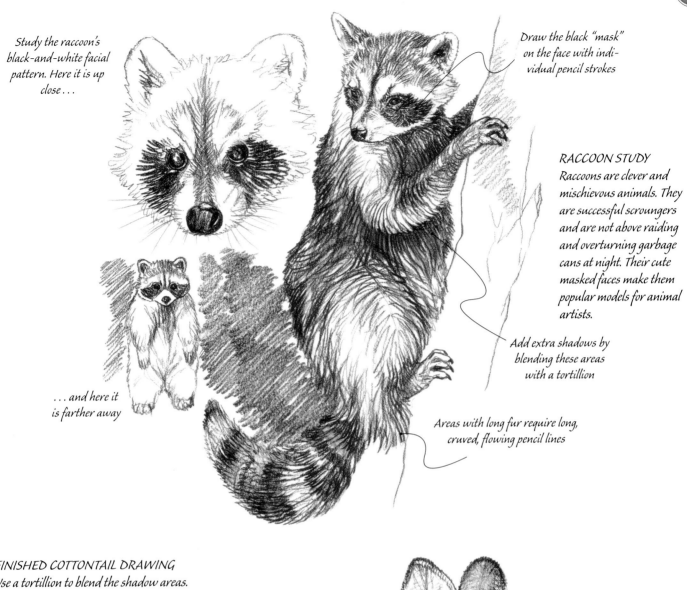

Study the raccoon's black-and-white facial pattern. Here it is up close . . .

Draw the black "mask" on the face with individual pencil strokes

### RACCOON STUDY
Raccoons are clever and mischievous animals. They are successful scroungers and are not above raiding and overturning garbage cans at night. Their cute masked faces make them popular models for animal artists.

. . . and here it is farther away

Add extra shadows by blending these areas with a tortillion

Areas with long fur require long, cruved, flowing pencil lines

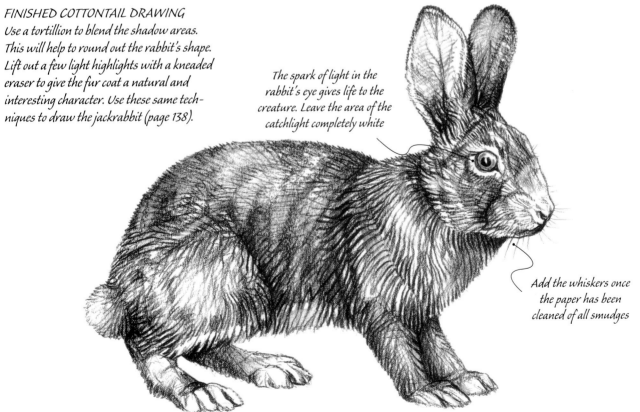

### FINISHED COTTONTAIL DRAWING
Use a tortillion to blend the shadow areas. This will help to round out the rabbit's shape. Lift out a few light highlights with a kneaded eraser to give the fur coat a natural and interesting character. Use these same techniques to draw the jackrabbit (page 138).

The spark of light in the rabbit's eye gives life to the creature. Leave the area of the catchlight completely white

Add the whiskers once the paper has been cleaned of all smudges

# Jackrabbit

This creature is called a rabbit even though it's actually a hare. While little cottontails seldom weigh over 4 pounds (2kg), large jackrabbits can weigh up to 10 pounds (5kg) and can run 35 miles per hour (56kph) over short distances.

*JACKRABBIT*

## ANIMAL SECRET

The smaller size and ears distinguish the cottontail rabbit from the jackrabbit.

### 1 DOODLE TO ESTABLISH CORRECT SHAPES
*Doodle the basic shapes to achieve the correct proportions and pose.*

### 2 REFINE THE OUTLINE
*Use tracing paper overlays to refine the basic shapes into an accurate outline. Add some of the face details such as the eye and nose. Outline some of the jackrabbit's musculature and the contour between the inner and outer ear.*

### 3 ADD THE FINISHING DETAILS
*The drawing of the rabbit is shown unfinished here. This illustration, however, shows how I'll work from left to right (since I am right-handed) to minimize smudging. Also, I try to do the animal's head early; if the head isn't successful, the whole drawing might as well be scrapped and begun again.*

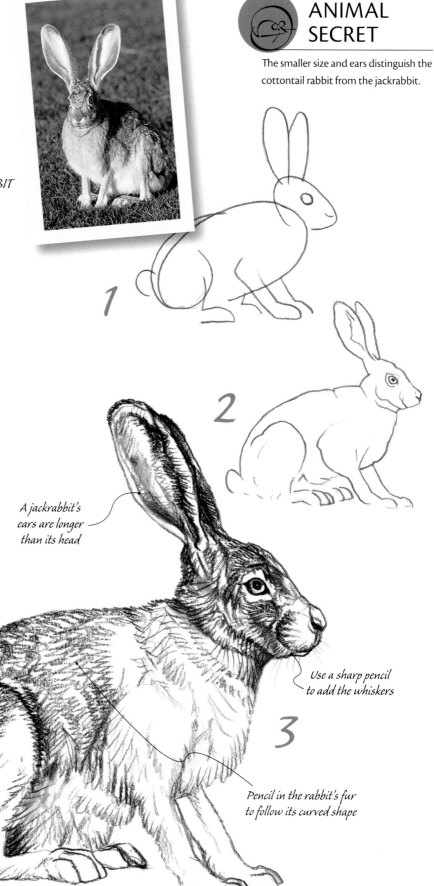

*A jackrabbit's ears are longer than its head*

*A few rubs with a tortillion adds shadow areas to the jackrabbit's tail and rump*

*Use a sharp pencil to add the whiskers*

*Pencil in the rabbit's fur to follow its curved shape*

 DEMONSTRATION

# Raccoon

This mischievous bandit is a common and cute subject that makes a good black-and-white pencil drawing. Remember when viewing an animal straight on to think of its face and body as essentially equal halves.

**1 DOODLE TO ESTABLISH THE POSE**
Doodle the basic shapes to establish accurate proportions and a pose you like.

**2 REFINE THE OUTLINE**
Use tracing paper overlays to establish a more accurate outline. Map out the placement of the facial details.

**3 INDICATE DARK VALUE AREAS**
Transfer your outline to the drawing paper. Lightly indicate the areas that will be the darkest darks.

**4 FINISH THE DRAWING**
Use an HB charcoal pencil and a tortillion to add the finishing details. Add the dark mask with single pencil strokes, allowing a little of the white paper to show through, to give the fur a more natural, realistic appearance. Add the whiskers once you have cleaned the drawing of marks and smudges.

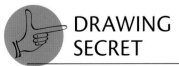 **DRAWING SECRET**

Notice how the white areas of the drawing appear to come toward you and the darkest areas seem to recede. This makes a flat drawing look three-dimensional to eye and gives the viewer a sense of depth.

ADULT RACCOON

Keep the branch simple so the focus remains on the raccoon

Leave a little bit of white paper showing through just above the eyes

Dark black helps separate the head and arm from the body

Use long wavy strokes here

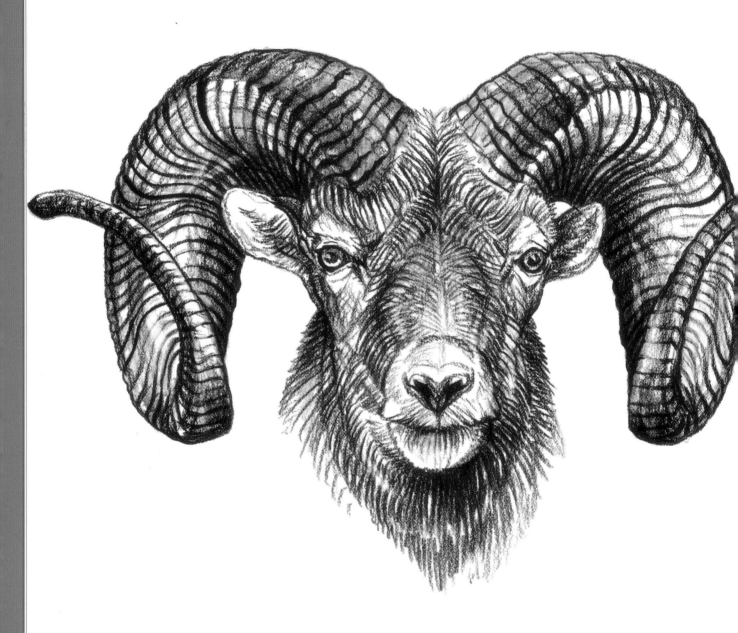

**Rocky Mountain Bighorn Ram**
*HB charcoal pencil on bristol two-ply vellum paper*
*11" x 14 ½" (28cm × 37cm)*

# Conclusion

I hope this book of secrets has proven to be instructional and helpful, and that it has inspired you to pick up your pencil and draw. I truly believe everyone can learn to draw animals with the help of a little instruction and a little practice. If you feel you have an interest in this craft, I hope you take the time to pursue this challenging endeavor. Instructional books and art classes make good starting points. Once you've learned some basic techniques and how to use your drawing tools properly, you can continue your drawing education at your own pace. So good luck, good drawing and have fun wearing out those pencils! Always remember: your goal is to become the unique, original artist that only you can be.

*Doug Lindstrand*

# Index

# Learn to Draw Like the Pros With
# These Other Fine North Light Books

If you're an artist armed only with a pencil, this book is for you! SECRETS TO REALISTIC DRAWING will have you creating lifelike drawings in no time by teaching you drawing principles in a clear and concise manner. The techniques, strategies and step-by-step demonstrations will help you quickly realize your artistic dreams.

**ISBN-13: 978-1-58180-649-6, ISBN-10: 1-58180-649-3**
Paperback, 128 pages, #33238

THE DRAWING BIBLE is the definitive resource you need in order to master this important discipline—it will teach you both how to draw and how to use your drawing materials to the best advantage. Learn how to realistically capture a variety of popular subjects and conquer the most crucial drawing principles today!

**ISBN-13: 978-1-58180-620-5, ISBN-10: 1-58180-620-5**
Hardcover with wire-o binding, 304 pages, #33191

Everyone has photographs of their favorite pets, and with DRAWING REALISTIC PETS FROM PHOTOGRAPHS, you can now use them to create lifelike drawings of your beloved furry and feathered friends. With bestselling author Lee Hammond's simple-to-understand instructions, you will learn all the basics.

**ISBN-13: 978-1-58180-640-3, ISBN-10: 1-58180-640-X**
Paperback, 128 pages, #33226

Tap the proven techniques and collective drawing wisdom of more than a dozen of THE ARTIST'S MAGAZINE'S and North Light Books' most venerable artists. THE PENCIL BOX covers basic supplies and tips for improvement in addition to dozens of drawing techniques, so you will find everything you need to start drawing better in one comprehensive package.

**ISBN-13: 978-1-58180-729-5, ISBN-10: 1-58180-729-5**
Paperback, 128 pages, #33403

*These books and other fine North Light titles are available at your local fine art retailer or bookstore or from online suppliers.*